Georges Braque

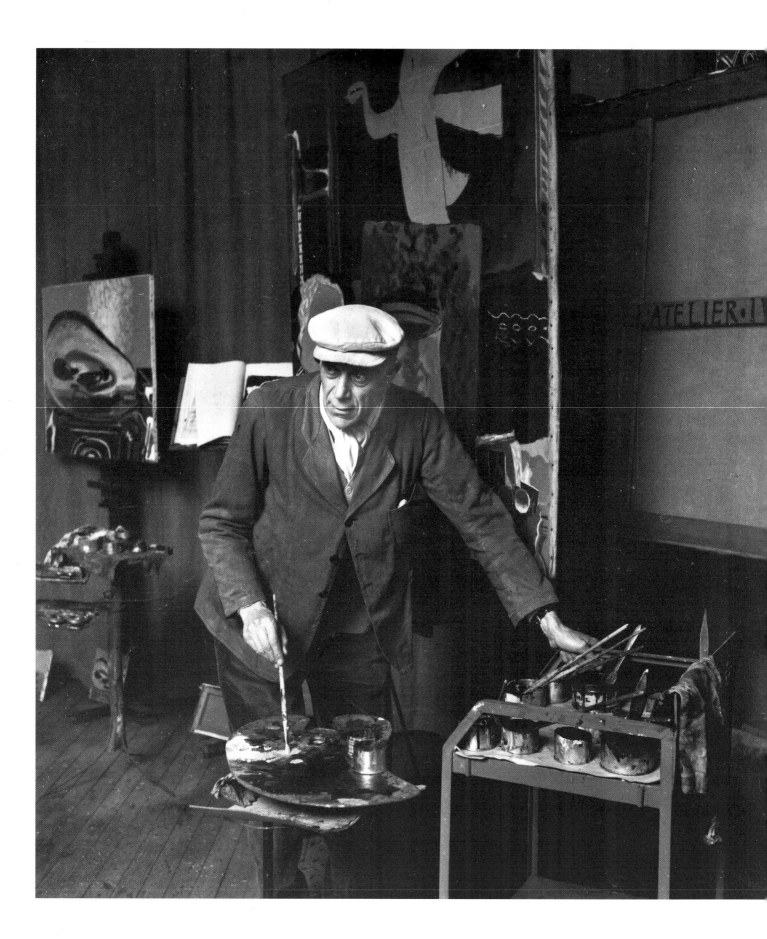

Georges Braque

By Jean Leymarie

With contributions by
Jean Leymarie, Magdalena M. Moeller
and Carla Schulz-Hoffmann

Solomon R. Guggenheim Museum, New York

Prestel

Published in conjunction with the exhibition
Georges Braque held at the Solomon R. Guggenheim Museum,
New York, June – September 1988

Cover illustration softcover:
The Billiard Table, 1944–52 (cat. no. 71),
The Jacques and Natasha Gelman Collection
Hardcover jacket: *Studio VIII,* 1952–55 (cat. no. 75)
Frontispiece: Georges Braque, Paris, 1953
(Photo Doisneau-Rapho, Paris)

Prestel-Verlag
Mandlstrasse 26
D-8000 Munich 40
Federal Republic of Germany

Soft cover edition not available to the trade

Distributed in the United Kingdom, Ireland and the rest of the world
with the exception of continental Europe, USA, Canada and Japan by
Thames and Hudson Limited,
30–34 Bloomsbury Street, London WC1B 3 QP, England

Distributed in the USA and Canada by
te Neues Publishing Company,
15 East 76 Street, New York, NY 10021, USA

Design: Dietmar Rautner, Munich
Typesetting: Max Vornehm, Munich
Offset lithography: Karl Dörfel GmbH, Munich
Printing: Wenschow Franzis-Druck GmbH, Munich
Binding: R. Oldenbourg GmbH, Heimstetten/Munich

Printed in the Federal Republic of Germany

ISBN 3-7913-0882-3

Contents

Lenders to the Exhibition
p. 6

Preface and Acknowledgments
Thomas M. Messer
p. 7

Braque's Journey
Jean Leymarie
p. 9

Georges Braque: The Cubist Phase
Carla Schulz-Hoffmann
p. 19

The Conquest of Space:
Braque's Post-Cubist Work After 1917
Magdalena M. Moeller
p. 25

Plates
p. 31

Documentation

Chronology
p. 271

Selected Exhibitions
p. 274

Selected Bibliography
p. 276

Photographic Credits
p. 278

Lenders to the Exhibition

Mr. and Mrs. William R. Acquavella, New York
Mr. and Mrs. Eric Estorick
The Jacques and Natasha Collection
Josefowitz Collection
Mr. and Mrs. David Lloyd Kreeger, Washington, D. C.
Marietta Lachaud, Paris
Mr. and Mrs. Claude Laurens, Paris
Quentin Laurens, Paris
Rosengart Collection, Lucerne
Lucille Ellis Simon, Los Angeles
Mrs. Bertram Smith, New York
Gustav Zumsteg, Zürich

The Art Institute of Chicago
Solomon R. Guggenheim Museum, New York
Kunsthalle Hamburg
Kunsthaus Zürich
Kunstmuseum Bern
Kunstmuseum Hannover mit Sammlung Sprengel, Hannover
Kunstsammlung Nordrhein-Westfalen, Düsseldorf
The Menil Collection, Houston
The Metropolitan Museum of Art, New York
Moderna Museet, Stockholm
Musée des Beaux-Arts, Le Havre
Musée National d'Art Moderne, Centre Georges Pompidou, Paris
Museo de Arte Contemporáneo, Caracas
Museum Folkwang, Essen
The Museum of Modern Art, New York
Norton Gallery of Art, West Palm Beach, Florida
Philadelphia Museum of Art
Saarland Museum, Saarbrücken, West Germany
San Francisco Museum of Modern Art
Staatsgalerie Stuttgart
Yale University Art Gallery, New Haven

Galerie am Lindenplatz, Liechtenstein
Galerie Louise Leiris, Paris
Galerie Rosengart, Lucerne
Jan Krugier Gallery, New York
Marlborough Fine Art (London) Ltd.
Perls Galleries, New York

Preface and Acknowledgments

Georges Braque first came to world attention as Picasso's friend and fellow creator during the formative period of Cubism, and the image of these two very different yet temporarily related artists lingers in our memories to the present day. With the perspective gained during subsequent decades, Braque's separate and very distinct personality became familiar and accessible to those privileged to follow the remarkable unfolding of his style. Yet, for reasons difficult to explain, museum reviews of the great Frenchman's art remained quite rare and none was offered in New York after the retrospective organized by The Museum of Modern Art in 1949, when a significant part of Braque's lifework was as yet unrealized.

To correct this omission, the Solomon R. Guggenheim Museum gladly accepted the invitation of Munich's Kunsthalle der Hypo-Kulturstiftung to organize jointly the current retrospective and to ask Jean Leymarie, Braque's friend and a distinguished connoisseur of the artist's work, to assume responsibility for the selection and the authorship of the catalogue. Our colleague Leymarie accepted the charge with full knowledge of the inherent difficulties since his selection was made in competition with two other Braque shows launched simultaneously by museums in Norway and in Japan. As organizers we did, however, profit from a reservoir not available to others, namely the personal collection of Mr. and Mrs. Claude Laurens, Braque's legatees, and of their son Quentin. The participation of these lenders, together with the active cooperation of Galerie Louise Leiris, Paris – the gallery most closely associated with the work and the memory of the artist – assured the realization of this ambitious project.

The Guggenheim's gratitude therefore is equally divided among those through whose scholarly efforts the exhibition came about and those whose generous loans allowed for the retrospective's accomplishment. In the first category, Carla Schulz-Hoffmann of the Bayerische Staatsgemäldesammlungen in Munich and Magdalena M. Moeller of the Sprengel Museum in Hannover deserve special mention for their scholarly contributions to the catalogue, while Jean Leymarie must also be thanked for reshaping and extending his original Munich version of the presentation with the Guggenheim in mind. Among lenders, in addition to those already mentioned, the Musée National d'Art Moderne in Paris must be singled out because of the number of works of great distinction this Parisian institution, now lodged with the Centre Georges Pompidou,

provided for the exhibition. But all lenders, whose names are listed separately in the catalogue unless they requested anonymity, are due the Guggenheim's profound gratitude for allowing a selection of Georges Braque's work to be reassembled in New York after so long a pause.

The Museum's most sincere appreciation must also be expressed to the National Endowment for the Arts for its generous support of this project. Finally, I would like to acknowledge the contributions of two Guggenheim staff members, Susan B. Hirschfeld, Assistant Curator, and Carol Fuerstein, Editor, for coordinating, respectively, the New York exhibition and its catalogue.

Thomas M. Messer, Director
The Solomon R. Guggenheim Foundation

Jean Leymarie

Braque's Journey

The spectator who looks at a painting goes over the same path as the artist, and since the path counts more than the thing itself, the journey is what interests us most.

Georges Braque

A most interesting anecdote about Braque was left to us by his friend the poet Reverdy. "In 1917 I went to join him in the Midi, near Avignon. One day, while we were walking from Sorgues through the fields to the hamlet where I was staying, Braque carried one of his pictures at the end of a stick over his shoulder. We stopped and Braque put the canvas on the ground, among the grass and stones. I was struck by something and told him about it: 'It's amazing how it holds up against the actual colors and the stones.' Afterwards, I learned that it was above all a matter of whether it would hold up against hunger. Today I can answer. Yes, it has held, and against much more, for the paintings are afraid of nothing." Georges Braque has stood the test of time, and, after the centennial of his birth, crossed the decisive threshold. His paintings, which fill us with their silent splendor, are an invitation to accompany him along his creative journey, his path as an artist and as a man.

Braque was born on May 13, 1882, in Argenteuil, on the banks of the Seine. As a child he could watch the barges of Monet sail by, and, in the distance, the Eiffel Tower going up, a new subject for Seurat. When he was eight, his family moved to Le Havre, on the estuary of the same river. He passed his boyhood around the undisturbed sites that had been the cradle or focus of Impressionism. Nothing awakens the visual imagination like the varied spectacle of a busy port, a subject represented by so many painters, and the old port of Le Havre, before it was destroyed during the last war, was particularly picturesque, with its great breakwater of oak pilings and deep berths that reached to the center of the old town. His father and grandfather ran a house-painting business, and on Sundays painted sensitive and direct studies in the open air, one of which the artist preciously preserved. From them, he acquired the secrets of their craft and a reverence for it, which became the foundation of his nobility as a human being and his conscience as a painter. Many contemporary artists have shaken off the servitude of the hand to claim only the decisions of the mind, but, as Bissière wrote in his insightful monograph, the first on the painter, Braque "inherited trade secrets and formulas which, in the final analysis, may be the essential part of painting, or a least its

firmest basis." In this way, he was able to contribute to the pictorial revolutions of his time by perpetuating the craft tradition of Chardin, letting himself be carried spontaneously by his surroundings and by his nature without having to choose his destiny. As he himself acknowledged in this, his most revealing statement: "I did not decide to become a painter, any more than I decided to breathe." Painting, for him, was a biological necessity and his means of self-realization. "If I had one goal, it was to realize myself from day to day. In realizing myself, it so happens that what I do looks like a picture. I go my way and continue doing so, that's all there is to it."

His first experiments in painting have been lost, except for a few landscapes and portraits of members of his family: his mother, his cousin reading, his grandmother hunched over her sewing. Despite the still timid handling and reserved color-schemes, his qualities show through: a slow and contemplative vision, an intimate feeling for paint as a material and its resonance.

Friesz and Dufy, his friends in Le Havre, a little older than he and more advanced technically, led him to Fauvism, the sunfilled path blazed by Matisse and Derain. As he said, "I did not like Romanticism, so this physical painting pleased me." In the summer of 1906 he accompanied Friesz to Antwerp, and his views looking down on the Scheldt River and the harbor were, as he recognized, the beginnings of his truly creative work, his quest for light and its decantation. In the fall of that year, he went to L'Estaque, near Marseille, a site painted by Cézanne, and in the Provençal light, his colors flared into a swirl of lines. The following summer, among the sundrenched cliffs and coves near Toulon, another of Derain's and Friesz's favorite haunts, he painted some of the masterpieces of Fauvism, with a pure and lyrically personal radiance based not on violent tonal contrasts, but on rare suspended harmonies, with a vibrant pointillist brushwork. At the end of this stay, he returned to L'Estaque, and there the transformation from decorative colors to constructive form began. Back in Paris, he was impressed by the Cézanne retrospective and turned wholeheartedly toward this pictorial mediator and spiritual guide. At the same time, in Montmartre, he saw the

9

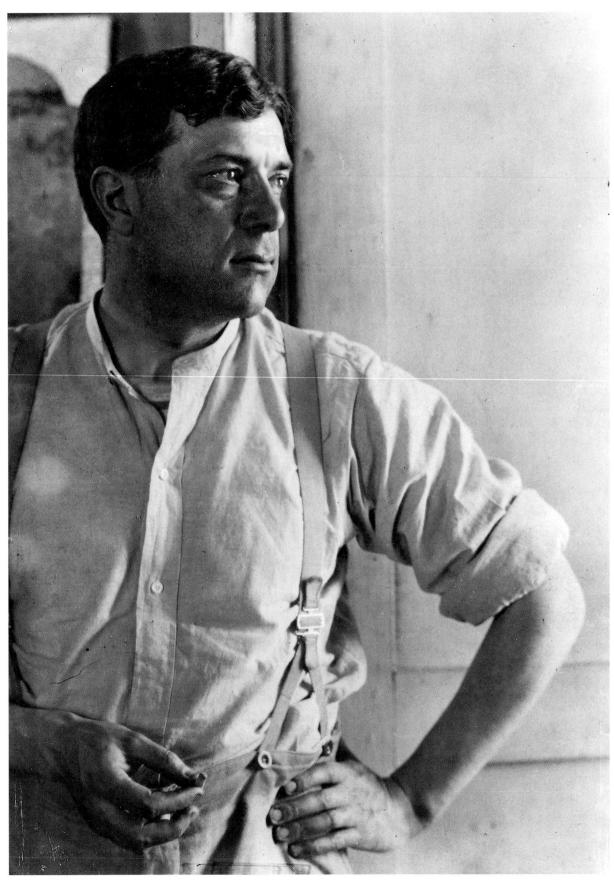

Georges Braque, 1922
Photograph by Man Ray

recently finished *Les Demoiselles d'Avignon* and made his decisive encounter with Picasso, his neighbor in Montmartre and elder by six months. Emulating the barbaric nudes and transgressions of Picasso, Matisse and Derain, Braque painted a few nudes of his own with very compact volumes that confirmed his change of orientation.

During his long third stay at L'Estaque, in 1908, Braque continued his volumetric structuring along decidedly Cézannian lines, avoiding the pitfalls of Expressionism and the temptations of primitivism to which some of his friends were succumbing. The horizon climbs up and finally pushes out the sky in an austere group of *Houses at L'Estaque* without doors or windows, pressed between tree trunks on a hillside like quarried blocks of stone. Exhibited that November in the gallery of the young art-dealer D.-H. Kahnweiler, soon to become the hotbed of Cubism, these pictures caught the eye of the critic Louis Vauxcelles, who noted that everything was reduced "to geometric patterns, to cubes." The preface was written by Apollinaire: "Here is Georges Braque. He leads an admirable life... he expresses a beauty full of tenderness and the nacre of his painting iridesces our understanding."

The still life, which had made its appearance with his *Jugs and Pipe* of 1906 (fig. 1, cat. no. 6) and would become his great and enduring specialty, was developed in the second half of 1908. After some compositions with typically Cézannian motifs of pitchers and fruit bowls, he suddenly painted his *Musical Instruments* (fig. 2, cat. no. 9), which he considered his first work in the Cubist mode, in that it created space and volume while negating perspective and showing different angles. Braque had many musical instruments in his studio which he liked not just for their forms but also to play. The reintroduction of a theme abandoned since the days of Chardin and the Baroque coincided with his pictorial concerns and his desire for a "total possession of things." The mandolin, clarinet and accordion combine their curvilinear and angular forms in a shallow space, harmonized in a sober color-scheme of gray, green and brown. The planes that open up, rise or turn back show more of each object than would normally be visible.

After the stereometric phase inspired by Cézanne came the so-called Analytical phase of Cubism, in which solid forms were decomposed to display their internal forms, the cubes exploding and breaking up into overlapping planes. Form was not destroyed, but rather reorganized in a new and complex way on the picture surface. "When fragmented objects appeared in my painting around 1909," Braque explained, "it was a way for me to get as close as possible to the object, as painting allowed." Lighter in tone and form than the Mediterranean houses of L'Estaque, the houses painted at La Roche-Guyon, near Mantes, in the summer of 1909, rise pyramidally under arching trees toward the keep of the old medieval for-

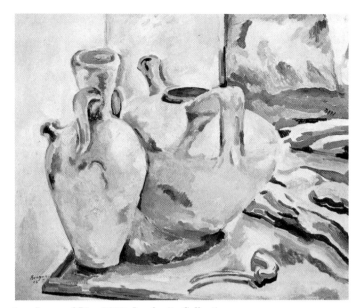

1. *Jugs and Pipe*. 1906. Josefowitz Collection

tress (fig. 3). The planes are suppler, shaped into *facets*, brought close to the eye, the contours are pierced with *passages*, interruptions that permit a more even distribution of light.

At the same moment, Picasso was in his Catalan homeland, near Tarragona, and when they compared their works in Paris at the end of the summer, the two pioneers realized that they were on parallel tracks: one concentrating on form and its pictorial energy, and the other on space and its pictorial unity. Their friendship was reinforced and transformed into an enthusiastic cooperation. The grandeur and richness of

2. *Musical Instruments*. 1908. Collection Mr. and Mrs. Claude Laurens, Paris

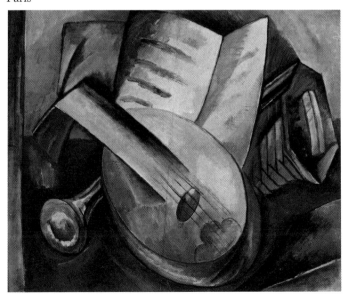

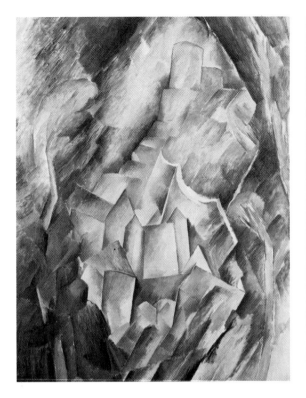

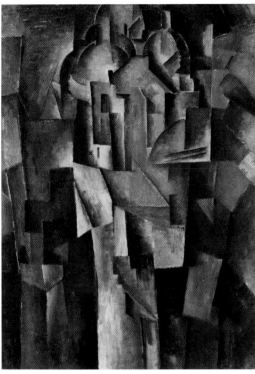

Cubism sprang from the conjunction of these two exceptional partners, mutually enriched by their opposite but complementary gifts, who shared a heroic adventure, "roped together," as Braque put it, "like mountain climbers." The transformation they initiated in the visual arts was echoed and confirmed by corresponding transformations in literature, music, science and philosophy.

In all fields reality ceased to be a transposable given and became instead an operational process; the system of a unified and fixed perspective was replaced by a dynamic and versatile construction with infinite combinations. Braque and Picasso dissociated the object from its imitational coordinates and, by a phenomenological reduction to its essential qualities, reconstituted it "ideally" on a two-dimensional surface that had its own laws. There is a possible coincidence between the organic structure of the world and the architectonic rhythm of the picture because there exists a universal geometry of form, a sovereign measure that governs intervals and links space to its content.

Between 1909 and 1928, with the exception of several views of the city seen from a window in 1910–11 (fig. 4), Braque renounced landscape, which in the middle of the previous century, when it was championed by Ruskin, had been the leading genre in European painting. Its replacement by the figure and especially the still life implied a change of attitude, which Braque expressed in these words: "In a still life, space is tactile, even manual, while the space of a landscape is a visual space." In the remarkable still lifes of the winter of 1909–10,

Braque accelerated the fragmentation of volumes, raising their prismatic shafts like crystalline concretions of space. Occasionally, a few naturalistic details – a candle on a piano, a palette or a violin hanging from an illusionistic nail – stress the contrast between the old and new systems of representation, testing the reality of the latter.

In the summer of 1910 Picasso went to Cadaqués, while Braque returned to L'Estaque. There he began a series of figures of musicians inspired by those of Corot, whose influence Apollinaire remarked upon at the time: "The softness of Corot combined with a great renewal of pictorial forms, this is what characterizes the art of Georges Braque." It was the moment at which the convergence of Picasso's and Braque's styles came the closest, when the crystallization of forms reached its most extreme and almost hermetic expression, set in an effervescent space that radiates through transparency or by refraction. In the spring of 1912 Braque returned to more relaxed works, heightening the beige and gray monochrome with deep blacks or dabs of warm tones, using oval formats to counteract the dispersion by the angles of rectangular supports and to create a more compact surface and vibrant texture. The turning point came that summer, when he joined Picasso near Avignon, at Sorgues. Braque, who had already used printed letters and numbers in his compositions, both as spatial cues and as evocative signs, reconnected in a creative sense with his initial training as a craftsman, experimenting with the possibilities of materials, transforming the materials themselves by mixing sand or sawdust with his pig-

ments. In September he made his first papier collé, or collage, a capital technique whose potential was immediately recognized by poets and whose scope was demonstrated by a comprehensive exhibition in Paris and Washington, D.C., in 1982. The papiers collés permitted the return of color and allowed it to coexist with form, and the reversal of the analytic procedure into a synthetic one, thanks to the use of condensed *signs* that evoke reality not through illusionistic imitation but through metaphorical allusion. This powerful way of articulating the new space and magnifying the most humble materials consecrated and governed the Cubist syntax, which was as simple in its means as it was complex in its effects.

Braque and Picasso were in Sorgues in August 1914 when the war overtook them and separated their destinies. Seriously wounded in 1915, Braque was not to take up his brushes again until 1917, after long months of hospitalization and convalescence during which he meditated upon the meaning of his art and what he called its *poetics*. With Picasso far from Paris, he readapted by associating for a time with Juan Gris and his friend the sculptor Henri Laurens, but soon recovered the integrity of his style, which was to continue growing on its own foundations. The internal discipline of Cubism was reconciled with the freshness of objects seeming to come of themselves to meet the forms that represent them. To quote Braque: "I am more concerned with being in unison with nature than with copying it." The creative process was so perfectly tuned that it remained invisible, and only the books of drawings interspersed with maxims which he kept, like a writer's journal, from 1918 on reveal some of his secrets. His method henceforth was to work on several canvases at the same time, over a period of months, if not years, by "impregnation, obsession, hallucination." His work falls into two categories: small cabinet paintings of supreme quality, and large-format compositions, either separate or in series, in which his power of orchestration is matched by the sureness of his execution.

His new, more relaxed manner, in which form, texture and color were unified in a single movement, was inaugurated in 1918 with the series of three vertical *Gueridon* pictures, today in museums in Philadelphia, Eindhoven and Basel. This theme first appeared in 1911 and was taken up by Picasso, Matisse and Derain, and would be the object of several series and stylistic variations by Braque until 1942. At the beginning the colors were muted, and the light, in a closed, almost nocturnal space, did not come from an external source, but was more of an internal phosphorescence. "The blacks, browns, all of the tones that compose the rich fur of wild animals, glimmer in the dark, like lamps in a sanctuary," wrote Jean Grenier. Abundant still lifes cover the tops of the vertical tables. The disposition is reversed and the same familiar objects – musical instruments, fruits and fruit dishes, glasses,

grapes, playing cards, pipes and tobacco – are developed lengthwise in elongated, horizontal formats peculiar to Braque. He took great care in preparing the grounds out of which the forms seem to grow, and it is the black background that emphasizes spatial depth and sets off the color. At the time he was surrounded by poets and musicians, the closest of whom was Erik Satie. The structural and rhythmic affinities between his painting and music have not gone unnoticed. If the Cubist canvases, which must be read like scores, according to their own rules, have the rigor of fugues, his subsequent works are much looser and often unfold with a ternary movement, like sonatas.

In 1922 the forty-year-old Braque was honored at the Salon d'Automne and moved from Montmartre to Montparnasse. Until 1927 he worked simultaneously on the *Mantelpiece* and *Canephora* series (see figs. 5, 6; cat. nos. 37, 38), parallel expressions of his monumental classicism, a celebration of home life and of the human figure as a caryatid. The *Mantelpiece* paintings combine two modes of representation: above, the mantel with its assortment of colored objects arranged in Cubist planes, and below, the empty, naturalistic space of the fireplace, with its dark hearth and light-colored recess. The *Canephora*, or offering-bearer pictures, which have their

5,6 *Canephora*. 1922. Collection Musée National d'Art Moderne, Centre Georges Pompidou, Paris, Bequest of Baron Gourgaud

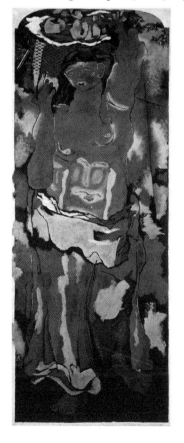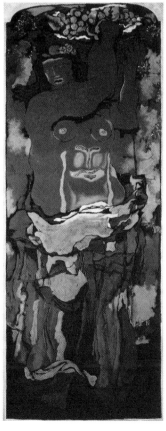

13

Georges Braque, ca. 1932

antecedents in the columns of the Erectheum, the statues of Versailles and the figures of Poussin and Renoir, exalt the human figure and the earth itself as latter-day personifications of the ancient goddesses of Fertility. Their volumes are defined "in the negative" by light-colored lines that stand out against the reddish brown flesh.

After having liberated "the amplitude of color," Braque wanted to inflect matter by the dense softness of his brushwork, "to understand just how far one could go in the alliance of volume and color." The reaction came in 1927 with several still lifes of an austere and vigorous splendor in which neatly outlined, thickly painted forms with distinct halves of light and shadow stand out. The following year, Braque renounced the thickly applied paint, the dense black background and the smooth brushwork in favor of a thin, matte, fresco-like film of pigment diluted on a ground made up of a grainy mixture of sand and plaster. The somber harmonies of grays, greens and dense browns of the previous decade gave way to light and airy tones of blues, greens and yellows, ochers and reds, set off by sharp contrasts between the lustrous – no longer velvety – blacks and whites. The objects spread into a vaster area, within nascent interiors in which light circulates and the walls seem to withdraw under the tactile pressure. The eye scans and savors according to the different ascending, frontal and descending movements, thus conquering the space between the floor and the ceiling (see fig. 7; cat. no. 44).

In 1925 Braque moved into the calm and well-lit house that he had built to his specifications near the Parc Montsouris; he soon decorated the dining room with two striking, vertically elongated panels that hark back to the fertile and varied *Gueridon* series (see cat. nos. 42, 43). In 1928, instead of going to Sorgues and Provence as usual, he returned to the Normandy of his boyhood days and soon acquired and renovated a house at Varengeville-sur-mer, near Dieppe, which became his summer quarters away from Paris, complete with a studio and garden. He also returned to landscape and painted some sensitive and luminous naturalistic seascapes that resemble stage sets – fishing boats stranded on the pebble beaches, cliffs with soft-furled edges set between gray sea and sky (see fig. 8; cat. no. 47). In 1931 his illustrations for Hesiod's *Theogony* and plaster panels incised with mythological scenes led to a group of very simple still lifes in which fine white lines were delicately scratched into the thin layers of predominantly brown and Indian red paint.

From 1933 to 1938 Braque abandoned himself to luxuriant decorative pieces, painting a series of horizontal still lifes set on round or rectangular tabletops and designated by the color of the tablecloth. Between the dense and sonorous *Still Life on a Pink Tablecloth* of 1933 and the subtle and airy *Still Life on a Yellow Tablecloth* of 1935, which determined his fame in the

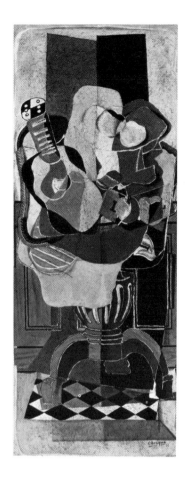

7. *The Table.* 1928.
Collection The Museum
of Modern Art, New York.
Acquired through
the Lillie P. Bliss Bequest, 1941

United States, he painted a more secret composition. This picture, *Still Life on a Red Tablecloth*, 1934 (fig. 9, cat. no. 50), which he kept in his studio, recapitulates the best-known works from this series in its intact freshness. In 1938 the ornamentation proliferated, weaving around the objects a continuous pattern of arabesques and flourishes. This rhythmic saturation created a state of movement and fusion that Braque called the *climate* of the picture: "A certain temperature must be reached in order to make the forms malleable." In the process, they tended to lose their identity and were drawn into the network of correspondences and metaphors that absorbed the painter more and more in his art and thought.

As if to control this decorative exuberance, between 1936 and 1939, and occasionally until 1944, Braque painted compositions with figures, or rather interiors in which the human figure plays an important, but not dominant role in the articulation of space. The notion of portraiture, of individual characterization, so essential in Picasso, was foreign to Braque's painting, not only because, as he explained, he was not dominating enough to confront and capture a model, but especially because his vision involves the universal rather than the individual. The figures, mostly female, alone or in pairs, symbolize his two main pursuits, painting and music. They

15

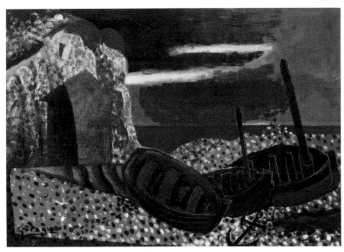

8. *The Beach at Dieppe*. 1929. Collection Moderna Museet, Stockholm

feature the same dark-light bisection as the still-life subjects, a device that lends volume to the flat silhouettes, but which is also the expression of a mysterious ambiguity between the body and the soul, the subject and its double, and between the living flesh and the specter of death. The theme of the *Studio*, frequent in Matisse and Picasso, and developed to an extraordinary degree by Braque, appeared for the first time in 1938 with a series of still lifes that included palettes and easels (see fig. 10; cat. nos. 54–57). Next to the tools of the painter there is a skull, which, on this eve of war, became the subject of evocative *vanitas* pictures.

During the Occupation Braque drew upon his strength and fervor as a craftsman, submitting to the *partiality of things*, like his friend the poet Francis Ponge, who said: "The world of silence is our only homeland and we turn to this resource according to the demands of the time." Musical instruments and objects of pleasure were replaced in his still lifes by the bare necessities – a glass of wine, a piece of bread, a morsel of cheese or ham – strictly apportioned and reduced to their essentials, placed on plain tablecloths against equally sober walls (see cat. nos. 59, 60). "If the great painter is the one who gives both the keenest and the most nourishing idea of painting, then, without hesitation, I would place Braque at the top," wrote Jean Paulhan after seeing these works at the Salon d'Automne in 1943. The previous year Braque also painted some domestic interiors, *Kitchen Table with Grill*, *The Stove* (cat. nos. 67, 68), *Washstand* and the hallucinatory masterpiece of this period, *Solitaire*, in which the woman playing cards is split into a dark side and a light side, suspended between despair and hope. Owing to the shortage of paints during the war, but also because of his obsession with texture, his love of materials and his need to see the other side of paintings, he continued in Paris the experiments with sculpture begun at Varengeville in the summer of 1939. They

are the sculptures of a painter, done in low relief, with subjects like the Faces, Horses, Fish, Birds, Plants, Vases, Plows, presented both as concrete things and as spiritual emblems, combining reminiscences of the forms of archaic Greece and China (cat. nos. 121–123).

In September 1944, immediately after the Liberation, Braque returned to Varengeville, painted the entire living room, filled with light coming from the windows, and began his masterful series of *Billiard Table* pictures (see fig. 11; cat. nos. 69–71), which buckle and tumble toward the spectator without losing their majestic and necessary geometry.

During interruptions due to ill-health, Braque continued his Oriental-style meditations and added new thoughts to the old ones set down in his *Cahiers*, that precious guide to his method, which he agreed to publish in January 1948. The main thing for him was to *eradicate* ideas and concepts that obscure – "A painting is finished when it has effaced the idea" – to escape from prejudices, conventions, fetters and the mechanisms of theory and emotions, so as to "keep the head free, to be present." And in this state of perfect openness, "to seek out the common which is not the similar," to maintain "hope against the ideal – constancy against habit – faith against convictions – spirituality against ideality – the perpetual against the eternal."

In 1948 he was awarded the First Prize at the Venice Biennale, and, visiting the city of waters, declared that he would have liked to have been an assistant in Carpaccio's studio. After having tested his mastery with such disarmingly simple subjects as copper kettles, packing crates and garden chairs, and on the threshold of his golden old age, when "life and art become one," he embarked upon the last and supreme phase of his journey.

9. *Still Life on a Red Tablecloth*. 1934. Private Collection, Paris

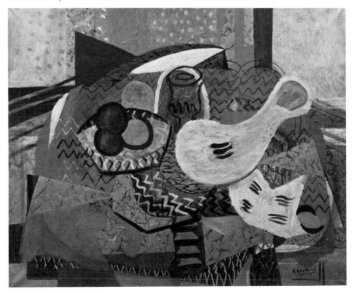

16

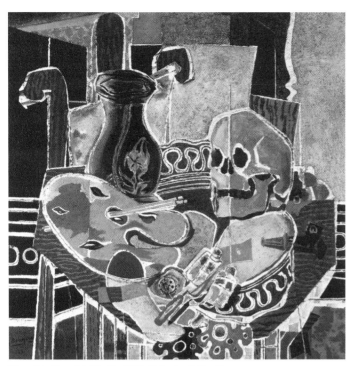

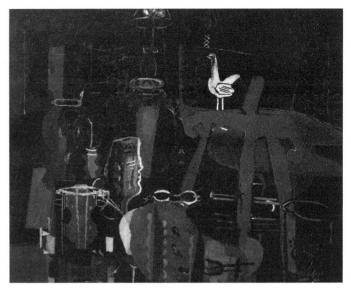

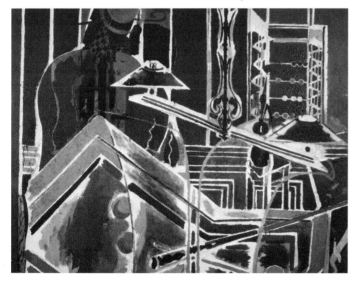

10. *Studio with Skull*. 1938. Private Collection

11. *The Billiard Table*. 1945. Private Collection, Paris

12. *The Studio VI*. 1950–51. Collection Fondation Maeght, Saint-Paul-de-Vence

13. *The Studio VIII*. 1952–55. Private Collection

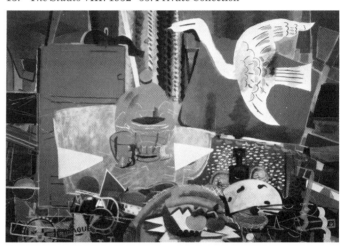

The visionary sequence of *Studio* paintings (1949–56) (see figs. 12, 13; cat. nos. 74, 75), the summation of his experience and his autobiographical message in the deepest sense, reveal the familiar surroundings of his work and the poetic transfiguration of which this laboratory was the heart. "I have made a great discovery," he said at the time, "I no longer believe in anything. Objects do not exist for me, except as there is a harmony among them and between them and myself. When one attains this harmony, one attains a sort of intellectual void. In this way, everything becomes possible, fitting, and life is a perpetual revelation. That is true poetry." Among the identifiable tools and attributes of the painter, and the ambiguous forms metamorphically blended in a fluid medium, permeable to exchanges, he introduced a mysterious bird, either resting on his easels or flying across his studio, imparting to the interior space its movement and its transubstantiation. "And this ringdove, or rather phoenix, winging speed-crazed across your studio or curled into a ball staring at its fleecy sky, unleashes a rush of air and a presence that quakes throughout your recent paintings," René Char wrote in his *Dialogue avec le peintre*.

Braque continued to provide his admirers with exquisite still lifes of apples, oysters and flowers (see cat. nos. 78, 84), and painted a fantastic vision of *The Bicycle* (cat. no. 88) of his younger days, yet it was the theme of the Bird that he treated with the most variety in his last period (see cat. nos. 77, 80, 87,

17

89, 118, 120). The bird, the principle of organic movement itself and the universal symbol of space, with no other meaning than its fateful flight, decorates the vaulted ceiling of the Louvre's gallery of Etruscan art, which the painter especially liked. Appropriately enough, Antonin Artaud, so clairvoyant in his intuitions, said that Braque's paintings at the time evoked "certain Etruscan mysteries." Shown outside the *Studio* now, the migrant bird celebrated by St. John Perse as having "the most ardor for life among our fellow-creatures," wings swiftly towards unlimited horizons, or returns to his *nest*, his natural shelter and the matrix of his flight, settling at times among flowers or palm fronds, or curling up among the fragrant paulownia bushes near the house.

The glory and stability of this flight depend upon the humblest of leavens: muted and sublimated earth colors. Braque said: "I try to draw my work up from the loam of the earth." It was this primeval loam – the flesh and blood of his paintings – and the soul of the elements that he kneaded with his workman's hands to make his last landscapes – vast seascapes, eternal fields and plows – pictures that Giacometti looked at with "the most interest, curiosity and emotion," because he considered them the most daring, the most alive. "I have plowed my furrow," the old painter could say, looking back over the path he trod with no less wisdom than genius, "and I have advanced slowly, in the same search... a line of continuity." Through the flux of matter in motion, pure painting, he gives us infinity to *touch*, the perpetual pulse of shadow and light, day and night.

Translated by Jean-Marie Clarke

Carla Schulz-Hoffmann

Georges Braque: The Cubist Phase

I must, therefore, create a new sort of beauty, the beauty that appears to me in terms of volume, of line, of mass, of weight.... Georges Braque[1]

So much thought and so many words have been devoted to the revolutionary artistic significance of Cubism as one of the first avant-garde movements that any further investigation promises to be both presumptuous and banal. Sensitive overviews, philosophically grounded interpretations and exhaustively detailed analyses are legion. Why, then, another examination of Braque's Cubist period, since it is unlikely to yield sensational results and will probably just reinterpret familiar material? The simplest reply, and no doubt a persuasive one, is to point out a need for completeness: how can one venture to publish a book about Braque without examining the decisive role he played as a Cubist? But perhaps the real reason is this: the phenomenon of Cubism appears so familiar, so obvious, that one can hardly discern what is concealed behind it. The word "Cubism" has almost lost its significative value. One speaks lightly of Cubist vocabulary when one merely encounters cubic forms in a picture, ignoring the programmatic claims that the movement's main protagonists, Picasso, Braque (and, in the case of Synthetic Cubism, Juan Gris) associated with the term; ignoring also how necessarily hermetic this phase was and had to remain, in accord with its fundamental idea.

To use a somewhat drastic image: Cubism was a temporary corset which all its real adherents were only too glad to take off, and which could never have served as a viable style. Its truly spectacular aspect was its conceptual approach, and once that had been sufficiently elucidated in artistic practice, all that remained of Cubism for the major talents was no more and no less than an accessible vocabulary that could be applied in various realms of endeavor.

And only because all this seems so obvious is it worth our while to focus on Braque in reexamining a few essential aspects of this Cubist chimera which also apply to Picasso in an often just slightly modified form. For from 1907 until about 1914, Picasso's artistic development is inconceivable without Braque, and vice versa. The problems they had in common and the influence they exerted upon each other during those years have almost completely obliterated the fundamental differences between these two artists. It is often impossible to determine with any certainty which of the two was the first to discover the solution to a particular problem and put it to

artistic use, and the viewer frequently finds himself nearly unable to distinguish their paintings – a phenomenon that, as we shall see, is a direct consequence of the Cubist method and its attendant concentration on a few subjects, among which the still life no doubt played the leading role. Naturally, this development crystallized only gradually. At first, each artist started out with his own congenial and favored subjects. For Picasso, this was the representation of the human figure, for which he had developed new stylistic possibilities in *Les Demoiselles d'Avignon*. Braque, on the other hand, had always devoted himself, in the main, to the study of the still life and landscape (see fig. 1), that is, to intrinsically static subjects; it was in this field that he made his significant innovations. Thus, for Picasso, the Cubist concentration on these particular subjects involved a much greater limitation than it did for Braque, and it is noteworthy that Picasso tried again

1. *Houses at L'Estaque.* 1908. Collection Kunstmuseum Bern, Hermann and Margrit Rupf Foundation

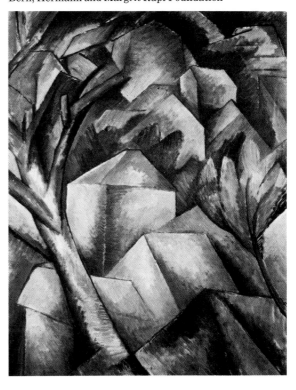

and again to apply the Cubist method in portraiture. It is significant also that African sculpture had a direct influence on Picasso (as can be seen in *Les Demoiselles d'Avignon*), and that the principles he discovered in this art were translated into his work, affecting not only its form but its content, while for Braque it was more a matter of recognizing a general formal parallelism.

What did the Cubists want to prove, why did they impose on themselves a style that, to a certain degree, had a leveling effect? As is well known, their point of departure was the recognition of the essential difference between art and nature and the resultant thesis that each constituted a different form of reality. And the challenge now was to demonstrate this concretely. Generally speaking, in Cubism – again, the term as used here refers to classical Analytical and Synthetic Cubism in the sense of Braque, Picasso and Gris – what is considered "real" is whatever existentially defines objects in their relation to time and space. It is not their accidental and variable individuality that constitutes their degree of reality, but the essential idea inherent in them. Analytical Cubism starts out with the concrete object, which is then dissected into the basic, empirically ascertained forms that determine its nature.

Woman with a Mandolin of 1910 (fig. 2) may serve as a representative example of numerous comparable Analytical Cubist works. What is it that is depicted here, and by what means? What are the criteria that establish this painting as a typical example of this stage of development? What artistic principles are elucidated by the method employed here?

Difficulties in answering these questions arise as soon as one attempts to describe the optically visible components of the picture. Since the painting is not concerned with the imitation of reality in the traditional sense, most of the elements conducive to an immediate identification are absent.

Two things are immediately noticeable:
1) The reticent brown gray and blue gray secondary colors, which correspond only partly to the natural colors of the objects, and which on the picture plane designate the woman, the mandolin and the background in a similar manner.
2) The individual forms, some of them geometric, that are spread across the picture plane like particles, requiring sustained attention before they unambiguously (though not in all their details) combine into the motif of *Woman with a Mandolin.*

The quality of reserve in the choice of colors, the avoidance of strong primary colors, is typical of Analytical Cubism. It seemed necessary, to avoid muddling the purpose of the artist's endeavor, to prevent strong color effects from competing with the formal construction of the objects. Ultimately, it was a matter of priorities: if one wanted to define the objects anew,

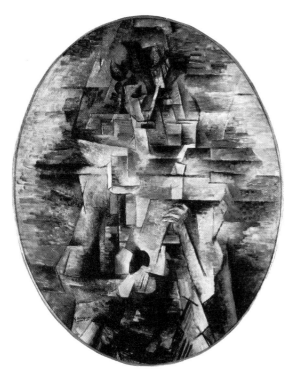

2. *Woman with a Mandolin.*
1910. Collection Bayerische Staatsgemäldesammlungen, Staatsgalerie moderner Kunst, Munich

disregarding their usual appearance, the primary objective was to master all the attendant formal problems, for an object is primarily a formal, not a color phenomenon. Thus a point of departure was chosen that, from a traditional point of view, was better suited to sculpture than to painting; that enabled the artist to express more easily the plastic elements of the objects in the picture in terms of measure, volume and weight. This absence of primary colors accounts in large part for the compact and monumental character of the pictures painted during those years; but these qualities are always related to the two-dimensional plane and do not convey a sculptural illusion.

How did Braque achieve this relationship to the picture plane, and thus the nonillusionistic character of the portrait? We said earlier that woman and mandolin were dissected into geometric forms and are no longer unambiguously recognizable; the objects as they naturally appear have been destroyed:
1) The proportions of woman and mandolin, their actual form, size and extent, cannot be inferred from the picture. What is describable and measurable instead are the individual nonrepresentational forms (frequently bounded with black-brown lines), only some of which carry an unmistakable representational meaning: the forms that make up the arm, the neck, the chin and the nose.
2) Organic and inorganic matter (woman and mandolin) are given equal value, both formally and coloristically: the

boundaries between the two realms are blurred. So are the differences between the material properties of various objects. The wood of the mandolin, the cloth of the dress, the face, arms and hands of the woman are all treated without regard to their different material properties. This blurring is taken so far that an object may seem to have varying degrees of solidity: the lower part of the woman and the left part of her head, for example, appear more opaque than her shoulders and the right part of her head, because they are darker and also more clearly delineated.

3) The boundaries separating objects from one another and from their surroundings have been eliminated in some places: the individual forms are only rarely enclosed entirely by lines; they are usually left open on or within one side, especially toward the edges of the picture. For example, in the upper right part, the woman's shoulder blends into the background and thus into the picture plane, and her right hand and the mandolin are inseparably united.

4) We are given not a single but a multiple view of the objects, as if the artist had walked around them in order to view and record from various angles the details that interested him. As a result, the fragmentary view is transformed into a comprehensive presentation. Various sides of an object that are in reality perceived in succession are here combined into an imagined whole and shown simultaneously on the picture plane. These different sides, however, are transposed and interlocked in such a way that the impression of successive motion does not arise; on the left, for example, the woman's head and neck are seen from the side, while on the right they are turned frontally into the picture plane and connected to their environment in a way that does not imitate the physical turning of a head, but rather presents two separate views. This blurs the element of time as well as of form: the connection of different visual angles and temporally separate moments of movement refers neither to an instant nor to a time sequence but to a simultaneity of separate phases of time that cannot be precisely determined.

5) Certain parts of the picture convey impressions of three-dimensional space – the bent arms, the perspectivally foreshortened form on the left in the shoulder area, the nose and so on – which, however, are always taken back, as it were, or relativized, by the flatness of other sections. This becomes especially noticeable near the edges of the picture, where the individual forms frequently appear to be defined and delimited toward the inside only, dissolving and blurring into the picture plane toward the edge. This spatial ambiguity, combined with the different angles from which the objects are seen, prevents the emergence of any illusion of a uniform perception of depth.

In conjunction, all these features unmistakably underscore the special character of art as distinct from nature. Ultimately, we are being presented with a pictorial restatement of the simple observation that a picture is a two-dimensional plane that must remain recognizable as such. Traditional illusionistic painting veiled this fact by imitating the conditions of form, space, color and time in the visible world. According to the Cubists, the result of this procedure was necessarily inferior to nature; it could only amount to a phantom image of reality. Braque expressed this position in a by now classic formulation: "I couldn't portray a woman in all her natural loveliness. I haven't the skill. No one has. I must, therefore, create a new sort of beauty, the beauty that appears to me in terms of volume, of line, of mass, of weight...."[2] It is obvious that he is speaking, not of the fortuitous appearance of things, but of the beauty that arises from the right apportioning of forms in a picture – of the beauty of art.

Given this premise, the question of whether a painted image bears the "right" relation to its model in nature becomes moot; what matters is the "rightness" of the picture in itself as an autonomous object. If one reexamines the particular manner in which *Woman with a Mandolin* is rendered, it becomes clear that it is "wrong" only in relation to visible

3. *Still Life with a Violin.* Summer 1911.
Collection Musée National d'Art Moderne,
Centre Georges Pompidou, Paris, Braque Gift

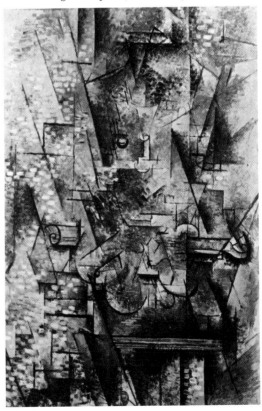

reality, but "right" and "conclusive" if one takes the picture plane as one's criterion. From the interlocking, nonrepresentational individual forms, some of them flat, others suggestive of volume, there develops an internal pictorial rhythm which also incorporates the parts of the composition that are relatively representational. In a reversal of natural conditions, the abstract forms are sometimes more logical than the "natural" ones: for example, the woman's right arm, analyzed into discrete shapes, is coherently related to the ensemble of forms and structures, while her more representationally painted left arm gives the impression of an extraneous element in the composition.

The oval format chosen by Braque for the *Woman with a Mandolin* is not atypical; many upright oval and horizontal oval Cubist compositions have been preserved – more than thirty painted, respectively, by Braque and Picasso alone during the period 1910 to 1914.

Several explanations for the unusual popularity of this format are conceivable. One general reason might be that the distinctiveness of Cubism in comparison with traditional, classical panel-painting is immediately revealed in the oval shape. The format may at the same time imply an ironic

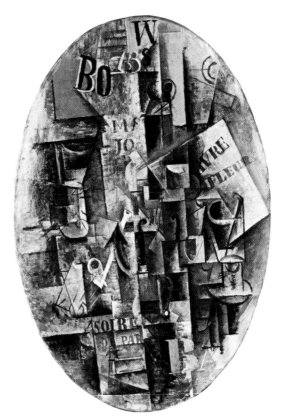

5. Pablo Picasso, *Violin, Glass, Pipe and Inkwell.* 1912. Collection Národní Galerie, Prague

4. Pablo Picasso, *"Ma Jolie" (Woman with a Zither or Guitar).* Paris, Winter 1911–12. Collection The Museum of Modern Art, New York. Acquired through the Lillie P. Bliss Bequest

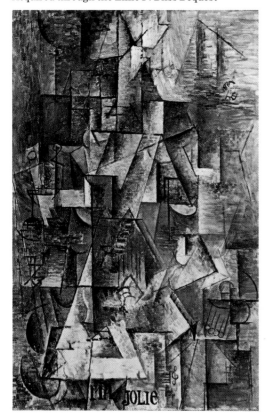

critique of a certain type of salon painting, frequently oval in shape, in which long established notions of what constitutes a picture are thoughtlessly replicated. Another reason, finally, may be that the tension between art and nature can be made impressively evident with the use of the oval format: the rectangle and square delimit a pictorial field that is firmly structured in all directions, while the oval leaves the edge comparatively fluid and indefinite; the pictorial field does not correspond to the habitual way of seeing nor to the notion of a picture as a view through a window. Often, too, the oval picture format receives a direct representational significance: it becomes an oval table, the surface upon which the still life in the painting is arranged.

The Cubists' analytical, inductive method led to ever greater difficulties as far as the readability of their pictures was concerned. Around 1911 the compositions frequently take on a merely playful quality (see fig. 3). The objects are taken apart in a manner that is sometimes not entirely logical; they no longer appear to have been analyzed with respect to their basic determinant forms, but instead with a certain arbitrariness. At this point the Cubists had reached a stage where they were in conflict with their own stated intentions: the difference between art and nature could no longer be demonstrated in this manner.

It is worth noting that Picasso and Braque, working on comparable projects, used a kind of trick as another way of introducing a reference to reality into the picture: they began, playfully and unmethodically at first, to substitute commonly recognizable "signs" for their corresponding objects. In Picasso's *"Ma Jolie"* (fig. 4), the words of the title, painted in large letters, refer in a characteristically Cubist, ambiguous manner to a popular song of the time as well as to Picasso's mistress, Eva; musical notes and clef establish the connection to music. In this way, a relationship to reality is established without falling back on traditional illusionistic means of representation.

The words and abstract signs in the picture must be seen as symbols of the real objects, without there being any kind of optical correspondence between them. In this case, they establish a more obvious reference to reality than the fragments of objects contained in the picture, and they do this without bearing the slightest relation to the real appearance of those objects.

Formally, the letters and signs are perfectly flat, and it is remarkable that this gives a certain spatial depth to the composition, which as a whole is clearly related to the picture plane. This observation is confirmed as soon as one covers up the words: it is only by contrasting the rest of the composition to the inherently flat letters that the viewer receives a spatial impression of the picture.

It is no longer possible to determine how Braque and Picasso made this discovery. Braque was at least technically familiar with this procedure from his days as a designer. The printed words on posters and particularly on the windows of Paris cafés, which interpose themselves as a perfectly flat foil between the interior and the happenings on the street, offered themselves for imitation. This assumption is supported by the fact that the letters inserted in Cubist paintings seem structurally to be floating on a frontal plane comparable to a sheet of glass, and that linguistically they often refer to bars, cafés, beer and newspapers (see fig. 5). In later years this method, which helped at least partly to counterbalance the increasingly ill-defined pictorial structure, was applied again and again in numerous variations. The Dadaists and Surrealists adopted the principle, although their purpose was in some respects a completely different one; since then it has become an important means of expression for many other artists. The inductive method was replaced by a deductive approach. Non-representational forms now supply the initial material, and it is only subsequently, by an intuitive operation, that one or another of these is given representational status.[3] This method is founded on the idea that reality in its essential manifestations is not an exact, precisely quantifiable value, but that on the contrary its essential nature is "inexactness," and furthermore, that this "nature" of reality is not suscepti-

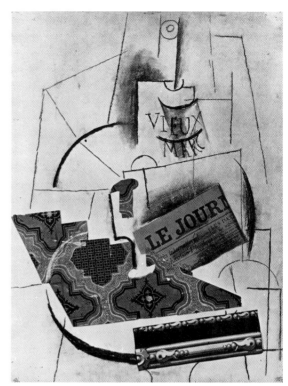

6. Pablo Picasso, *The Bottle of Vieux Marc*. 1913. Collection Musée National d'Art Moderne, Centre Georges Pompidou, Paris

ble to empirical exploration and analysis, but can only be intuitively approached through the imagination.

If art, according to Picasso's famous aphorism, is "a lie that makes us realize the truth,"[4] what kind of truth is it that Cubist art teaches us to understand? In addition to the insight into the fundamental difference between art and nature, are not these pictures trying to convey an essential

7. *Violin and Pipe: "Le Quotidien."* Winter 1913–14. Collection Musée National d'Art Moderne, Centre Georges Pompidou, Paris

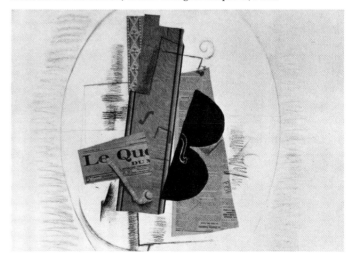

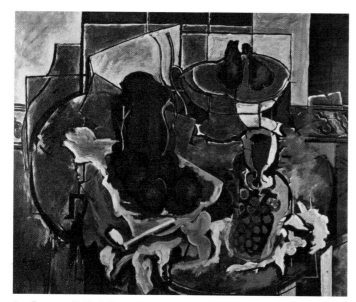

8. *Brown Still Life*. 1926. Collection Bayerische Staatsgemälde-sammlungen, Staatsgalerie moderner Kunst, Munich

"relativity" of reality itself? Taking any Synthetic Cubist collage as an example, it immediately becomes obvious that no imitation of experienced reality was intended here (see figs. 6, 7). A piece of newspaper cut out in the form of a bottle does not correspond to our optical notions of either a newspaper or a bottle. And yet the concrete piece of paper enables us to apprehend intuitively these very objects as integral wholes (not, however, as individual particulars) in our imagination. The piece of newspaper is on the one hand an abstract form within the composition of the picture (as autonomous object), and on the other hand the intuitively apprehended image of a figurative concept in all its potential imperfection.

This procedure evinces a certain analogy with the idea of eidetic reduction in the phenomenology of Edmund Husserl,[5] though this should not be taken to imply a direct influence; what is meant, rather, is a presumably unconscious simultaneity of parallel notions. Guy Habasque, who was the first to examine this analogy in his article "Cubisme et Phénomenologie,"[6] comes to the conclusion that with this "phenomenological method" Synthetic Cubism introduced "a priori knowledge" into painting.[7] However, one can only agree with this conclusion if one accepts Husserl's eidetic-intuitive approach as generally binding. It seems more appropriate, in my opinion, to describe Synthetic Cubism as an attempt to convey a priori knowledge through pictures; but it remains at least doubtful whether this is possible at all in the medium of painting, and whether in principle such a priori knowledge can assume an objective, generally binding function independent of method.[8]

If, therefore, in Cubism the fragmentary and imperfect is understood to be a necessary aspect of reality, then that picture is more real, and more authentic, which goes beyond empirical description to show things in their essential incompleteness (not their accidental suchness).

This is how the crisis of the art of painting was overcome: it could and would no longer accept a definition of itself as an illusionistic projection of a reality that was much more perfectly captured by photography. By furnishing experimental proof that art is subject to its own laws, and by developing a viable pictorial vocabulary for this purpose, the Cubists opened up new possibilities for painting and at the same time removed all stylistic barriers. If it is self-evident that art can never illusionistically correspond to the reality that surrounds us but always expresses something different, then every style is possible. In this respect, the Cubist position corresponds to Kandinsky's equation of the "great realism" with the "great abstraction."

And it is fascinating to observe in what different directions Picasso and Braque moved after their common Cubist adventure. Picasso was now able again to freely develop his explosive vitality, while the more quiet and steady Braque continued exploring what had at all times, including his Cubist period, been his principal interest: the harmonious balance and beautiful lines of still lifes whose almost classical *peinture* and elegant, never aggressive palette place him among the great French painters of pure objectivity (see fig. 8). In this respect, the post-Cubist Braque is much closer to Matisse, though the two artists used fundamentally different pictorial means, than he is to Picasso. Where Matisse is extravagantly colorful, Braque offers a perhaps less spectacular but for that very reason lastingly impressive body of work whose calming effect exemplifies Matisse's demand for an art that is decorative in the best sense of the word.

NOTES

1. Georges Braque in an interview with Gelett Burgess, "The Wild Man of Paris," *Architectural Record*, May 1910, p. 405.
2. Ibid.
3. The theoretical systematization and development of this method goes back to Juan Gris, who also introduced the concepts of induction and deduction to characterize the differences. Cf. the groundbreaking essay by Ernst Strauss on Juan Gris's *"technique picturale"* in *Amici, Amico, Festschrift für Werner Gross zu seinem 65. Geburtstag am 25.11.1966*, ed. Kurt Badt and Martin Gosebruch, Munich, 1968, pp. 335–362.
4. Interview with Marius de Zayas, in *The Arts*, May 26, 1923, quoted in Edward F. Fry, *Cubism*, New York and Toronto, reprint edition, 1978, p. 165.
5. Cf. Edmund Husserl, *Ideen zu einer reinen Phänomenologie und phänomenologischen Philosophie*, Halle, 1913.
6. *Revue d'Esthétique*, Tome II, Paris, 1949, pp. 151–161.
7. This analogy was noted earlier by Ortega y Gasset in "Sobre el punto de vista en las artes," *Revista de Occidente*, Madrid, 1924, pp. 129–160, fn. pp. 159–160; cited by Fry, pp. 39, 193.
8. Furthermore, Habasque's definition of the concept of "Synthetic" Cubism (which leads him to recommend that the term "Eidetic" Cubism be adopted in its place) is not quite accurate (p. 161). Synthesis in the Cubist sense does not consist, as Habasque believes, in the restoration of a whole with the help of individual elements acquired by analysis; synthesis, in this case, means the harmonious connection of reality with the laws of the autonomous work of art as *tableau objet*; and by reality, in the above definition, I mean intuitively apprehended, empirical experience as imaginative reality inclusive of foreknowledge. For although Synthetic Cubism formally dispenses with the analysis of objects, such analysis remains immanent in it as a discretionary factor.

Translated by Joel Agee

Magdalena M. Moeller

The Conquest of Space:
Braque's Post-Cubist Work After 1917

At the beginning of 1917, after recovering from his severe war injury, Braque began to paint again. That he took up his work where he had left off in 1914 is only natural. His new paintings – the most important of which was *The Musician*, executed around the turn of the year 1917–18 (fig. 1) – resume the style of the papiers collés. But at the same time, a previously unknown clarity and radiance make themselves felt in his composition, a stylistic hallmark that is also present in the contemporaneous paintings of Juan Gris and in the collages of the sculptor Henri Laurens. The uncommonly brilliant, sharply edged planes are layered, as in the works of Synthetic Cubism, setting off a narrowly delimited space that lies parallel to the surface of the canvas. Yet by the variable ways in which they are structured – dots, wood grain, etc. – a liveliness is introduced that seems to set space in motion.

With *The Musician* Braque brought his Cubism to an artistic climax and at the same time to its conclusion. The works that were to follow diverge from strict Cubism and bring new dimensions to the problems of volume and color and especially to the exploration of space. "The Impressionists wanted to render atmosphere; the Fauves, light; and Cubism dared address itself to space," Braque declared in an interview with Dora Vallier.[1] His principal aim, a goal to which he subordinated all the elements of his painting, was to gain new ground in the depiction of Cubist space with its objects folded into the picture plane. He wanted to create a spatial reality that would be pictorially immanent, independent of factual reality. "The goal is not to render an anecdotal fact but to create a pictorial fact (*'fait pictural'*)" – that is one of the comments Braque formulated on his sickbed and later contributed to the magazine *Nord-Sud* in 1917.[2] Braque developed this *"fait pictural"* to its formal and coloristic perfection and succeeded in amplifying the stylistic repertoire of Cubism even as he simplified it more and more. A phase, lasting until 1927, in which tactile perception of surfaces was of foremost importance, was succeeded by various experimental stages in which the spatial continuum is expanded, until in 1937 with the beginning of the late work, Braque is in secure command of all his means and combines them into a singular synthesis. Much as Henri Laurens perfected Cubist sculpture, Georges Braque brought Cubist painting to perfection.

In the pursuit of his goal, Braque proceeded in accord with his temperament, very carefully and with great patience. He never squandered his energies and did not permit himself to be swept away by spontaneous enthusiasm; on the other hand, he vigorously counteracted any signs of fatigue in his forms and colors. The principal object of all his investigations remained the still life, since it allowed for a limited, clearly surveyable space. For this reason Braque turned to figure and landscape with a certain reserve.

Every one of Braque's works evinces a precisely calculated balance of compositional forces, an almost meditative use of formal means that betrays no evidence of the process of creative unrest. Every work appears to be a continuation of the preceding one. There are no abrupt stylistic revolutions in Braque's creative development; it flows in a serene, gently

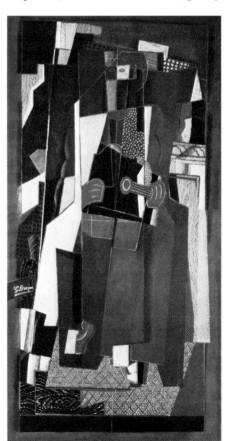

1. *The Musician.* 1917–18. Collection Kunstmuseum Basel, Gift of Raoul La Roche

25

winding movement through the years, and the motif series that characterize the various stylistic stages reappear again and again. Never does a sudden leap of style put into question what has previously been attained, as is the case with Picasso. The terrain secured is never abandoned, even when a new phase of varied possibilities of expression emerges, or a new cycle of pictures and picture series begins. Even works created far apart in time are organically interrelated.

I

In the winter of 1918–19, after reverting to the methods of Synthetic Cubism, Braque paints a series of large still lifes that breathe a new spirit and that already show the poetry and sensuous sonority that characterize his work from now on (see cat. no. 32). Form, color and texture are melded into one. A tactile space contrasts with visual space. The *Still Life with Table* of 1918 shows the artist's new approach as clearly as does his *Café-Bar* of 1919 (fig. 2). The balanced composition presents the typical props of Braque's Cubist still lifes: table, musical instrument, fruit bowl, pipe, newspaper. But the hard edges have changed into curved, vibrating lines; the structured order has become an apparent chaos. The letters of the alphabet also undergo this softening of form. A certain restlessness appears in the structuring of individual surfaces; they, too, vibrate and have a luxuriant fullness about them. Color is applied more or less thickly, the broad brushstroke is clearly visible. Paint is used as a source of texture as well as color. Soon after, Braque was to mix sand, sawdust, filings, etc. into his paint. The coloration of particular objects – and also their quality of seeming to shine from within – are especially emphasized by the gray and black patterning of the background. The result is a contrast of serenity and severity, of flat planes and relief-like structure. The viewer's eye, not finding a compositional center for support, is forced to follow the extreme verticality of the picture's construction and discover the tactile charms, the sensibility of technique in this invented pictorial reality.

The vertical format of his decorative tables (gueridons; cat. nos. 36, 44, 51) – a motif that recurs in Braque's work until 1952 – alternates with several smaller, oblong still lifes (see cat. nos. 34, 35, 39, 40). Of these, *Guitar and Glass* of 1921 (cat. no. 34) is one of the most outstanding. Interest in the texture of paint is here contrasted with an interest in the "scope of color,"[3] combined with an increased autonomy of line. Everything is transposed into a musical rhythm; repetitions of form (reprises) and various two-dimensionally applied tonalities make the still life virtually audible and refer directly to the piece for voice and orchestra "Socrate,"which was composed by Braque's close friend Erik Satie in 1917–19 and performed in 1920.[4] The still life's motif and its various

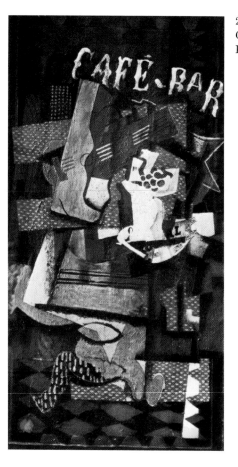

2. *Café-Bar.* 1919. Collection Kunstmuseum Basel

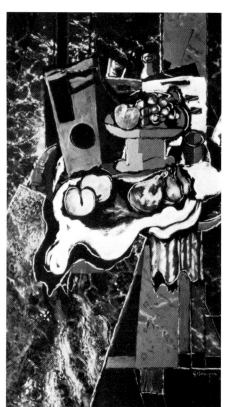

3. *Fruit on a Tablecloth and Fruit Dish.* 1925. Collection Musée National d'Art Moderne, Centre Georges Pompidou, Paris

26

components are now but a pretext for an independent, abstract use of artistic means.

In 1922 Braque begins working on two new series of vertical-format pictures that continue until 1927: the *Canephora* and the *Mantelpiece* groups. The *Canephora* works (see cat. nos. 37, 38) especially are a reminiscence of Neoclassicism, a theme that attracted many painters of the time and that was understood as a reaction against Cubism, as a *"rappel à l'ordre."*[5] Picasso, too, created large-scale, massive figures inspired by classical sculpture and characterized by an extreme voluminosity.

In Braque's work, however, the spatial element remains limited. His human figures develop on the picture plane in the manner of reliefs. Like objects in a monumental still life, their immobile forms are placed before a dark background that lends the color a heightened autonomy. The free rhythm of compositional elements that was intimated in the still lifes now comes to full expression. Dominant everywhere is the mobile, peculiarly tensionless line, which, along with the soft dabs of color, creates an impression reminiscent of baroque abundance. One searches in vain for the sharp hardness of Cubist edges and planes; in the *Canephora* works Braque has found his way to a delight in the senses, a painterly richness that were previously unknown to him; nevertheless the overall structuring of the pictures is in strict accordance with the rules of the Cubist conception of space.

A large number of still lifes with apples, pears, melons and grapes as well as some floral still lifes are also marked by the new style. Volume and color, elements which Cubism tried to separate, combine again. In these subjects, too, Braque wanted to explore, with a soft, naturalistic handling of the brush, "how far one can go in blending volume and color."[6]

The same striving for visual and textural experience, the same delight in the painterly modulation of surfaces, determine the *Mantelpiece* series but the structure is considerably more solid here. *Fruit on a Tablecloth and Fruit Dish* of 1925 (fig. 3) seems like a synthesis of the *Gueridon* and the *Mantelpiece* works. It is one of Braque's most sophisticated paintings. Direct observation of nature determines the outlines of the objects in the still life that is placed in the upper part of the composition and presented in layered planes in accordance with the Cubist principle. Zither, fruit bowl, glass and bottle are each divided into a light and a dark half and are thus firmly braced in the picture plane. All these objects are assembled on a round wooden table, which in turn is placed before a dark ground of marble plates. Unlike the *Mantelpiece* paintings, here the view into depth is interrupted by a plate that is obliquely positioned in such a way that it is not clear whether it is behind or in front of the table. If it is behind the table, the two-dimensional still life appears in the foreground as a tangible group of objects, giving rise to a feeling of space, of vol-

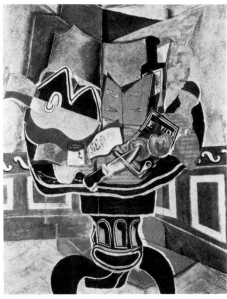

4. *The Large Table.*
1928–29.
The Phillips Collection,
Washington, D.C.

ume, that is purely the result of strict adherence to the Cubist tactic. An optical tension between formal flattening of the picture plane and spatial, tactile fiction is created.

II

A new development begins in 1928, without, however, interrupting the continuity of the creative process. Braque abandons naturalistic depiction and the sensitive painterly element so as to make visible the picture's structure, its framework, which is now no longer restricted to the narrowly delimited pictorial plane but reaches far into space. In addition, his palette, which for the past ten years has been dominated by dark tones of green, gray and black, is relieved by light colors. Braque applies the new program to a familiar motif: the *Gueridons. The Large Table* of 1928–29 (fig. 4) is the most radical picture of this series. On the upward-tilted surface of the table, the objects, starting from a conspicuous central axis, tower up to the ceiling, with whose two-dimensional elements they combine. In the lower half of the composition, the arched feet of the table form the greatest imaginable contrast to the parquet floor and the wall panels. Their rounded shape is taken up by the curved edge of the table, the organically formed guitar, the knife blade and the page of sheet music. This contrast of curved lines and angular, flat forms of thinly applied paint is sufficient to create an impression of space and volume. With simple means Braque conquers the three-dimensionality of the room.

A different way of making space palpable is offered by pictures in which an undulating line moves freely, without regard for the organic, decorative planes that Braque placed beneath it. The first examples of this kind are the depictions of bathing figures modeled after Picasso's beach scenes

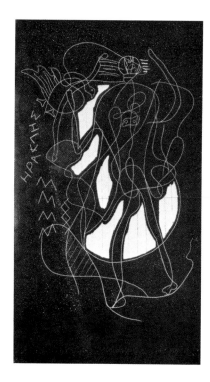

5. *Heracles*. 1931–32.
Private Collection

Tablecloth of 1935 (Private Collection, Chicago) form a direct transition to the late work. The oil paint is mixed with sand and thickly applied, and the palette is limited to pastel tones, with rose predominating. *Fruit Dish and Napkin* of 1929 (cat. no. 46) may be regarded as a precursor of these ornamental still lifes, its forms and colors already combining into a decorative pattern of flat planes.

III

Beginning in 1936–37 all the means of expression explored by Braque combine into a synthesis. They mutually complement and reinforce each other and bring forth pictures in which he operates freely with the artistic means at his disposal. Maturity and mastery take the place of programmatic analysis. It is meaningful, therefore, to consider these years the beginning of Braque's late period.

Thematically this body of work marks a break in the hitherto orderly succession of cycles. A greater restlessness makes itself felt in the (sometimes transient) emergence of new motifs, in the occasional reappearance of old motifs, and in the combination of normally separate motifs. A further obstacle to a clear overview is presented by Braque's method of working on his pictures for long periods of time, in many cases years. The interiors, the billiard tables, the studios and the birds have established themselves as the most important themes of the late period.

In 1938 the ornamental still lifes culminate in *Still Life with a Mandolin* of 1937–38 (fig. 6). The undulating line of the transparent pictures is blended with the colored planes and the overlaid network of patterns. "The task," Braque said, "is to find the temperature in which things can be kneaded."[9] By temperature Braque means a warmth in the picture that

painted in Dinard in 1928; thematically, however, they probably originate in the summers Braque spent in Normandy beginning in 1929 (see cat. no. 47). He destroyed many of these pictures, since their somewhat expressive, surreal manner was foreign to his own artistic bent, but they led him to an original graphic style, which in turn had a fruitful influence on his painting. The sixteen etchings for Hesiod's *Theogony*, created on commission for Ambroise Vollard and published in 1932, depict whimsical figures drawn with thin lines on a neutral ground.[7] The same arabesque-like quality appears in some of the figures engraved into sheets of plaster and painted over with black, dated 1931 (see fig. 5). In these pictures movement assumes a central position in place of the usual unbroken stasis.

This transparency of the physical, a weightless, floating matter that fills space completely, also appears in certain still lifes painted between 1932 and 1934. *Large Brown Still Life* of 1932 (cat. no. 49), with its flowing movement and bold, seductive rhythm, is one of the most successful solutions.

At this stage of his development, Braque was able to turn to landscape painting. Pictures like *The Beach at Dieppe* of 1929 (cat. no. 47) hardly differ from the still lifes in their intention. The superimpositions and translucent sections evince a similar transparency of form and color.

In 1933 Braque's "transparent period" comes to an end. It is succeeded by pictures in which he confronts the problem of a densely filled plane. Braque had discovered "that ornament liberates color from form."[8] Still lifes such as *Still Life on a Red Tablecloth* of 1934 (cat. no. 50) or *Still Life on a Yellow*

6. *Still Life with a Mandolin*. 1937–38. Private Collection

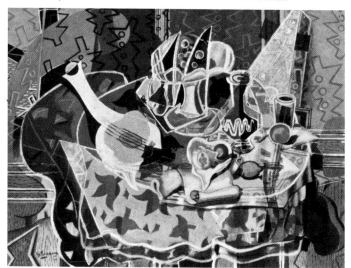

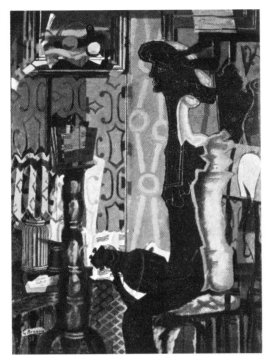

7. *Woman with a Mandolin.* 1937. Collection The Museum of Modern Art, New York

envelops the objects and makes them soft and pliable, greatly reducing their autonomous value. As a result pictorial space becomes dense, melts down into a malleable mass and receives an unprecedented spiritual timbre, which Braque was to further intensify in the *Studio* series.

Space and matter, these hitherto separate elements of his art, are given identical status in his late work. The magnificent *Studio* series, which offers the most perfect resolutions of this problem, is preceded by *Studio with Skull* of 1938 and *The Studio* of 1939 (cat. nos. 56, 57), both of which harken back to *Still Life with a Mandolin* in their ornamental richness as well as their horizontal division by various axes. *Studio with Skull* is also a forerunner of the *vanitas* still lifes with skulls he painted during the war years, while *The Studio* is closely related to the one- and two-figure *Interior* scenes.

From 1936 to 1946, after the *Canephora* and the *Bather* paintings, the theme of the human figure appears in various individual pictures. The first important one is *Woman with a Mandolin* of 1937 (fig. 7), followed by *The Duo,* painted in the same year (Collection Musée National d'Art Moderne, Centre Georges Pompidou, Paris), *The Painter and His Model* of 1939 (Private Collection), *Solitaire* of 1942 and *Man with a Guitar,* begun in 1942 and completed in 1961 (cat. no. 64). In each of these the human figure is depersonalized, presented as a decorative element. It serves mainly as a means of spatial organization, defining a frontal plane but at the same time integrated with the vertical rhythm of the flat surfaces and the all-encompassing pattern. For this purpose the figure is divided into a light and a dark half, like the objects in the still lifes, so as to reduce the compactness of the body surface. The simultaneous presentation of frontal view and profile is an intentional side effect, a Cubist device for the simulation of volume. There is no symbolic meaning in this division of the figure into two parts – Braque always objected to such interpretations of his work – but rather a poetic and mysterious quality that emanates directly from the pictures, from the interrelationship of forms and colors.

Additional *Interior* canvases are painted during the war years, but without figures: *Interior with a Palette* (Private Collection), *The Stove* (cat. no. 68), or *Kitchen Table with Grill* (cat. no. 67), executed between 1942 and 1944, culminating in *The Salon,* painted in 1944 (fig. 8), which reproduces the entire sense of space in a room and in addition opens a view to the outside through a window. The *Interior* paintings are accompanied by a sizeable number of still lifes with loaves of bread (see cat. no. 60), fish (see cat. no. 58), teapots or the already mentioned skulls (see cat. nos. 56, 65). Another remarkable painting of this time is *Still Life with a Ladder* of 1943 (cat. no. 66). In many of these works Braque simplifies his style in order to bring out the modesty, the sadness of the motif. He dispenses with the web of lines and lets the large, unmodulated planes stand as they are. These simple, unadorned pictures, in which Braque achieves a close and intense contact with the objects, thematically anticipate the quiet *Garden Chair* paintings and floral still lifes executed between 1943 and 1948 (see fig. 9; cat. nos. 72, 73).

In 1944 Braque begins the *Billiard Table* series; he concludes it in 1949, completing a total of seven compositions (see cat. nos. 69–71). Here he modulates space with unusual boldness by tipping the billiard table toward the observer, so that it can be seen both horizontally and vertically. This frag-

8. *The Salon.* 1944. Collection Musée National d'Art Moderne, Centre Georges Pompidou, Paris

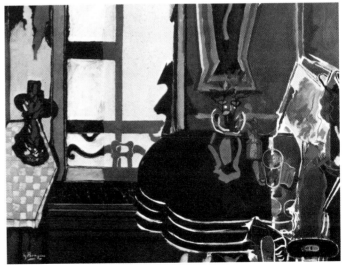

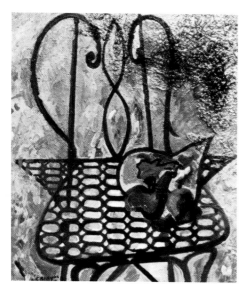

9. *The Garden Chair.* 1948. Collection Musée National d'Art Moderne, Centre Georges Pompidou, Paris

mented way of depicting an object is directly derived from Cubism; so is the renewed limitation of the palette to dark tones. Many aspects of the *Billiard Table* paintings recall the decorative still lifes of 1933 to 1935, where slanted lines of walls and moldings make a perspectiveless room appear persuasively real. The most remarkable version of the *Billiard Table* theme can be seen in the Musée National d'Art Moderne, Centre Georges Pompidou, Paris. The one most nearly like it is the 1945 example, *The Billiard Table* (cat. no. 69).

"One must not imitate what one wants to create."[10] This statement by Braque applies with the full strength of its meaning to the *Studio* series, which represents another high point in his art. The first five paintings were created in 1949; the last three, interrupted by illness, in 1950–51, 1954–55 and 1954–56. Each version is numbered. Since number VII was begun before but finished after number VIII, it is called number IX. There is no number VII. The important motifs are already presented in *The Studio I*: a jug, a palette, a female torso in profile and a bird. It is the same bird that made its first, vaguely outlined appearance in *The Studio* of 1939. All these motifs reappear together or individually in the subsequent versions. In *The Studio VI* the large headless bird is joined by a small white one perched on the easel.

In each instance Braque harmoniously distributed all his props across the picture plane, so that there is no central focus. The web of lines, the delicate structures, the brown color that bathes everything in a uniform light – all these factors soften the dynamic severity of the forms and create a sensitive, vibrating surface, a flowing, enigmatic space in which all things are interconnected. It was thanks to his special sensitivity to the uniqueness and beauty of material things, thanks to his capacity for sentient and feeling vision, that Braque was able to attain the high spirituality of these paintings. He endows "dead" things with a mysterious life and lets

them exist through their interrelatedness. "Objects have no reality for me unless they are in agreement with each other and with myself. When one achieves this harmony, one arrives at a certain spiritual nonexistence – I can only call it a state of peace – that makes everything appear possible and right. Life then becomes a continuous revelation. This is true poetry."[11]

The same metaphysical bent, the same condensation of space and matter are present in *Night* of 1951 (Collection Musée National d'Art Moderne, Centre Georges Pompidou, Paris) and *The Large Vase* of 1952 (Collection Mme Henri Georges Clouzot, Paris), which were painted around the time of the last versions of the *Studio* theme, and also in some pictures that were long left unfinished and were brought to completion in 1952: for example, *Reclining Woman* of 1930–52 and *The Red Table* of 1939–52 (Collection Musée National d'Art Moderne, Centre Georges Pompidou, Paris).

The poetic content of all these late works is also found in the *Bird* pictures with their quiet resonance. It is the flying bird that crosses the paths of light in the *Studio* paintings and that now, strong and clear, in great dignity and untouched by anything accidental, has found its freedom in the universality of space. Space undergoes its last metamorphosis in these pictures. It loses its dimension and can no longer be given formal expression. Only the bird makes it palpable by the cut of its flight. Space is endless, dense matter (see cat. no. 87).

"I do not seek limitation, I seek de-limitation."[12] This ultimate goal is attained in the *Bird* pictures, with which Braque's artistic work comes to an end. Throughout his creative life Braque tried to universalize and simplify the objects of nature and to transform them into objects of art. He reformed instead of deforming them, and in doing so he made the tangible space of Cubism intangible, allowing it to become a poetic mystery, without, however, relinquishing his idiosyncratic pictorial reality.

NOTES

1. Georges Braque, *Vom Geheimnis in der Kunst, Gesammelte Schriften und von Dora Vallier aufgezeichnete Erinnerungen und Gespräche*, Zürich, 1958, pp. 20–21.
2. Georges Braque, "Pensées et réflections sur la peinture," *Nord-Sud*, December 1917.
3. *Vom Geheimnis*, p. 27.
4. Cf. Grete Wehmeyer, *Erik Satie, Studien zur Musikgeschichte des 19. Jahrhunderts*, vol. 36, Regensburg, 1974, pp. 233–246.
5. Cf. Christopher Green, *Cubism and Its Enemies: Modern Movements and Reaction in French Art, 1915–1928*, New Haven and London, 1987, pp. 57 ff.
6. *Vom Geheimnis*, p. 27.
7. Cf. Magdalena M. Moeller, in *Georges Braque, Ausstellung zum 100. Geburtstag, Zeichnungen, Collagen, Druckgraphik, illustrierte Bücher aus der Staatsgalerie Stuttgart und Sammlungen in Baden-Württemberg*, Graphische Sammlung, Staatsgalerie Stuttgart, 1981–82, pp. 24–28.
8. *Vom Geheimnis*, p. 28.
9. Ibid., p. 79.
10. Ibid., p. 78.
11. Ibid., pp. 66–67.
12. Ibid., p. 88.

Translated by Joel Agee

Plates

Paintings

Translated by Jean-Marie Clarke

* Indicates not in exhibition
Selected references are listed in abbreviated
form. For full listings see the Selected
Bibliography, pp. 276–278

1

The Artist's Grandmother (La Grand-mère de l'artiste). 1900–02
Oil on canvas, 24×19¾″ (61×50 cm)
Signed l. r.
Collection Mr. and Mrs. Claude Laurens, Paris

A half-length figure of the artist's maternal grandmother, wearing spectacles and bent over her sewing. The light falling on the carefully modeled planes of the face and on the simplified hands – reworked later – sets them off against the dark mass that is enlivened somewhat by the black and red hairnet. Despite the timid handling, Braque's qualities already show through: his slow and contemplative vision, his feeling for paint as a material and its resonance.

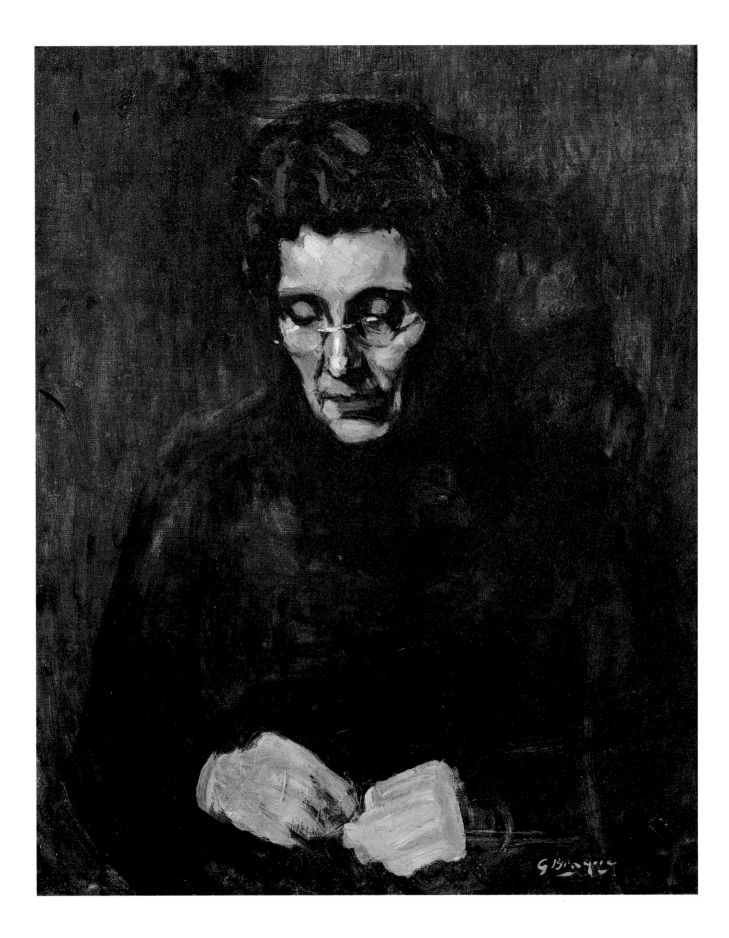

2

The Côte de Grâce at Honfleur (La Côte de Grâce à Honfleur). 1905

Oil on canvas, 19¾×24⅜″ (50×62 cm)
Signed l.r.
Collection Musée des Beaux-Arts, Le Havre

Braque spent the summer of 1905 at Le Havre and Honfleur with his
friends the critic Maurice Raynal and the Spanish sculptor Manolo. The
Côte de Grâce at Honfleur is not the seacoast, but the shaded path that
climbs the hill to the chapel of Notre-Dame de Grâce, with its beautiful
view of the estuary of the Seine and the harbor of Le Havre. The artist did
not depict the famous panorama, but rather an intimate corner of the
park, near the Calvary, in the local style of the early Monet and Boudin.
The canvas was acquired in 1930 by the city of Le Havre.

3

The Bay of Antwerp (La Baie d'Anvers). 1906

Oil on canvas, 19¾×24″ (50×61 cm)
Signed and dated l. r.
Private Collection, Liechtenstein

Friesz and Dufy, his two slightly older friends from Le Havre, put Braque
on the path of Fauvism, toward the solar paintings of Matisse and Derain.
In the summer of 1906 he accompanied Friesz to Antwerp and stayed
there from August 14 to September 11. He painted a dozen canvases in his
studio overlooking the Scheldt River, works filled with color ordered by a
linear structure, and with a very personal lyrical charm. But the vaporous
and changing light of the North did not lend itself well to saturated color,
and Braque left afterwards for the Mediterranean, where his palette
could blaze with colors undiffused by the atmosphere.

4

Landscape near Antwerp (Paysage près d'Anvers). 1906

Oil on canvas, 23⅝×31⅞″ (60×81 cm)
Signed l. l.
Collection Solomon R. Guggenheim Museum, New York, Gift, Justin K.
Thannhauser, 1978
78.2514 T1

This landscape is a variant of the preceding one in a slightly larger for-
mat. The framing of the view of the harbor and port is exactly the same,
but the elements of the composition have been modified: buildings have
been added in the background on the opposite shore, and the dock in the
foreground has been left out. The colors are different, too: yellow and
mauve predominate, and there is less green and blue. Finally, the
brushwork with curvilinear and dotted accents is more stylized. It may be
deduced from this that the preceding version was painted after the motif
and then used as a model, in the studio, for the present work.

5

L'Estaque. 1906

Oil on canvas, 23⅝×28¹⁵⁄₁₆″ (60×73.5 cm)
Signed l. r.
Collection Musée National d'Art Moderne, Centre Georges Pompidou, Paris

After the decisive visit to Antwerp, Braque made his first trip to
L'Estaque, near Marseille, where Cézanne painted. He stayed at the
Hôtel Maurin from October 1906 until February 1907, and painted views
of the small port and nearby sites. He combined a technique of separate,
and at times dabbed, brushstrokes with surfaces enveloped by decorative
curves, which here converge on the two figures near the center.
The luminous atmosphere has been rendered not by saturated and con-
trasting colors, but by unusual harmonies, especially orange and mauve,
emerald green and carmine.

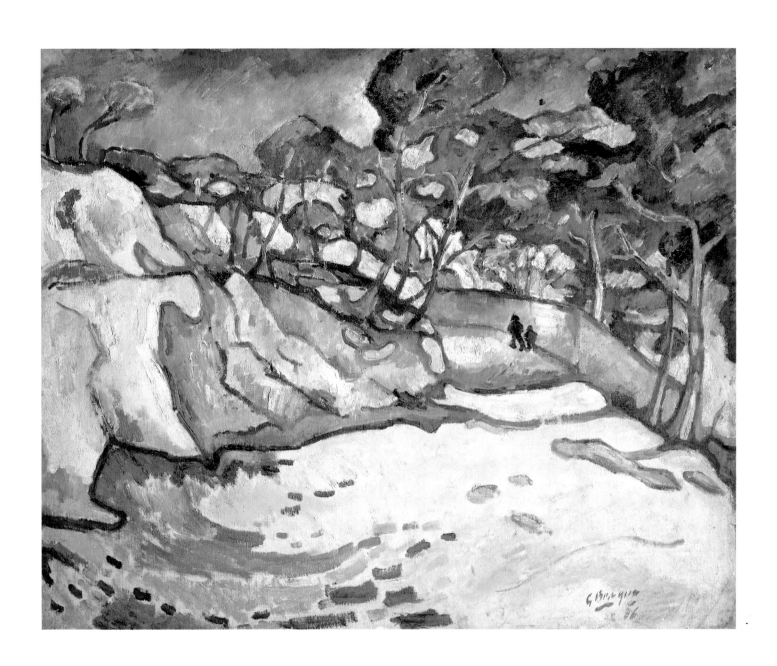

6

Jugs and Pipe (Jarres et pipe). 1906

Oil on canvas, 20¹¹/₁₆×25″ (52.5×63.5 cm)
Signed and dated l. r.
Isarlov 1932, no. 13
Josefowitz Collection

This colorful still life, which stands alone among the landscapes of the Fauve period, heralds the pictorial genre that prevailed in Braque's work after 1908. The rounded forms of the Cézannian jug and pitcher are set on an oblique axis. The pipe, an attribute of the painter, will often be represented in subsequent still lifes.

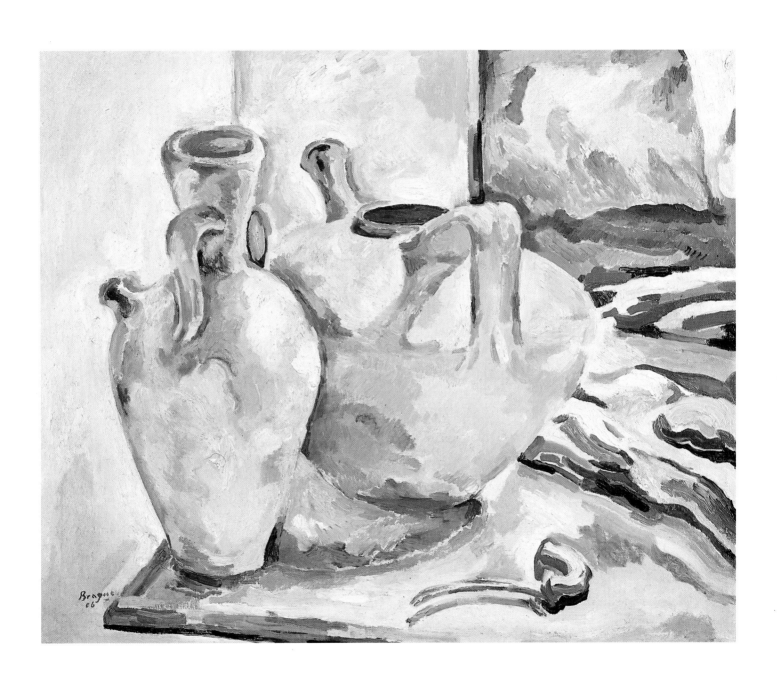

7

Seated Nude (Femme nue assise). 1907

Oil on canvas, 21⅝ × 18⅛″ (55 × 46 cm)
Isarlov 1932, no. 20
Collection Musée National d'Art Moderne, Centre Georges Pompidou, Paris, Gift
of Louise and Michel Leiris

Before meeting Picasso, and following the examples of Matisse and
Derain, Braque tried his hand at the nude, for its expressive value rather
than because of its natural beauty. The color is still Fauve, but the subject
demands a volumetric representation of the form related to the back-
ground. The model is shown from the back, nude from the waist up, comb-
ing her hair with her arm raised to the nape. The sharp curve of the chair
reinforces the diagonal sway of the body and its rough anatomy. There is
a preliminary version at the Milwaukee Art Center.

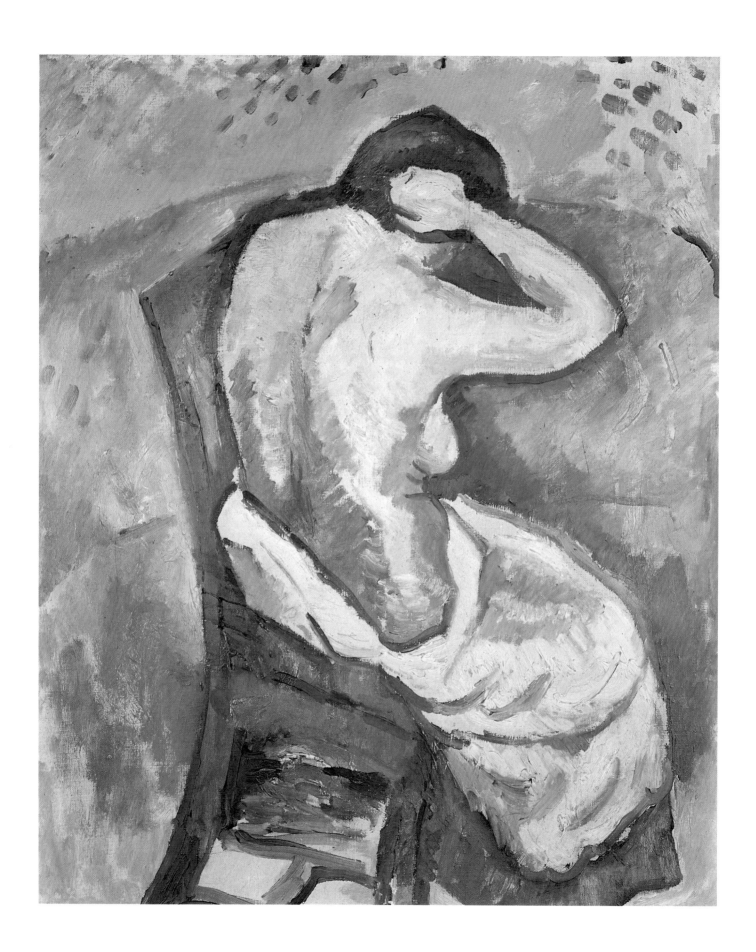

8

The Bay of Lecques (Le Golfe des Lecques). 1907

Oil on canvas, 15×18⅛″ (38×46 cm)
Signed l. r.
Isarlov 1932, no. 25
Collection Musée National d'Art Moderne, Centre Georges Pompidou, Paris, Gift
of Louise and Michel Leiris

In May 1907 Braque established himself at La Ciotat, between Marseille
and Toulon, where he was joined by Friesz. On the Golfe des Lecques, at
the other side of the bay, is the beach of Saint-Cyr-sur-Mer. The composi-
tion is disposed frontally and in four successive rising planes: the light
yellow and orange ground, the dark blue sea with two white sails, the pur-
ple hills outlined in black, and the mauve and green sky, with a very high
horizon. The paint is still applied in dabs, but the handling is firmer in
order to set off the volumes and to tighten the color scheme.

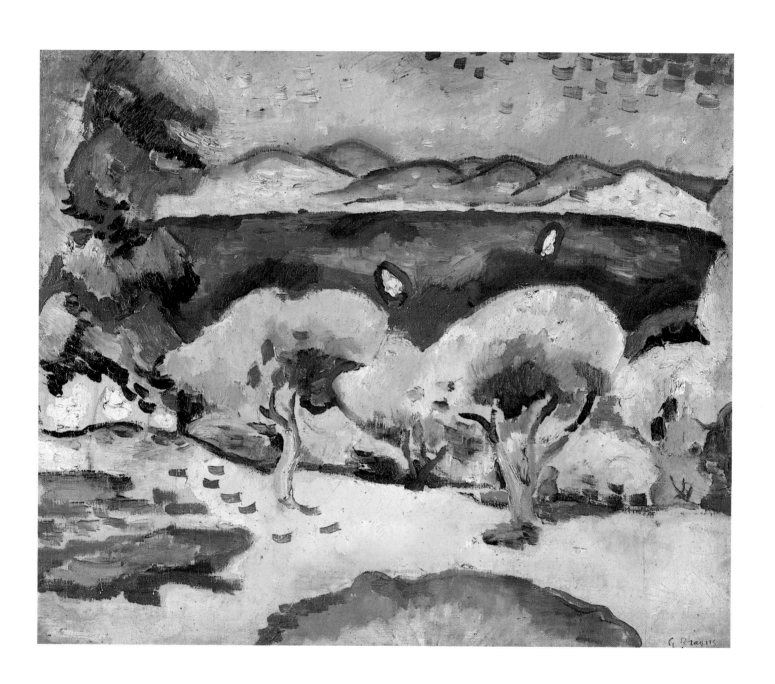

9

Musical Instruments (Les Instruments de musique). 1908

Oil on canvas, 19¾×24″ (50×60 cm)
Signed and dated l. r.
Isarlov 1932, no. 30
Mangin (W. de R.) 1982, no. 7
Collection Mr. and Mrs. Claude Laurens, Paris

This still life, which remains in the hands of his family, meant a great deal
to the artist. He considered it to be his first truly Cubist work, in which a
new tactile and visual space was created without using illusionistic per-
spective. It introduced the musical instruments that he had in his studio
and liked to play. The mandolin, the clarinet, the accordion and the score
combine curved and angular forms, a sober ocher and green color-scheme,
and warm and cool tones. The planes that open, tilt up or back already
show more of the objects than would have been visible in the traditional
mode of representation.

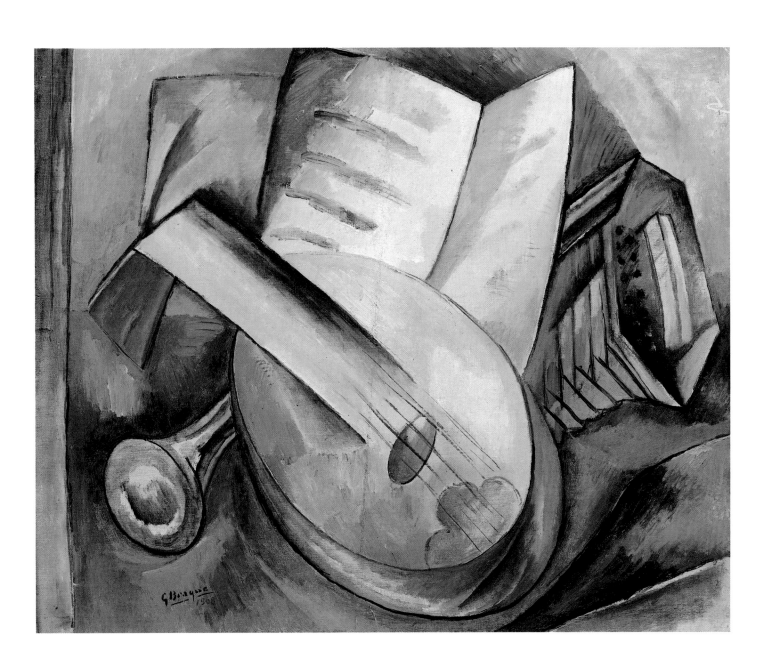

10
Guitar and Fruit Dish (Guitare et compotier). 1909

Oil on canvas, 28¾×23¾″ (73×60 cm)
Signed on reverse
Isarlov 1932, no. 58
Mangin (W. de R.) 1982, no. 36
Collection Kunstmuseum Bern, Hermann and Margrit Rupf Foundation

Braque's still lifes represent musical instruments, fruits and their recep-
tacles, or, as here, combinations of these two elements from the realms of
nature and the man-made. This transitional work with its geometric
structure belongs to the Cézannian phase of Cubism. It heralds the
Analytical phase, when volumes would be decomposed into their different
parts. The objects, seen from above and from different angles, are brought
up to the surface by tilted planes. Color is refined and reduced to set off
the rhythm and movement of the forms.

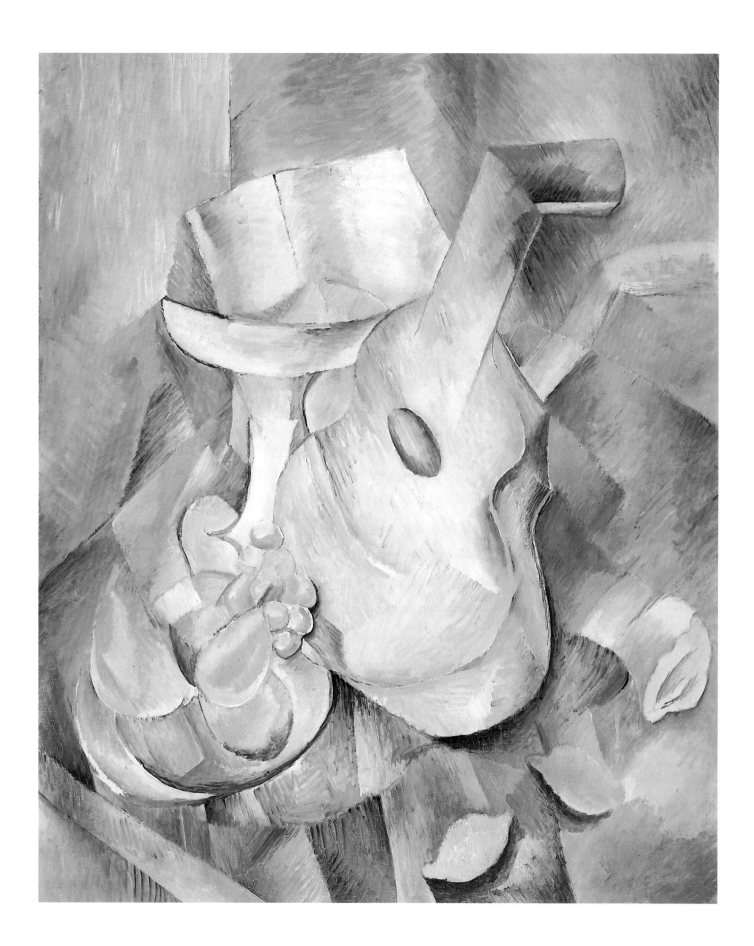

11

Harbor in Normandy (Le Port à Normandie). Early spring 1909

Oil on canvas, 32×32″ (81×81 cm)
Je sais tout, Paris, April 15, 1912, repr. p. 350
Umělesky Měsíčník, Prague, Spring 1912
Isarlov 1932, no. 46
Mangin (W. de R.) 1982, no. 44
Collection The Art Institute of Chicago, Purchase from the Walter Aitken Fund
Income, Major Acquisitions Centennial Fund Income, Martha E. Leverone Fund,
and Restricted Gifts of Friends of The Art Institute of Chicago in honor of Mrs.
Leigh B. Block Committee on Major Acquisitions

This was one of the two canvases that Braque exhibited at the Salon des
Indépendants in the spring of 1909 and that the critic Louis Vauxcelles
characterized as "cubic oddities." It represents an imaginary scene
painted in the square format which the artist occasionally used for works
he considered important. Fishing boats with taut sails and rigging are
returning to port between two jetties, each of which is terminated by the
round tower of a lighthouse. The sea and the sky partake of the same unity
of texture and structure as the fragmented and geometricized solid forms.
The color-scheme has been reduced to a neutral scale of browns and bluish
grays, while the network of vertical, horizontal and diagonal lines fash-
ions a new space and distributes the light in variously oriented planes.
There are two other contemporary versions of Norman harbors (Isarlov 62
and 63, Mangin 50 and 51).

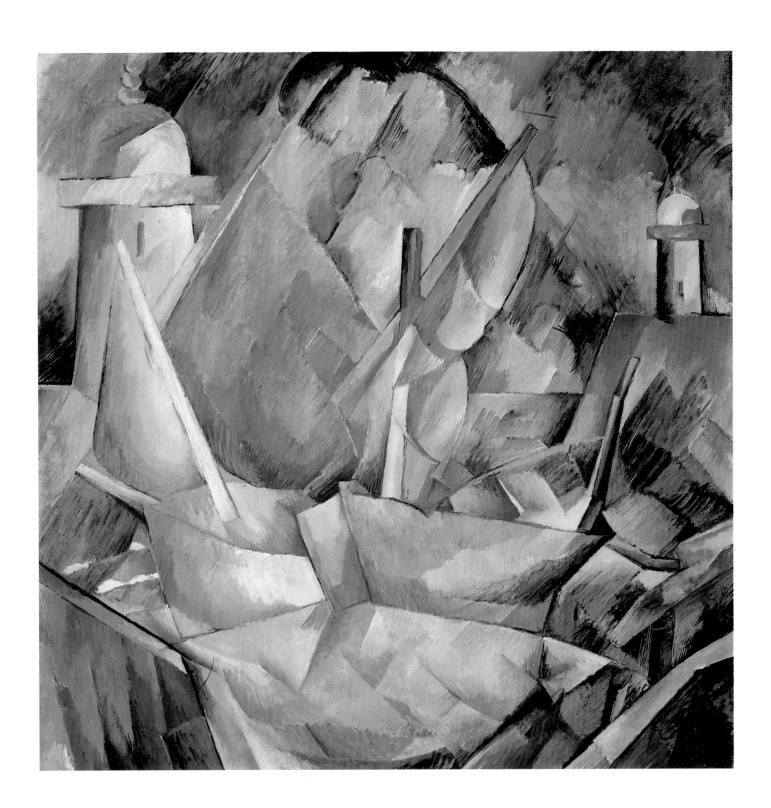

12
Violin and Palette (Violon et palette). 1909–10

Oil on canvas, 36⅛×16⅞″ (91.7×42.8 cm)
Signed on reverse
Kahnweiler 1920, p. 24
Isarlov 1932, no. 70
Mangin (W. de R.) 1982, no. 56
Collection Solomon R. Guggenheim Museum, New York
54.1412

The fragmentation is intensified in this and in the following work, two
famous pendants of tall and narrow formats painted in the winter of
1909–10 and revelatory of the Analytical approach. As soon as they were
finished they were acquired by the critic and dealer Wilhelm Uhde, whose
portrait Picasso then painted in the same style as these two still lifes. The
objects extend vertically with their multiple facets, each with its own
light and orientation, like concretions of the shallow space they occupy.
We recognize the violin set on a table with drapery, the music score on a
stand and, hanging from a nail on the wall, the painter's palette. This
trompe-l'oeil nail with a cast shadow has a functional justification, and its
pictorial role is to accentuate the contrast between traditional illusionis-
tic representation and the new conceptual representation, putting the
validity of the latter to the test.

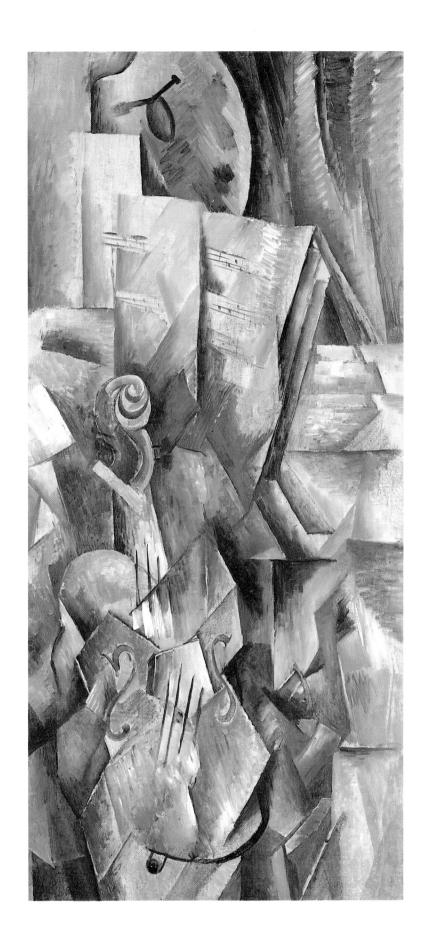

13

Piano and Mandola (Piano et mandore). 1909–10

Oil on canvas, 36⅛ × 16⅞″ (91.7 × 42.8 cm)
Signed on reverse
Isarlov 1932, no. 76
Mangin (W. de R.) 1982, no. 57
Collection Solomon R. Guggenheim Museum, New York
54.1411

This picture, the pendant of the preceding work, features the same verti-
cal, fragmented structure. In Braque's own words: "Fragmentation
helped me to establish space and movement in space.... During this
period I painted a lot of musical instruments, first of all because I was sur-
rounded by them, and also because their forms, their volume, came into
the ken of the still life as I understood it." The two musical instruments
represented here, one of which is sometimes identified as a harmonium,
and the other as a lute or mandolin, are in fact an upright piano and a type
of lute called a mandola which appears in many canvases of the
Analytical phase. The more naturalistic treatment of the candlestick and
half-burnt candle, like the trompe-l'oeil nail in the preceding work,
serves as a point of reference to stress the contrast between the two modes
of representation.

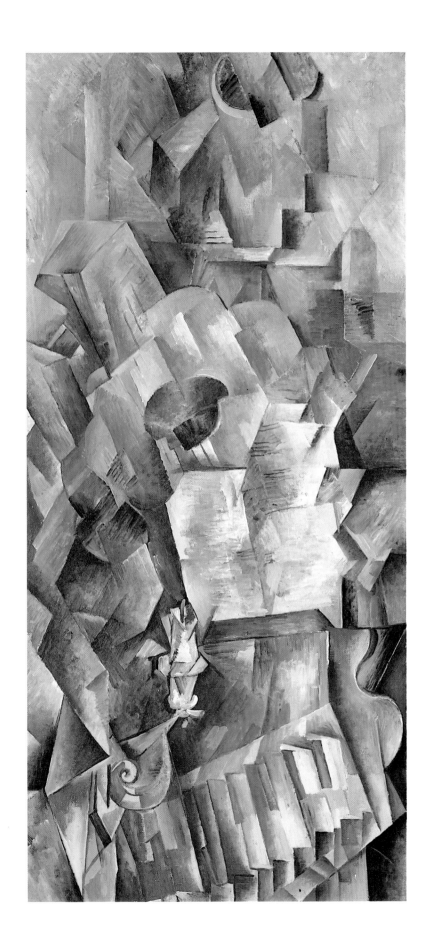

14

* *Still Life (Nature morte).* 1911

Oil on canvas, 13×16″ (33×41 cm)
Signed l. r. and on reverse
Isarlov 1932, no. 99
Mangin (W. de R.) 1982, no. 110
Collection Musée d'Art Moderne, Strasbourg

This still life from the hermetic phase of Analytical Cubism, the first can-
vas by Braque to enter a French public collection, was acquired in 1923 by
Hans Haug, the remarkable director of the Strasbourg museums, a spe-
cialist in ancient art and great appreciator of modern art. The tall glass
outlined in black is visible, but the curves of the guitar are absorbed by the
vibrant play of overlapping planes. There is the same restrained effer-
vescence in the forms as in the colors.

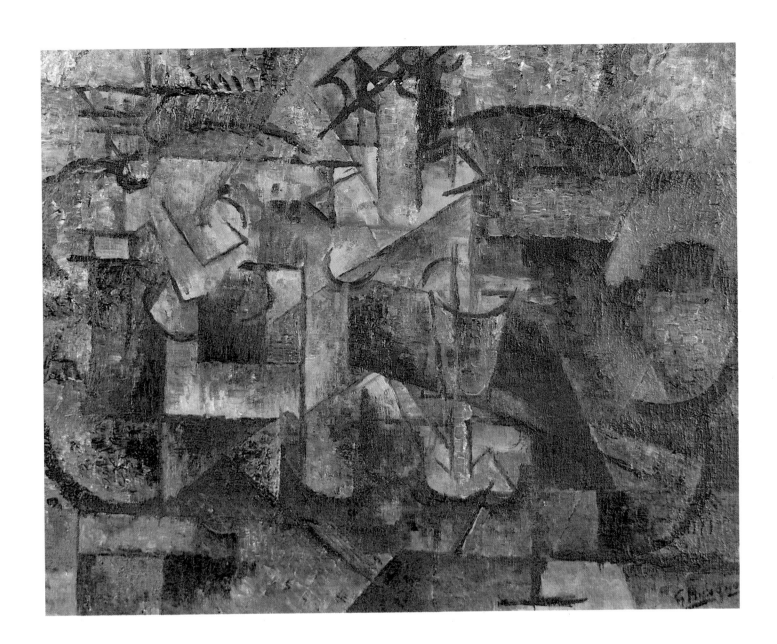

15

Flute and Harmonica (Flûte et harmonica). 1911

Oil on canvas, 13×16¼″ (33×41 cm)
Isarlov 1932, no. 97
Mangin (W. de R.) 1982, no. 76
Philadelphia Museum of Art, The A. E. Gallatin Collection

The sharp corner of the table is visible at the bottom center. The oblique
form of the easily identifiable flute straddles the subtle orthogonal planes
of this shimmering composition. The harmonica, less easy to read, is
unusual in the artist's repertoire of instruments, and is indicated at the
lower left by the regular forms of its mouth. Two wind instruments whose
airy sounds have their chromatic equivalents in this composition.

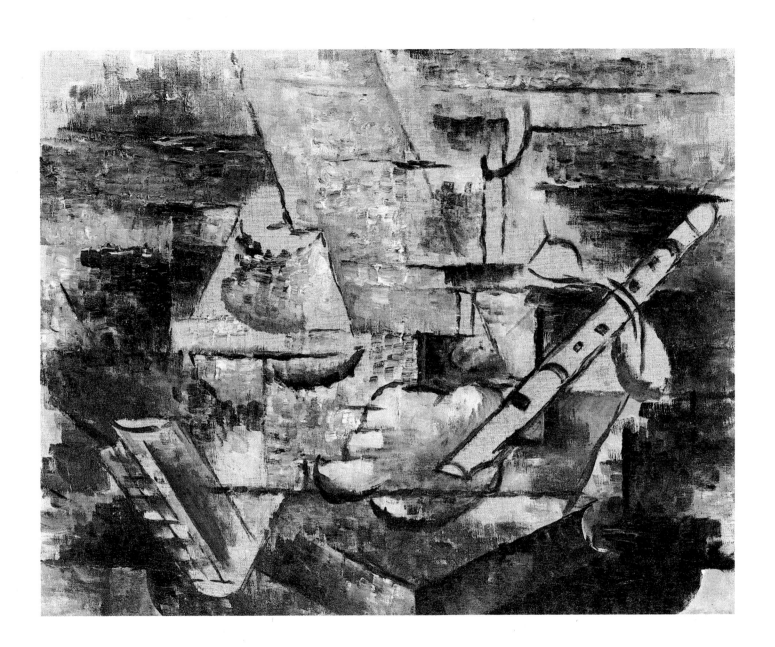

16

Rooftops at Céret (Les Toits à Céret). Summer 1911

Oil on canvas, 34¾×25½″ (88.2×64.8 cm)
Signed on reverse
Ozenfant 1928, p. 76
Isarlov 1932, no. 116
Mangin (W. de R.) 1982, no. 90
Collection Mr. and Mrs. William R. Acquavella, New York

In the middle of July 1911, Picasso went to Céret, a charming village in the Roussillon, near the Spanish border, where the sculptor Manolo, a mutual friend of Braque and Picasso, had gone to live. Braque joined him there a month later and the two painters continued the disintegration of volume to the point of near-abstraction. The old red roofs and chimneys of the Catalan town seen through an open window are rendered with dappled strokes of ocher and gray tones that refract the light. The Solomon R. Guggenheim Museum has a view of Céret painted during the same period by Picasso. After Céret, Braque abandoned landscape painting until 1928.

17
The Table (Le Guéridon): Stal. 1912

Oil on canvas, oval, 28×23¾″ (73×60 cm)
Signed on reverse
Isarlov 1932, no. 125
Mangin (W. de R.) 1982, no. 132
Collection Museum Folkwang, Essen

Here the oval is set on the vertical axis and the almost abstract linear
structure is combined with a technique of dabbed brushstrokes. The sten-
ciled and freehand letters that Braque introduced into his paintings in
1911 had a twofold function, pictorial and poetic. They are fixed, flat and
undeformed elements that serve as points of reference for the spatial
organization of the objects.

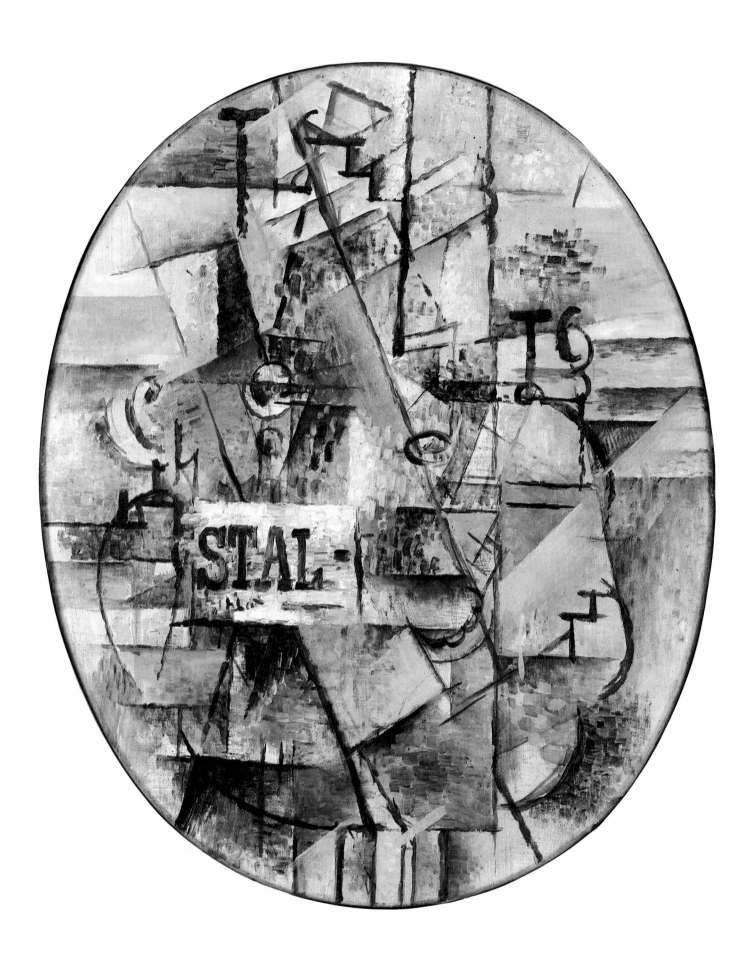

18

Table with a Pipe (La Table à la pipe). 1912

Oil on canvas, oval, 23½×28¾″ (59.5×73 cm)
Signed l.r.
Isarlov 1932, no. 162
Mangin (W. de R.) 1982, no. 123
Courtesy Galerie Rosengart, Lucerne

Braque began using oval formats in 1910, and then increasingly during
the Cubist period, disposed along one or the other axis. "With oval for-
mats, I regained the sense of the horizontal and vertical." This countered
the dispersion of the angles, making the pictorial surface more compact
and giving it a more vibrant texture. Rhythmic condensation reaches its
highest pitch in this work. Standing out among the familiar objects com-
posed of interpenetrating vertical planes on the round tabletop – music
score, guitar, playing cards and graphic signs and letters – the pipe, which
gives the canvas its title, is the most readily identifiable element of this
dynamic and perfectly mastered composition.

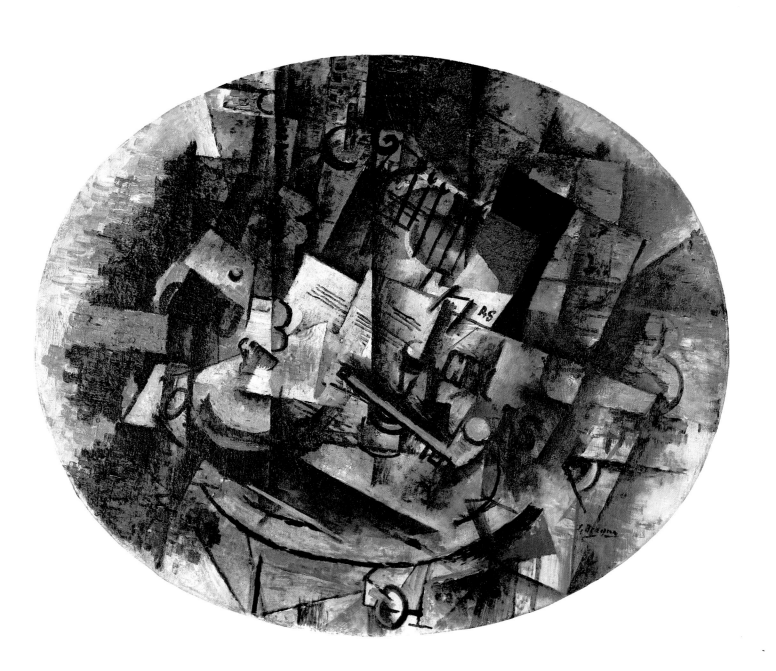

19

Fruit Dish, Bottle and Glass (Compotier, bouteille et verre): Sorgues.
1912

Oil and sand on canvas, 23¾ × 29″ (60 × 73 cm)
Umělesky Měsícník, Prague, no. 6–7, 1913, repr.
Les Soirées de Paris, April 15, 1914, repr.
Isarlov 1932, no. 146
Mangin (W. de R.) 1982, no. 144
Collection Musée National d'Art Moderne, Centre Georges Pompidou, Paris,
Gift of Louise and Michel Leiris

This still life was painted at Sorgues, near Avignon, as the typographical
inscription indicates. It is one of the first canvases in which the artist
added sand to his oil paint, thus enriching and transforming the quality
of the medium and enhancing the colors. The iconography and texture
relate it to the first papiers collés. Bunches of grapes were often included
in the Cubist repertoire for their visual impact and sensual purity.

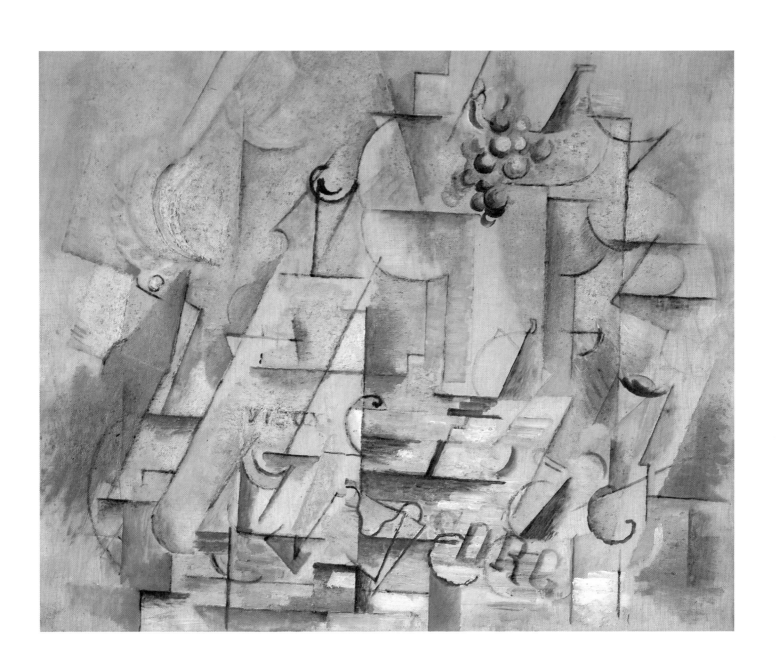

20
Still Life with Violin (Nature morte avec violon). 1913

Oil (and charcoal?) on canvas, 25⁹⁄₁₆×36¼″ (64×92.1 cm)
Signed on reverse
W. George 1921, p. 561
Isarlov 1932, no. 197
Mangin (W. de R.) 1982, no. 202
Courtesy Perls Galleries, New York

The guitar and the mandolin alternate as motifs in the still lifes of musical subjects that characterized this period, and during which there was a total interaction between Braque's paintings and his papiers collés. Braque used his skills as a painter-decorator to imitate the wood of the table and violin, to do the lettering of the inscriptions, and to vary the qualities of the materials and their textures. The pictorial space is articulated by overlapping straight and curved planes that permit the light to breathe, as it were. The materials, the space and the light on the ocher, gray, black and white tones are in complete harmony.

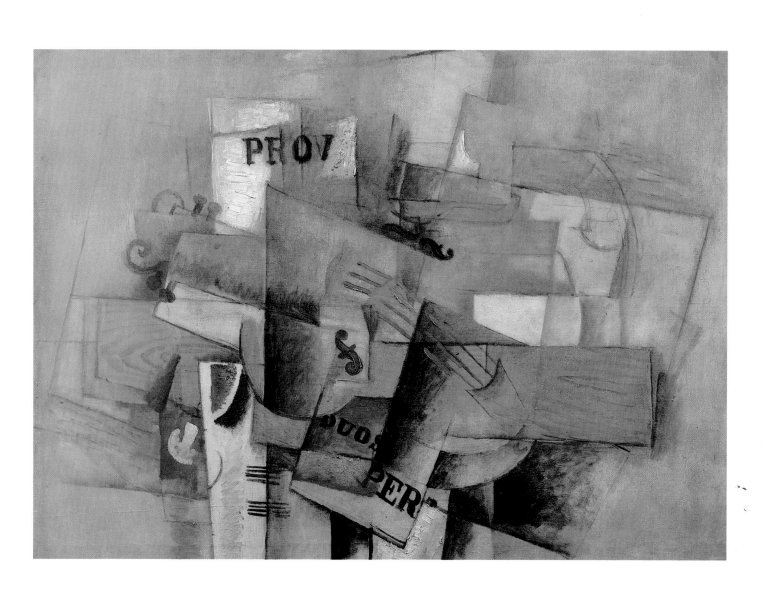

Violin and Clarinet (Violon et clarinette). 1913

Oil on canvas, 21⅝ × 17″ (55 × 43 cm)
Signed on reverse
Isarlov 1932, no. 161
Mangin (W. de R.) 1982, no. 180
Národní Galerie, Prague, Vincent Kramar Collection

Synthetic Cubism reintroduced color and a rich texture in larger planes.
The name of Bach often appears in Cubist still life compositions, which
were executed with the rigor of fugues. The pictorial signs are interre-
lated in a musical way and should be read accordingly. As Nicolas Calas
wrote: "The Cubists used the violin and the clarinet in their paintings as
metaphors for the palette and brush."

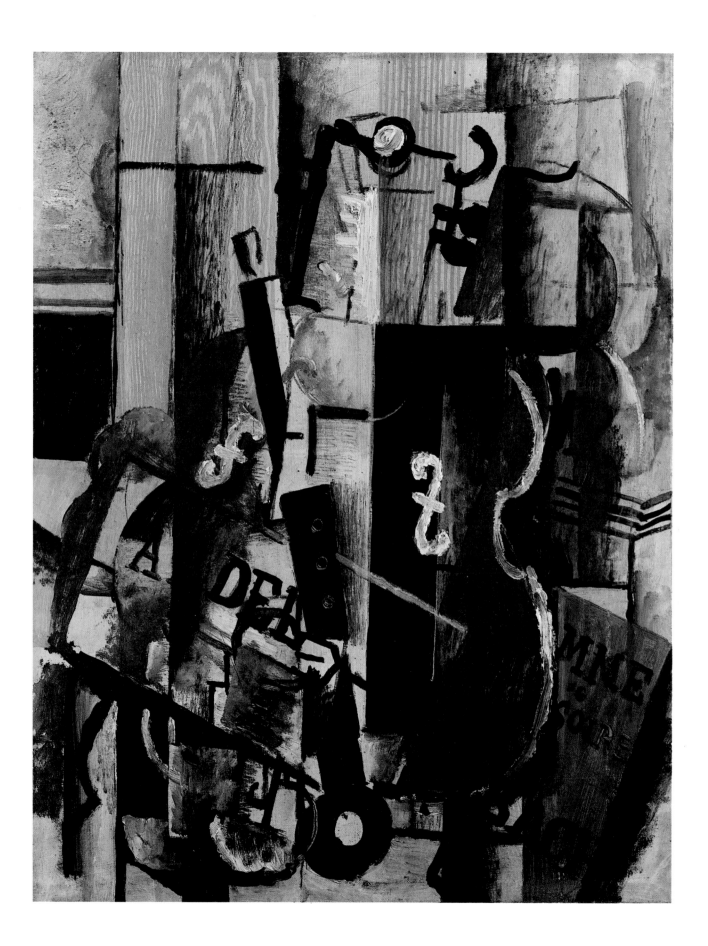

22

Fruit Dish and Cards (Compotier et cartes). Spring 1913

Oil, pencil and charcoal on canvas, 31⅞×23⅝″ (81×60 cm)
Signed on reverse
Isarlov 1932, no. 160
Mangin (W. de R.) 1982, no. 151
Collection Musée National d'Art Moderne, Centre Georges Pompidou, Paris,
Gift of Paul Rosenberg

This painting is a transposition, with a few modifications and enhance-
ments, of Braque's first papier collé (Mangin 150), which was not avail-
able for this exhibition. Both works were owned by the art collector and
critic Wilhelm Uhde. Braque faithfully reproduced the pieces of printed
paper imitating oak panels, complete with their grain and molding.
The new elements are the black table-edge and the playing cards, which
make their first appearance in Cubist iconography.

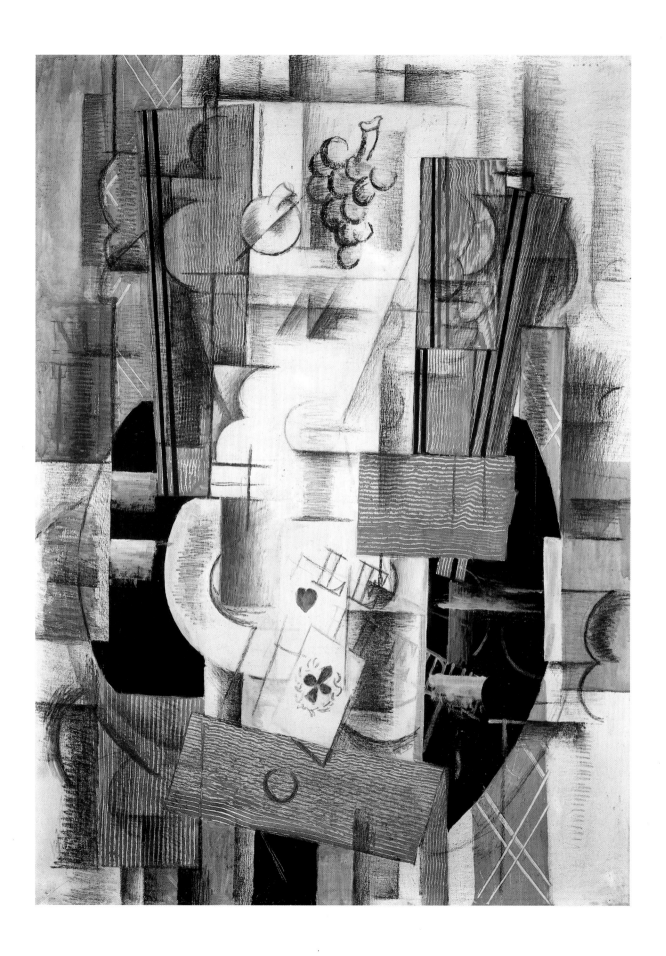

23
The Guitar (La Guitare). 1912

Charcoal and *faux bois* paper pasted on paper, 28⅟₁₆×23¹⁵⁄₁₆″ (72×60 cm)
Mangin (W. de R.) 1982, no. 191
G. Braque, papiers collés, exh. cat., 1982, no. 4 (Paris), no. 4 (Washington)
Private Collection

Braque created his first papiers collés in Sorgues in September 1912 from
a roll of paper printed in imitation wood-grain that he had bought in Avig-
non. Like a number of other early works in this technique, this one is
remarkable for the economy and purity of its means. A single piece of
beige paper with grain and molding imitating oak paneling has been
painted in the middle of the composition, giving it a material and a musi-
cal resonance. Lines drawn in charcoal represent a guitar and its sur-
roundings. The capital letters from the beginning of the word *"Journal."*

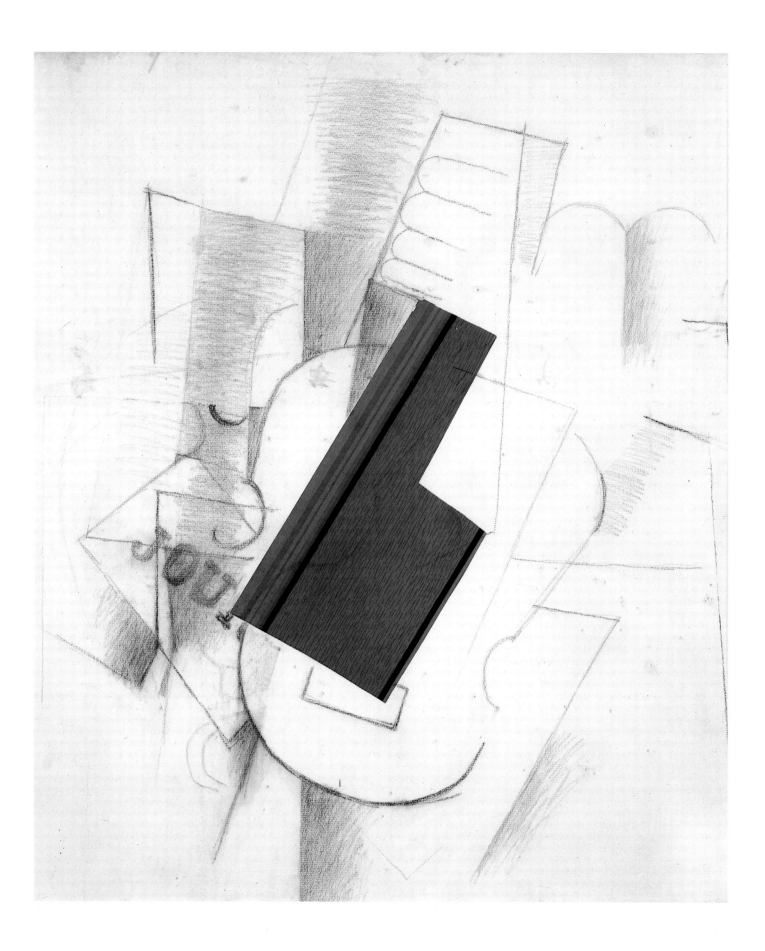

24
Guitar and Bottle (Guitare et bouteille). 1913

Gouache, pencil, charcoal, *faux bois* paper, black paper and brown paper on canvas,
39¼×25⅝″ (99.7×65.1 cm)
Signed on reverse
Isarlov 1932, no. 170
Mangin (W. de R.) 1982, no. 203
G. Braque, papiers collés, exh. cat., 1982, no. 28 (Paris), no. 29 (Washington)
Collection The Museum of Modern Art, New York, Acquired through the Lillie
P. Bliss Bequest

The papiers collés adhere to the plane surface of their support and create
absolute plastic signs that draw their value from the matte quality of the
tones and the rightness of the spatial relationships. The composition is
organized vertically around the overlapping pieces of brown, black and
imitation-wood printed paper. The black piece of paper on which the
strings of the guitar are drawn in white chalk, like a negative, appears in
other papiers collés by Braque. Lines drawn in pencil and charcoal have
been set delicately between the planes established by the pasted paper.

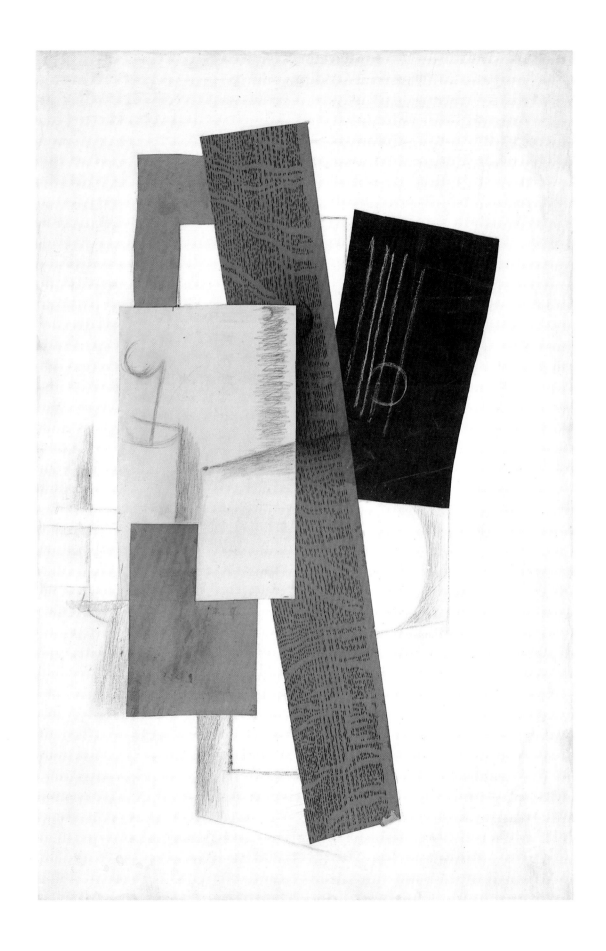

25

Clarinet (La Clarinette). 1913

Charcoal, newspaper, black paper and *faux bois* paper on canvas, 37½ × 47⅜″
(95.2 × 120.3 cm)
Signed on reverse
Isarlov 1932, no. 174
Mangin (W. de R.) 1982, no. 204
G. Braque, papiers collés, exh. cat., 1982, no. 29 (Paris), no. 28 (Washington)
Collection The Museum of Modern Art, New York, Nelson A. Rockefeller Bequest

In this, the largest of Braque's papiers collés and one of the most beauti-
ful, drawing and collage have been delicately and perfectly harmonized.
It once belonged to the painter Ozenfant, who created Purism and
founded a famous school of modern art in New York. A long strip of printed
imitation-oak paper crosses the horizontal axis of the oval table, suggest-
ing its texture and grain, and covers two strips of black paper and the
graceful oblique of the clarinet. The subtly torn piece of newspaper –
"*L'Echo d'A[thènes]*" – is the sonorous element, both in the chromatic and
in the verbal sense, which connects the clarinet and the glass drawn in
charcoal.

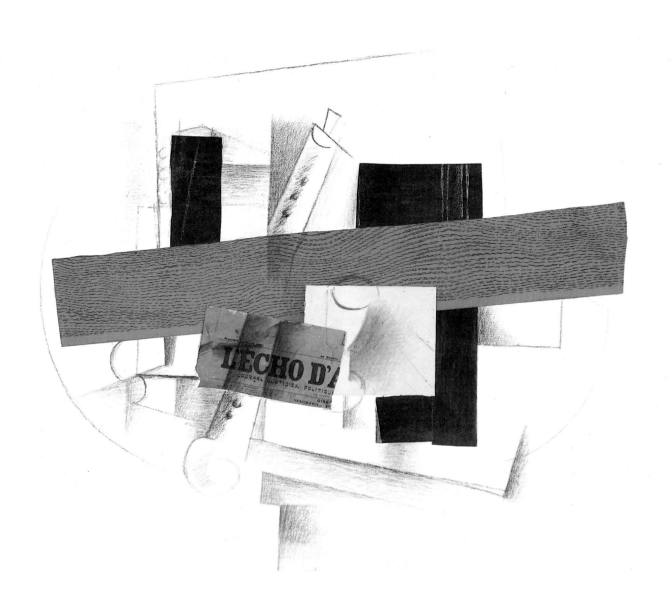

26
The Checkerboard (Le Damier). 1913

Charcoal and brown paper on light-colored paper, 17¾×31⅞″ (45×81 cm)
Les Soirées de Paris, April 15, 1914, repr.
Isarlov 1932, no. 172
Mangin (W. de R.) 1982, no. 197
G. Braque, papiers collés, exh. cat., 1982, no. 31 (Paris), no. 30 (Washington)
Collection Musée National d'Art Moderne, Centre Georges Pompidou, Paris,
Gift of Louise and Michel Leiris

This papier collé is noteworthy for its narrow horizontal format and the
simplicity of its means. Two pieces of freely cut-out brown paper suffice to
balance the spatial arrangement and to give that musical touch so charac-
teristic of Braque. A few light strokes of charcoal on the bare ground
define the round tabletop with a checkerboard and an ace of clubs.
Checkerboards and playing cards are typical of Cubist iconography. The
ace of spades and the ace of hearts appear in other papiers collés.

27
Pipe, Glass and Die (Pipe, verre et dé). 1914

Charcoal, *faux bois* paper, black paper, green paper, newspaper and cigarette package wrapper pasted on paper, 19¾×23⅝″ (50×60 cm)
Mangin (W. de R.) 1982, no. 234
G. Braque, papiers collés, exh. cat., 1982, no. 46 (Paris), no. 45 (Washington)
Collection Kunstmuseum Hannover mit Sammlung Sprengel, Hannover

In Braque's first collages there was more charcoal drawing than pasted
paper, usually sober-colored paper imitating wood. Here, there is
little drawing, the cutout forms predominate, ordering the composition
with their pure, flat shapes. There is also color, and the contrast be-
tween the green and black reverberates through the pale gray and brown
color-scheme. The fragment of the issue of *Journal* is dated Monday,
January 26, 1914.

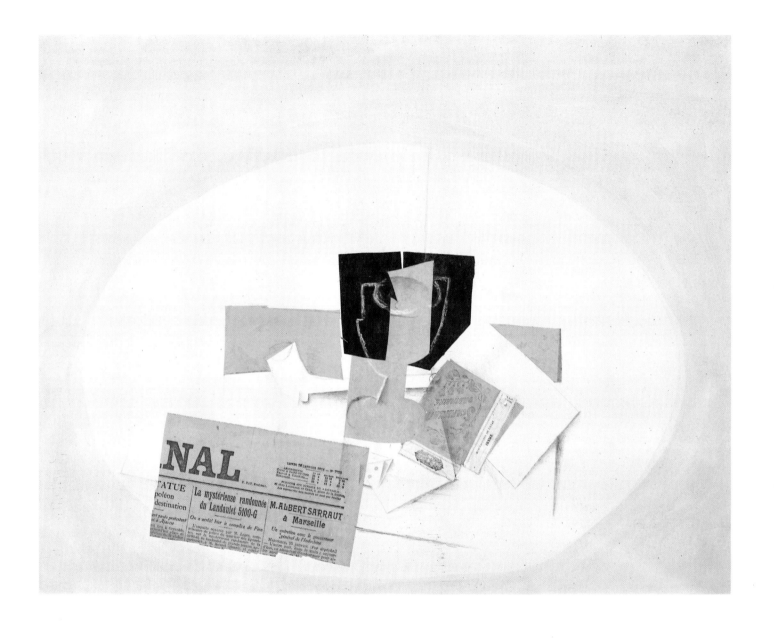

28

The Bottle of Rum (La Bouteille de rhum). 1914

Charcoal, newspaper, beige paper, wrapping paper, black paper, touched up with
gouache, cut out and pasted on cardboard, 25¾×18⁵⁄₁₆″ (65.5×46.5 cm)
Mangin (W. de R.) 1982, no. 241
G. Braque, papiers collés, exh. cat., 1982, no. 52 (Paris), no. 51 (Washington)
Private Collection

Picasso and Juan Gris boldly combined oil paint with their papiers collés,
while Braque used only drawing techniques with his: first charcoal, then
gouache, which brought color back and regularized it according to
Seurat's pointillist system. A number of Cubist still lifes painted in oil
also depict a bottle of rum, identifiable by its label. A bottle of marc is also
a frequently used motif.

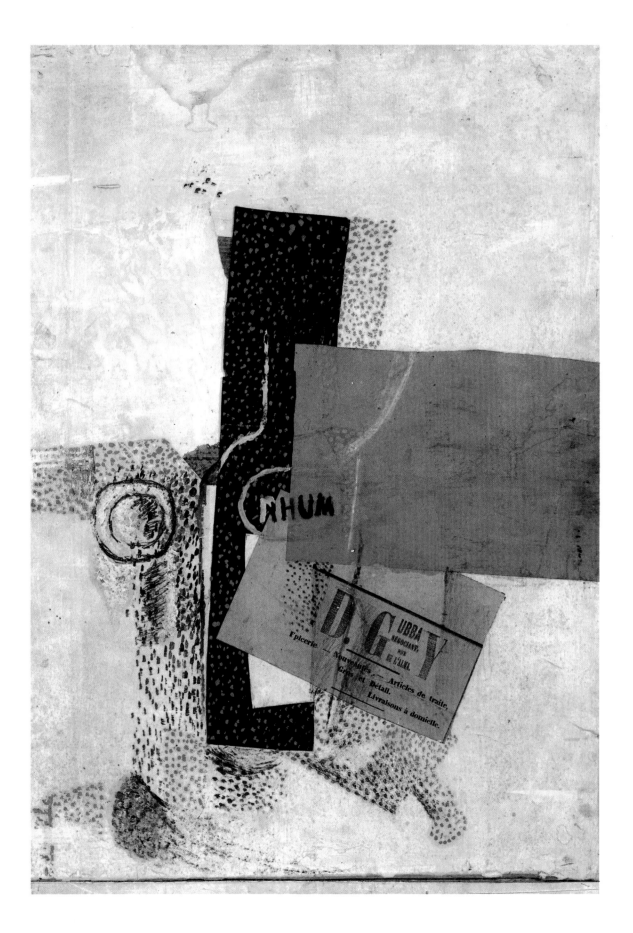

29
Glass and Ace of Clubs (Verre et as de trèfle). 1917

Oil on canvas, 13¾×18″ (35×46 cm)
Signed and inscribed *Sorgues 17* on reverse
Signed l. c.
Mangin 1973, p. 16
Courtesy Jan Krugier Gallery, New York

As the inscription on the back of the canvas indicates, this little work, now
exhibited for the first time, was painted at Sorgues in the summer of 1917,
when Pierre Reverdy was there. It belongs to a series of *tableaux-objets*
related to the bas-reliefs of the sculptor Laurens, and whose exquisite
compositions are inscribed in a variety of shapes: rectangles, lozenges,
octagons, mandorlas. The block-lettered signature is integrated into a
decorative composition made up of four compartments.

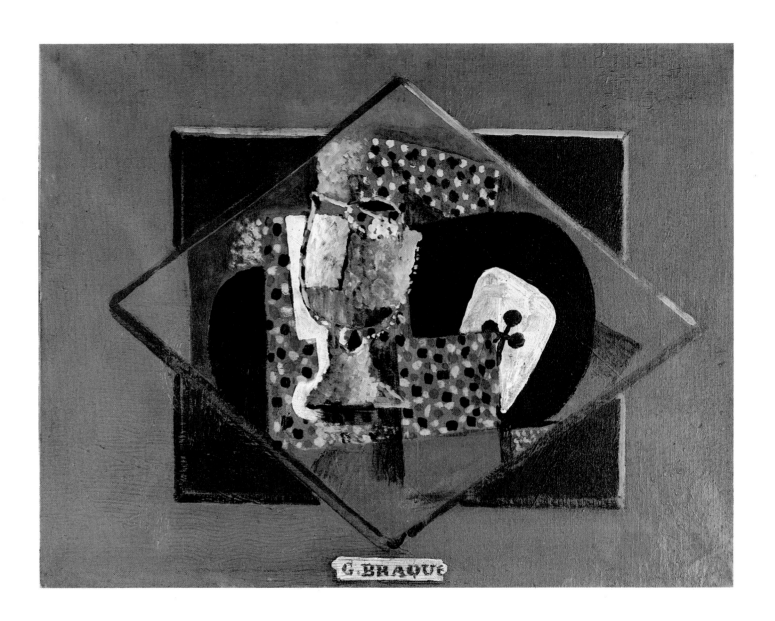

30

Glass, Pipe and Newspaper (Verre, pipe et journal). 1917

Oil on canvas, 21¹¹⁄₁₆ × 16¹⁵⁄₁₆″ (55 × 43 cm)
Signed and dated on reverse
Mangin 1973, p. 6
Collection Mr. and Mrs. Eric Estorick

Braque's mobilization and then wounding in May 1915 interrupted his
activity for three years. When he took up his brushes again in the spring
of 1917, after many months of hospitalization and a long convalescence,
he was separated from his old friend Picasso, who was working in Italy
and Spain with the Ballets Russes. Personally and aesthetically, he was
drawn to Juan Gris and Henri Laurens. This still life depicting his charac-
teristic motifs – pipe, glass, newspaper – belongs to this phase of readap-
tation. The broader planes of Synthetic Cubism lend themselves to a
richer and more diverse pictorial substance, with decorative stripes and
contrasts of texture.

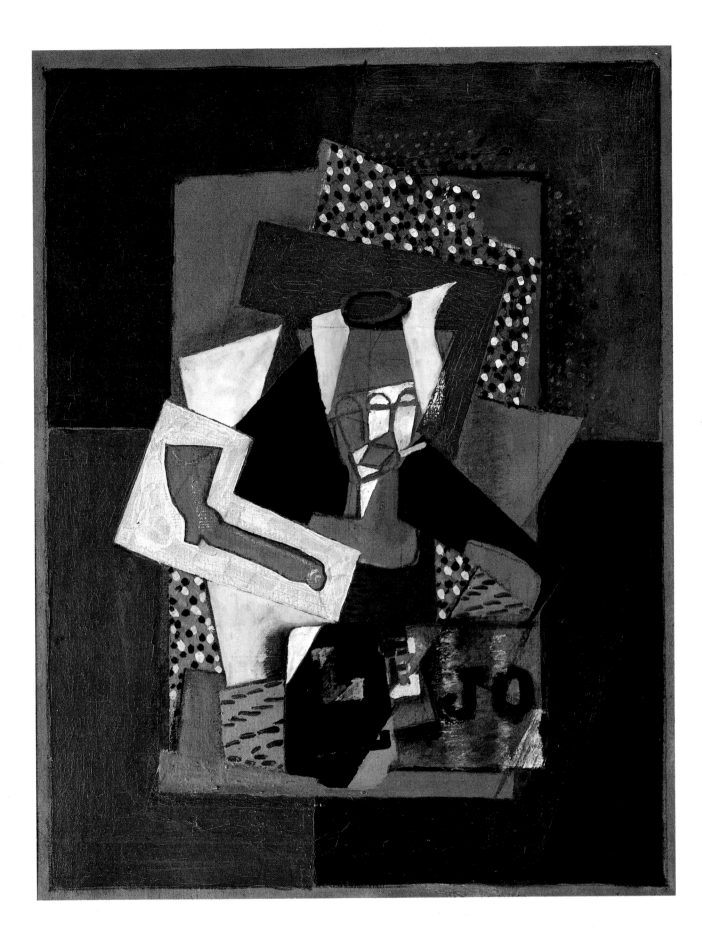

31

Still Life with Ace of Clubs (Nature morte à l'as de trèfle). 1914–18

Oil on canvas, 22⁷⁄₁₆ × 20⁷⁄₈″ (57 × 53 cm)
Private Collection

Begun on the eve of the war, this still life was finished in 1918, at a time
when Braque was changing his style in the *Gueridon* series (see cat.
no. 30). The oval table outlined in black, shown from above, is brought
close to the picture plane in a canvas of almost square format. Among the
familiar objects gathered as if in a nest is the ace of clubs already seen in
many other works (see cat. nos. 22, 26, 29). These dark-toned objects,
painted in grays and browns, are not lit by an external source, but glow
with their own light, an inner phosphorescence bound up with the mate-
riality of the color. What the color lacks in brilliance it gains in inner reso-
nance.

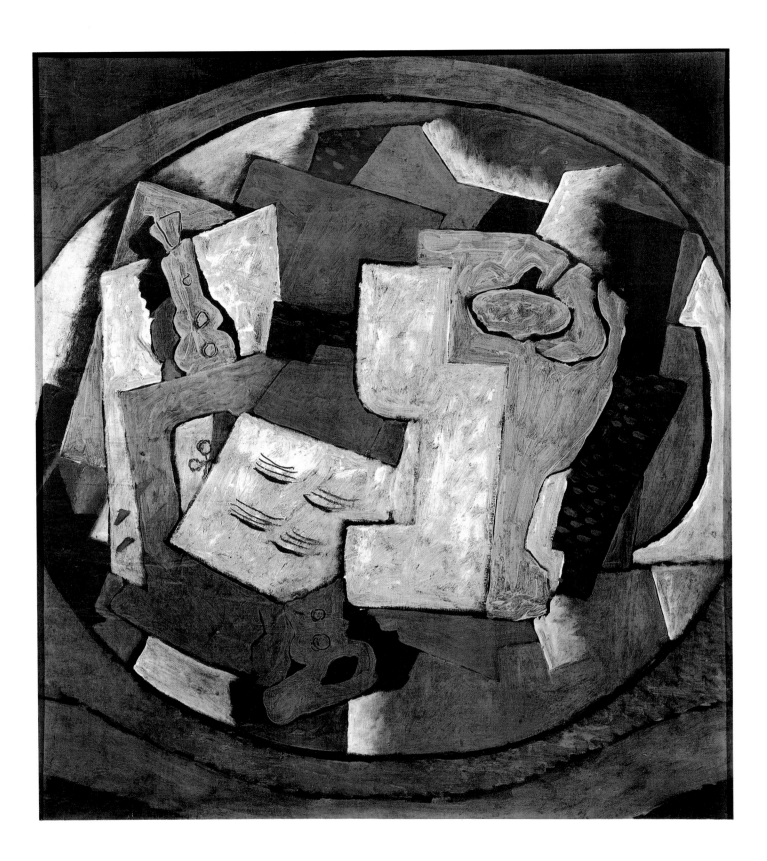

32

Guitar, Glass and Fruit Dish on Sideboard (Guitare, verre et compotier sur un buffet). Early 1919

Oil on canvas, 31⅞×39½" (81×100.3 cm)
Signed and dated on reverse
Bissière 1920, pl. 15
Isarlov 1932, no. 256
Mangin 1973, p. 46
Collection Solomon R. Guggenheim Museum, New York, Gift, Justin K. Thann-
hauser Foundation, by exchange, 1981
81.2821

This splendid canvas was reproduced in the first monograph on Braque, published by Bissière in 1920. It marks the final stage of the still lifes begun in 1918 and exhibited in March 1919 in Braque's second one-man show, at Léonce Rosenberg's gallery. The characteristic motifs are recapitulated in a rhythmic pattern of overlapping planes: the grooved sideboard, the guitar with its score, the fruit dish with pear and grapes, the glass bisected into a dark and a light side. The two green bands with vermilion dots relieve the sober brown and white color-scheme set against a black background.

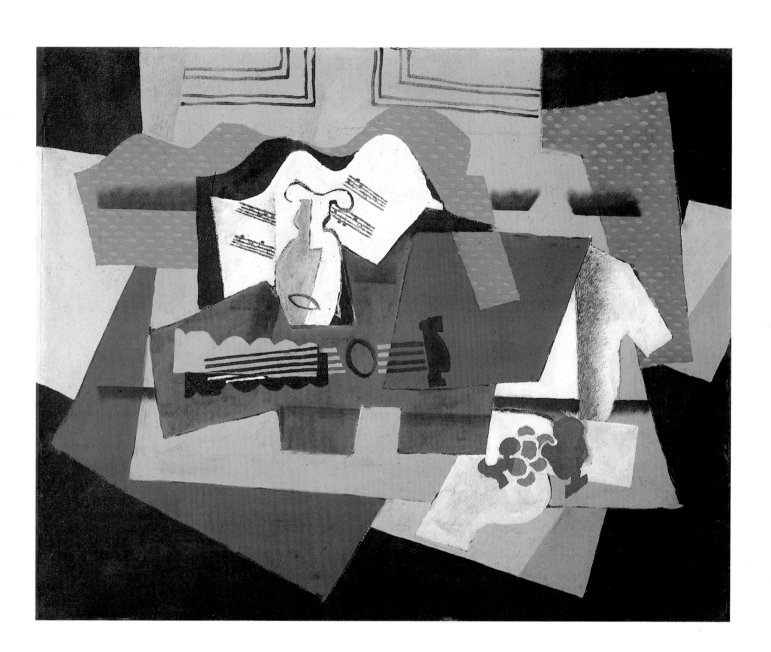

33
The Buffet (Le Buffet). 1920

Oil on canvas, 31⅞×39⁵⁄₁₆″ (81×100 cm)
Signed on reverse
Isarlov 1932, no. 266
Mangin 1973, p. 72
Private Collection, Liechtenstein

The still life composed of fruits, musical instrument and score is placed on
a dining room sideboard. The broad, suppler planes of Synthetic Cubism
interpenetrate harmoniously against a rich black ground that gives the
color and oil medium its resonance and its amplitude. Juan Gris said that
in the guitar Braque had found his equivalent of the Madonna of the
old masters. The stylized bunch of grapes adds a sensual note to the
hushed atmosphere with its restrained color-scheme heightened by a few
accents of yellow.

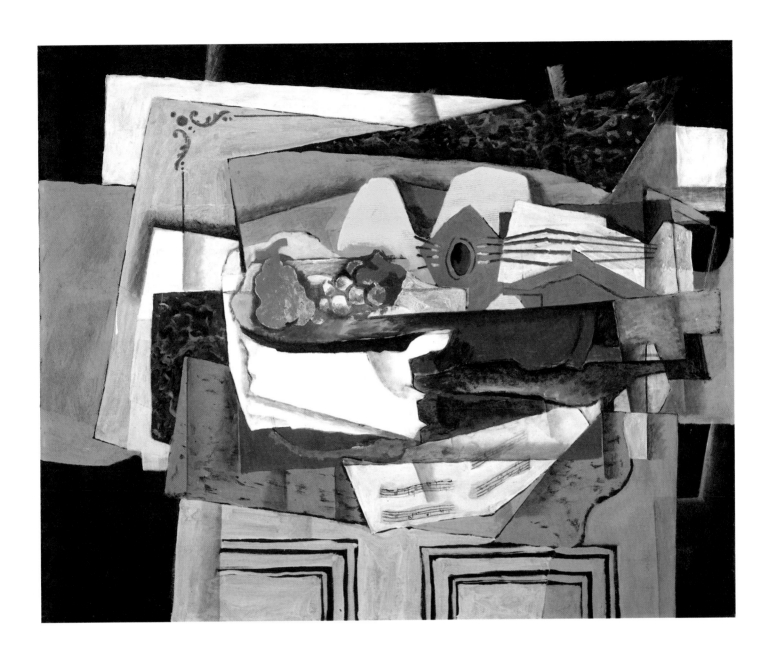

34
Guitar and Glass (Guitare et verre): Socrate. 1921

Oil on canvas, 16¹⁵⁄₁₆ × 28¾″ (43 × 73 cm)
Isarlov 1932, no. 289
Mangin 1973, p. 87
Pouillon and Monod-Fontaine 1982, no. 17
Collection Musée National d'Art Moderne, Centre Georges Pompidou, Paris, Gift
of Mr. and Mrs. André Lefèvre

The inscription *Socrate* refers to the dramatic symphony based on the
dialogues of Plato composed by Erik Satie in 1917 which was performed
twice in 1920, first in a piano version and then with an orchestra. At the
time, writers, composers and artists manifested a renewed interest in
antiquity. The two contemporary composers then closest to Braque were
Darius Milhaud (1892–1974), with whom he worked in 1923 on
Diaghilev's ballet *Les Fâcheux,* and especially Satie (1866–1925), who
had a keen grasp of painting and whom he saw every week. In 1920 he
illustrated Satie's *Le Piège de Méduse* with colored wood engravings.
When Satie died, Braque bought his piano and kept it in his home. This
still life is treated horizontally, in a very grave and simple manner befit-
ting the subject, with oppositions of white and black, but also with lively
festoons, a touch that was in keeping with the humor of Satie and of the
Greek philosopher.

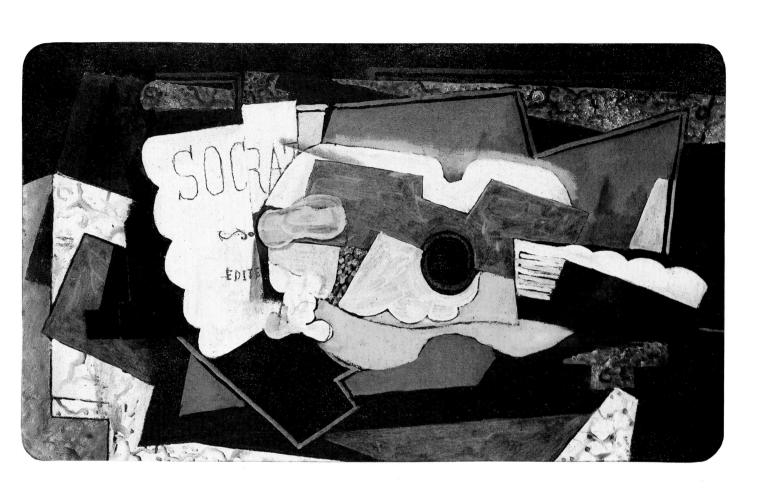

* 35
Still Life with a Guitar (Nature morte à la guitare). 1921–22

Oil on canvas, 23⅝×39½″ (60×100 cm)
Signed on reverse
Isarlov 1932, no. 299
Mangin 1973, p. 90
Collection Národní Galerie, Prague

Between 1921 and 1927 Braque painted a series of *Mantelpiece* canvases
presenting still-life elements in vertical format like the *Gueridon* pic-
tures. The established mode of Cubist representation and the new, more
naturalistic mode are harmoniously combined. Here,the composition is
cut off just above the fireplace; the still life is set lengthwise on the marble
mantel. There is a great variety of textures: smooth and rough planes,
imitation marble veining, spotted and striated strips. In this horizontal
still life, which is structured like music, the letters half hidden by the
guitar, the predominant object, spell out the word "*Quatuor,*" or "quartet";
another *Mantelpiece,* of vertical format, owned by the same museum,
features the word "*Valse.*" Artistic relations between Paris and Prague
were very intense at the beginning of the century.

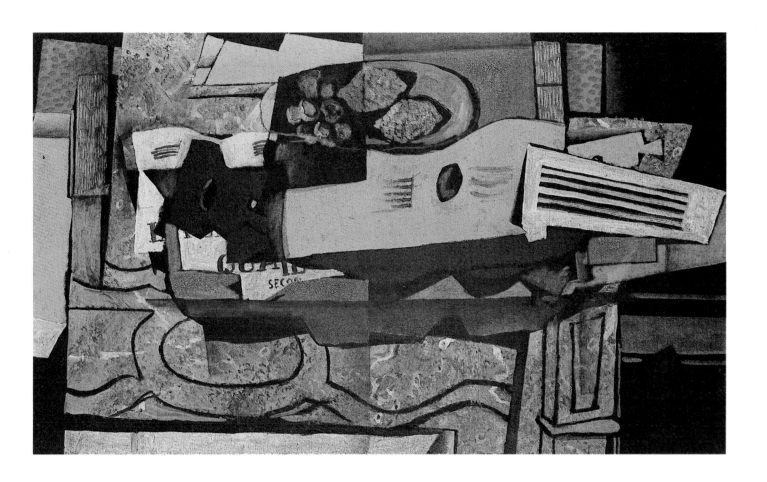

36
The Table (Le Guéridon). 1921–22

Oil and sand on canvas, 75×27¾″ (190.5×70.5 cm)
Signed l. r.
Mangin 1973, p. 97
Jointly owned by The Metropolitan Museum of Art, New York,
and Mrs. Bertram Smith, 1979

This painting, which was exhibited in the special room devoted to Braque
in the Salon d'Automne of 1922, was acquired by Count Etienne de
Beaumont, a collector and patron of the arts. It marks the magnificent
beginning of a new series of vertical gueridons that continued until 1930.
The space of the wood-paneled room is still shallow, but there is a flow of
light and the colors have been lightened. The green table is drawn out vert-
ically and the top is tilted toward the picture plane to show the usual
objects predominantly in whites. It is set on a heavy yellow tripod pedes-
tal represented in a realistic and tactile manner. The eye moves up from
the checkered floor to the upper part of the wall, which features a motif
that will be characteristic of the gueridons, a sort of folded screen, colored
in black here.

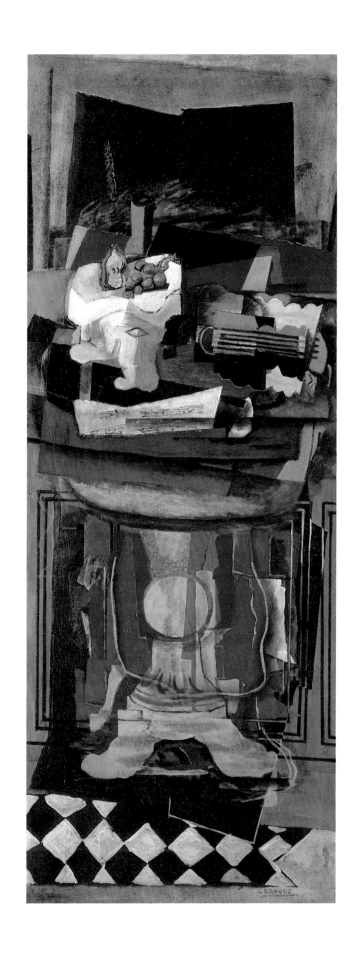

37

Canephora (Canéphore). 1922

Oil on canvas, 71¹/₁₆×28¹⁵/₁₆″ (180.5×73.5 cm)
Signed l.r.
Isarlov 1932, no. 318
Mangin 1973, p. 109
Pouillon and Monod-Fontaine 1982, no. 19
Collection Musée National d'Art Moderne, Centre Georges Pompidou, Paris,
Bequest of Baron Gourgaud

The two monumental *Canephora* figures designed as pendants (see next
entry) and prepared in very developed sketches with color notes (see cat.
nos. 101, 102) are often dated 1923, although they were shown at the
Salon d'Automne of 1922, the year of Braque's fortieth birthday. On this
occasion Braque was given the honor of a special room. The present work
was reproduced in the October 1922 issue of *L'Amour de l'art.* These
seminude figures were the first of a majestic series that continued until
1926, concurrently with the *Mantelpiece* works, and were represented
either standing, with the fruit basket on their shoulders, or seated with
the basket propped on their hips, while the last figures were simple
bathers lying on the beach, without drapery or baskets. The volumes and
anatomical forms are not modeled but rendered by the undulating con-
tours and by curious lines scratched into the brown paint of the flesh, a
sort of drawing "in the negative" of Braque's own invention.

38

Canephora (Canéphore). 1922

Oil on canvas, 71¹/₁₆×28¾″ (180.5×73 cm)
Signed l.r.
Isarlov 1932, no. 317
Mangin 1973, p. 108
Pouillon and Monod-Fontaine 1982, no. 20
Collection Musée National d'Art Moderne, Centre Georges Pompidou, Paris,
Bequest of Baron Gourgaud

The two rhythmically related *Canephora* paintings differ in a number of
details, in particular in the movement of the arms lifting the basket of
fruit to one or the other shoulder. These ceremonial offering-bearers, the
descendants of the Greek caryatids, as well as the statues of Versailles,
figures of Poussin and the late Renoir, were Braque's answer to the neo-
classical giantesses painted by Picasso. They are latter-day mother-god-
desses, personifications of the fertile powers of the earth, hence their
colors – yellow, brown and organic green – and they present a calm and
magnified image of the human species.

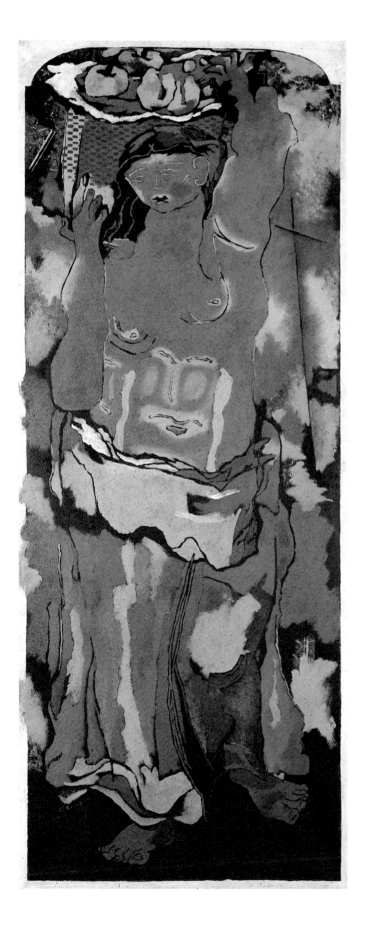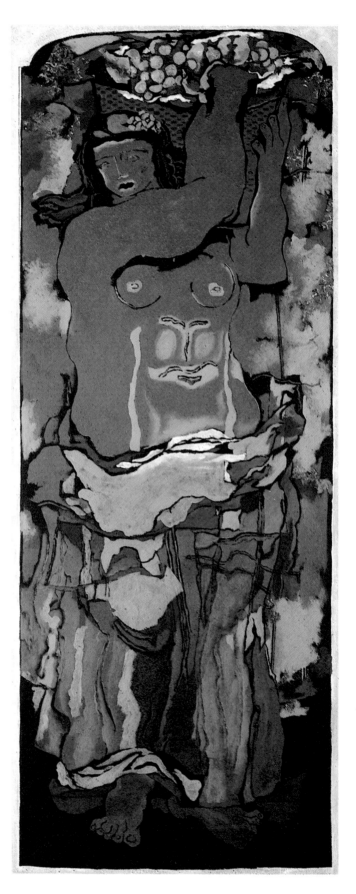

39

Glass and Fruit (Verre et fruits). 1922

Oil on canvas, 12¼×25⅝″ (31×65 cm)
Signed l. l.
Rosengart Collection, Lucerne

This is a perfect example of the delightful small cabinet paintings of still-
life subjects that Braque painted between his sessions with the more
monumental pieces. The black ground, characteristic of the period from
1918 to 1926, emphasizes spatial depth and the resonance of the colors
sustained by the marvelous intimacy of the whites. Block letters, whose
double function we have already mentioned (see cat. no. 17), still occur,
but they will soon disappear with the increased fluidity of his brushwork.

40

Lemon, Bananas, Plums, Glass (Citron, bananes, prunes, verre).
1925

Oil on canvas, 11¹³⁄₁₆×29³⁄₁₆″ (30×74 cm)
Signed and dated l. l.
Mangin 1968, p. 58
Kunsthaus Zürich, Johanna and Walter L. Wolf Collection

In this elongated format, which he liked and mastered with the decorative
perfection of the great ornamental panel painters, Braque laid out a color-
ful assortment of fruits: bananas, a lemon, apples and plums. These fruits
are shown without a receptacle, set directly on the white cloth spread on
the orange table, and the transparent glass is enveloped in undulating
greenery. The alternating pale yellow and gold stripes of the background
accentuate the fragrant curves of the leaves and fruit.

41
Bather (Baigneuse [aux trois fruits]). 1926

Oil on canvas, 39¼×31⅞″ (100×81 cm)
Signed and dated l.l.
Isarlov 1932, no. 420
Mangin 1968, p. 72
Private Collection, Osaka, Japan

This nude figure is the final avatar of the *Canephora* works (cat. nos. 37, 38). The offering-bearers have become simple bathers without baskets of fruit or drapery, but they retain the broad forms, majestic poses and the particular treatment of the anatomy of those figures. Braque does not use the over-sensual color red to express the flesh, but tones that are close to those of the earth and the natural elements. The blond hair flows behind the shoulders down to the group of three apples, whose symbolic value is expressed by their plastic beauty.

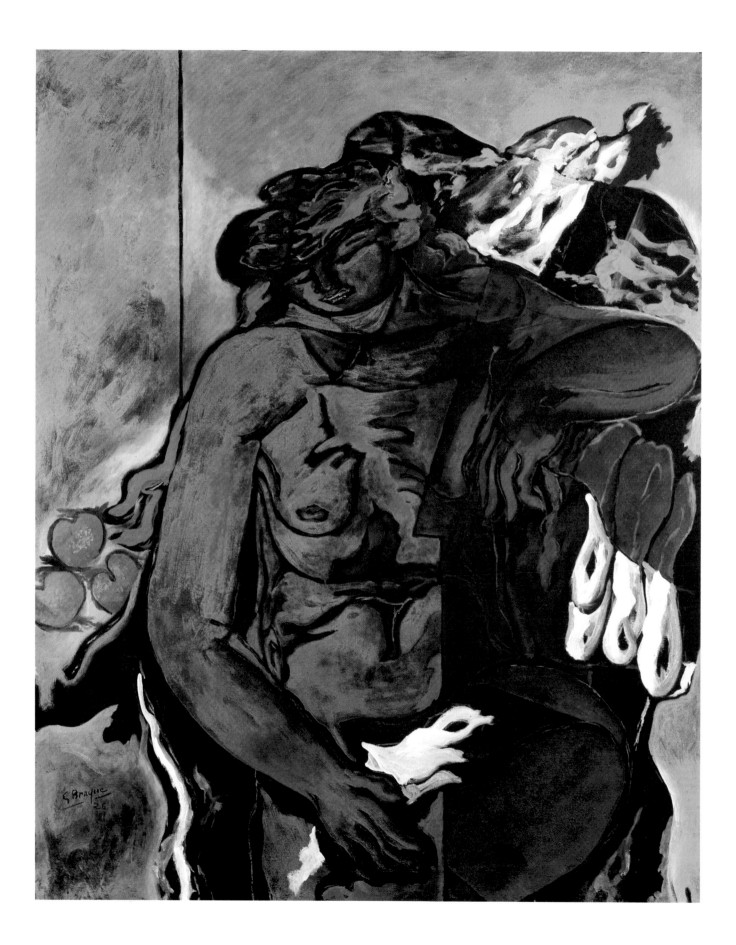

42, 43
Still Life with a Pitcher (Nature morte au pichet). 1926–27
Still Life with a Fruit Dish (Nature morte au compotier). 1926–27

Oil on canvas, each 75⁹⁄₁₆ × 16¹⁵⁄₁₆″ (192 × 43 cm)
Mangin 1968, no. 118
Collection Mr. and Mrs. Claude Laurens, Paris

These elongated, vertical compositions, narrower than the two
Canephora paintings (cat. nos. 37, 38) were executed as a pair of decora-
tive panels for the dining room of the house that Braque had built accord-
ing to his design near the Parc Montsouris. Two still lifes, one of which
displays a bowl full of fruit and the other a pitcher bisected into a dark half
and a light half. They are organized according to the same tripartite
rhythm as the *Gueridon* and *Mantelpiece* compositions, with the curved
shape of a human figure standing like a column that is pinched in the mid-
dle. Their clear light colors were matched to the luminous atmosphere of
the room with its rustic furniture. They summarize and unify the artist's
various styles: naturalistic, Cubist and geometric.

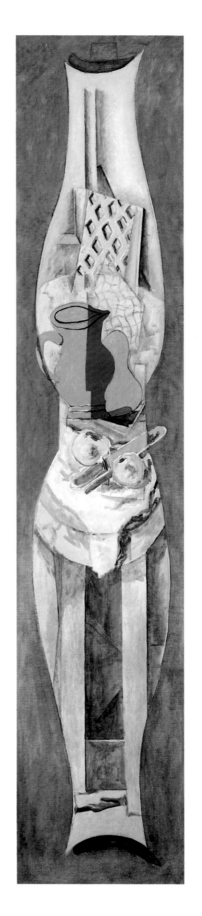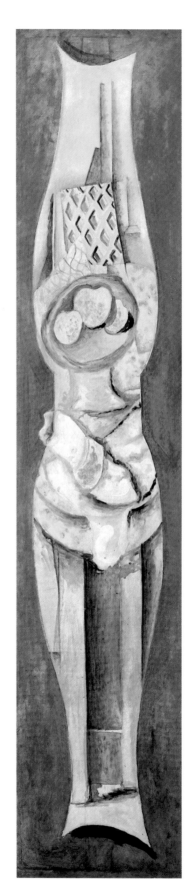

44
The Table (Le Guéridon). 1928

Oil and sand on canvas, 70¾×28¾″ (179.7×73 cm)
Signed and dated l. r.
Isarlov 1932, no. 478
Mangin 1962, p. 3
Collection The Museum of Modern Art, New York. Acquired through the Lillie
P. Bliss Bequest, 1941

This is the first in a series of four large-format *Gueridon* or *Table* pictures
painted in 1928–29. The other three are in Copenhagen (Statens
Museum for Kunst), Washington, D. C. (The Phillips Collection) and a
private collection (cat. no. 45). These works display a complete change in
the handling of color, materials and space. The former black grounds are
replaced by a grainy coating made from a mixture of sand and plaster,
covered by a film of paint that has the mat aspect of fresco. Impasto is used
to render the guitar strings. The thinly applied color is lighter and
more luminous around the whites and the blacks, themselves applied in
smooth planes and not in the thick coats of the earlier works. More is
shown of the interior space, visible now between the baseboard and the
ceiling. The vertical fold in the composition emphasizes the amplified
curves of the objects.

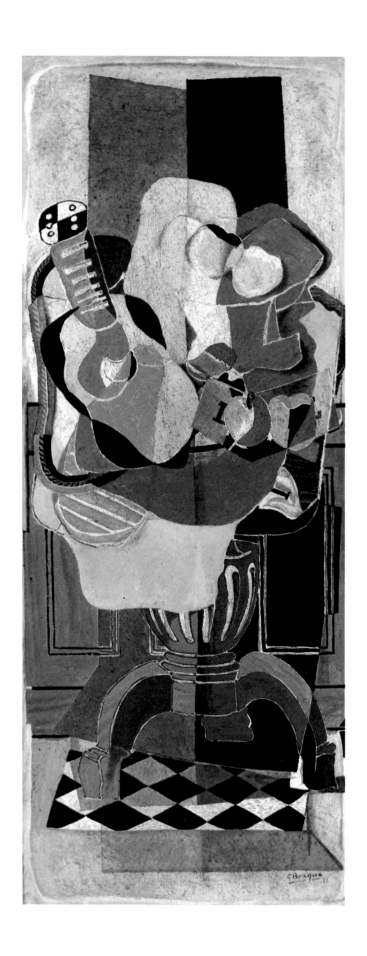

45
Still Life on a Table (Nature morte sur la table). 1928
Oil on canvas, 70¾×28¾″ (180×73 cm)
Signed l. l.
Mangin 1962, p. 5
Private Collection

This canvas belongs to the same group as the previous one and presents
the same basic features, but with many differences in terms of color and
composition. The table is not a gueridon, that is, a round table on a tripod
pedestal, but a rectangular wooden table with a drawer and curvilinear
legs. The beige and white planes create the objects, the two principal ones
being the guitar and fruit dish, which change places. Here a glass and a
music score have been added. The space of the room remains about the
same, close to the picture plane; there is the usual wood paneling and
folded shape at the top, but the checkered floor has been eliminated.

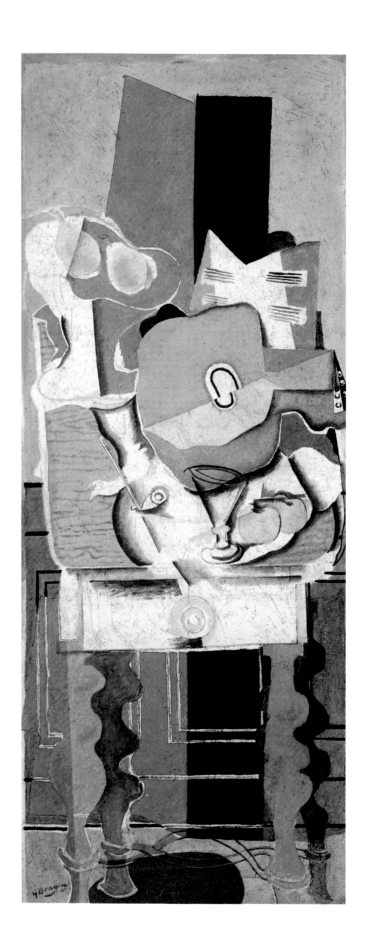

46
Fruit Dish and Napkin (Compotier et serviette). 1929

Oil on canvas, 10⁷⁄₁₆×16³⁄₁₆″ (26.5×41 cm)
Signed and dated u. r.
Isarlov 1932, no. 491
Mangin 1962, p. 29
Collection Staatsgalerie Stuttgart

This picture belongs to a strange group of still lifes from 1929–30 characterized by dynamic lines, a geometric structure and a decorative texture, and in which some of Picasso's influence may be felt. The composition is divided into six parallel vertical bands of uneven lengths and different tonalities. The two outer bands show the bare wall of the room and the baseboard. The central area is a pattern of lozenge-shaped ornaments that covers the tablecloth and the background above. Dark outlines render the curves and spirals of the fruits in the dish filled with grapes, as well as those of the glass and the rolled up napkin. Bright and luminous colors radiate around the white passages.

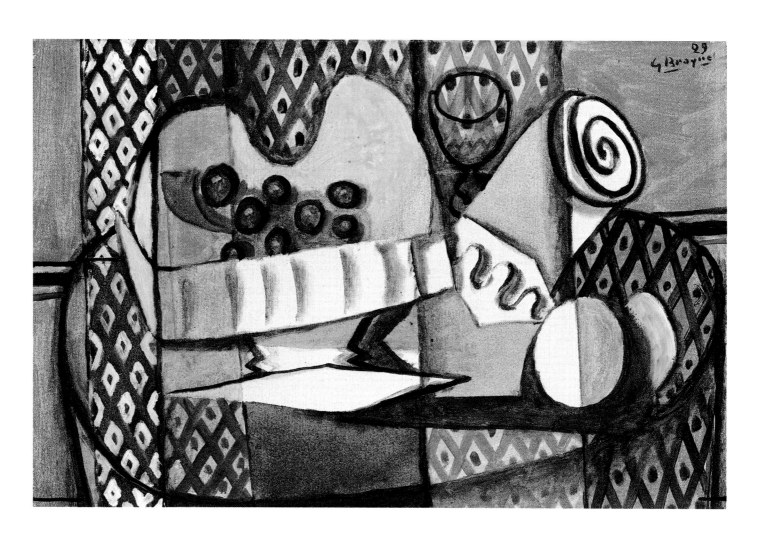

47

The Beach at Dieppe (La Plage de Dieppe). 1929

Oil on canvas, 9⁷/₁₆ × 13¾″ (24 × 35 cm)
Signed and dated l. r.
Mangin 1962, p. 7
Collection Moderna Museet, Stockholm

In 1928 Braque returned to the Normandy of his youth and began spend-
ing his summers there, painting landscapes again for the first time since
1911. In 1928 and 1929 he painted small seascapes at Dieppe that were
conceived as still lifes or stage sets, combining both a decorative rhythm
and a concern for the visual facts. The soft limestone cliffs, against which
huddles a cabin, stand with their furled edges against the dark sea and
sky. Three squat, foreshortened boats, seen from above and at an angle,
have been pulled up on the beach full of round white and brown pebbles
that lend themselves well to a pointillist treatment. There is no human
presence in this crepuscular scene full of mystery and expectation.

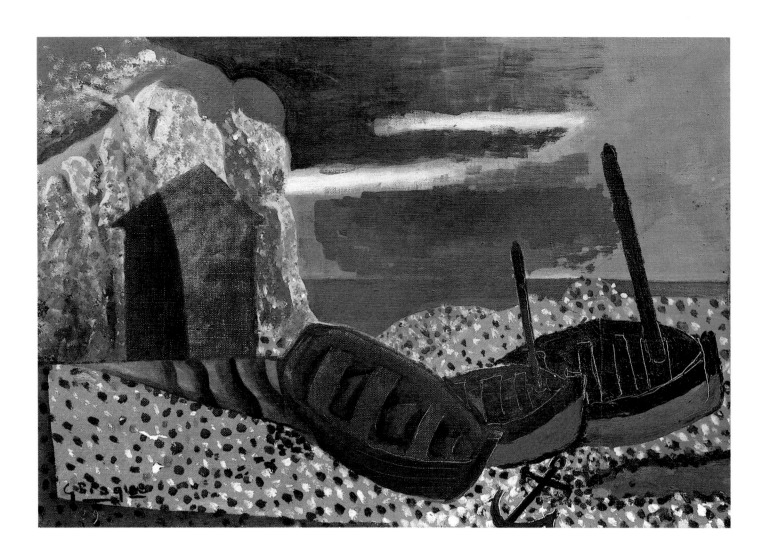

48
Still Life with Fruit Dish, Bottle and Mandolin
(Nature morte au compotier, bouteille et mandoline). 1930

Oil on canvas, 45⅝×35″ (116×89 cm)
Signed l.l.
Mangin 1962, p. 43
Collection Kunstsammlung Nordrhein-Westfalen, Düsseldorf

In 1930 Braque painted a new series of large still lifes characterized by
more complex spatial structure, thin and fluid brushwork, and a play on
the relationships between the light and the dark planes. The two legs are
part of a console table with a marble top set in the corner of a room, two
walls of which meet on the left. There are two fruit dishes on either side of
the familiar mandolin, one containing grapes and the other, apples.
Surfaces covered with dots alternate with plain ones.

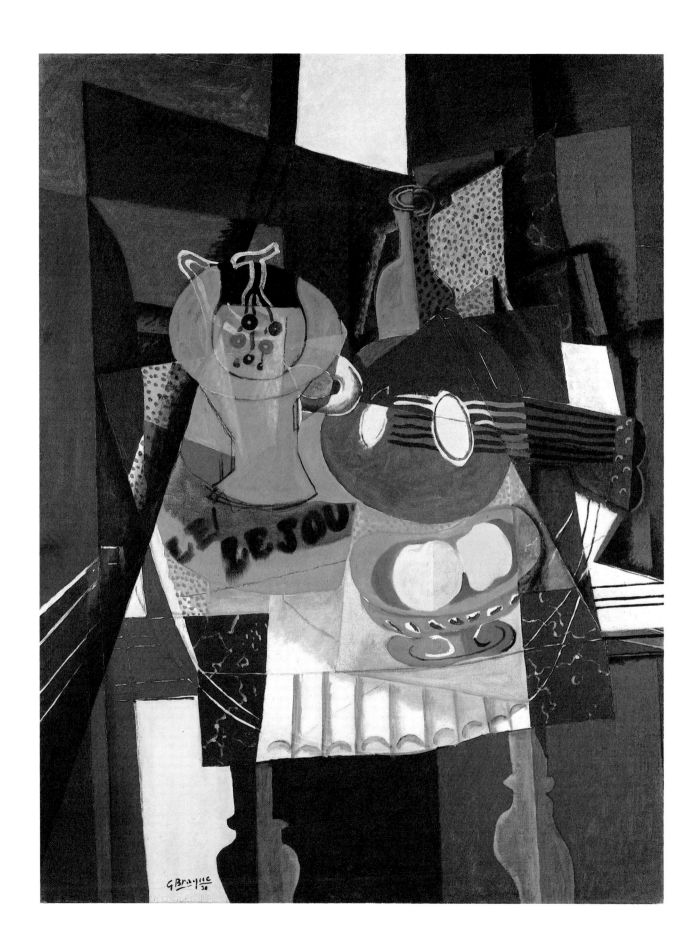

49

Large Brown Still Life (Grande Nature morte brune). 1932

Oil on canvas, 51⁹⁄₁₆ × 74¹³⁄₁₆″ (131 × 190 cm)
Signed l. r.
Mangin 1962, p. 82
Pouillon and Monod-Fontaine 1982, no. 23
Collection Musée National d'Art Moderne, Centre Georges Pompidou, Paris,
Gift of Mrs. Georges Braque

Between 1931 and 1934 Braque painted an unusual series of very linear
and simple still lifes, of which this one, the largest, decorated his dining
room. Directly related to the curvilinear style of the *Bathers* and to his
incised plasters, a technique that he invented, they are characterized by
their undulating line, their sober decoration and fine white lines
scratched into the thinly applied paint restricted to sober browns and
greens, to blacks and Indian red. The objects with delicate and
floating contours are gathered in the center, framed by two diffuse
intersecting rectangles.

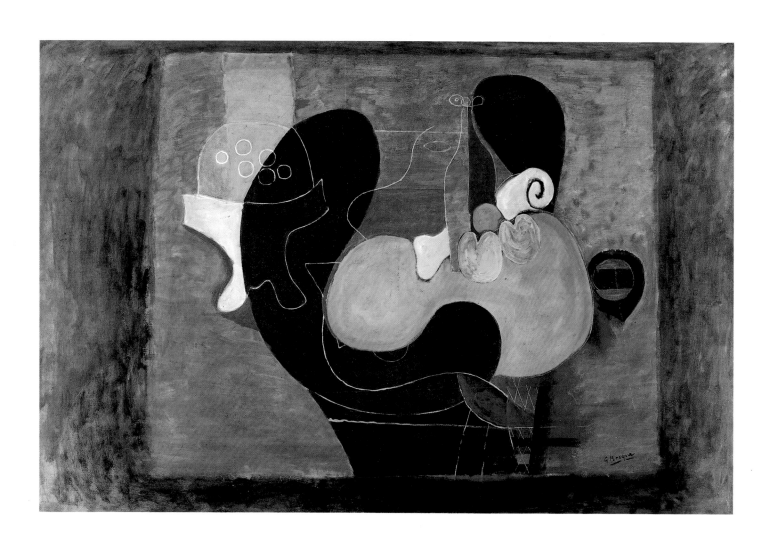

50

Still Life on a Red Tablecloth (Nature morte à la nappe rouge). 1934

Oil on canvas, 31¹⁵⁄₁₆ × 39¾″ (81 × 101 cm)
Signed l. r.
Mangin 1962, p. 106
Private Collection, Paris

Among the famous still lifes that Braque painted between 1933 and 1938,
designated by the color of the tablecloth (pink, yellow, mauve, blue),
which earned him the Carnegie Prize and determined his success, this
work is little known. Its freshness intact, it remained in the painter's
studio. The table swells and raises its curved and sumptuous mass
against the spotted and marbled planes of the delicate and airy back-
ground. The vibration of the broken black and white lines against the red
tablecloth stimulates the richness of the colors and enhances the
unadorned guitar with its white swan-like forms. The black lines of the
score mark the pink pages which are open like butterfly wings.
With a limited repertoire of motifs, Braque demonstrated a talent
for constant renewal.

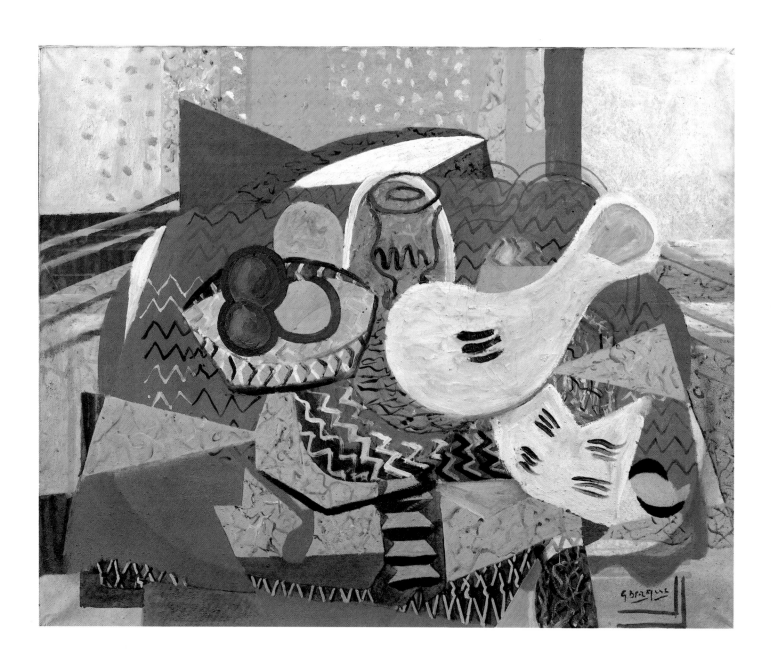

51
The Table (Le Guéridon). 1935

Oil on canvas, 70¼×28½″ (180×73 cm)
Signed l. r.
Mangin 1961, p. 8
Collection San Francisco Museum of Modern Art, Gift of W. W. Crocker

A new type of gueridon appears in this work: a metal table on thin metal
legs twisted together. It is covered with a red tablecloth that features
curved and serrated folds. The floor is plain, but geometric ornamentation
made up of white lines invades the wood paneling and the wall. Braque
said that he "realized that the ornamental part freed the color from form."
The color is vivid and light, and the substance of the objects both palpable
and airy. This impression is accentuated by the curious framed still life of
fruit that hangs on the wall and that is composed entirely of a network of
lines above the two black and yellow bands.

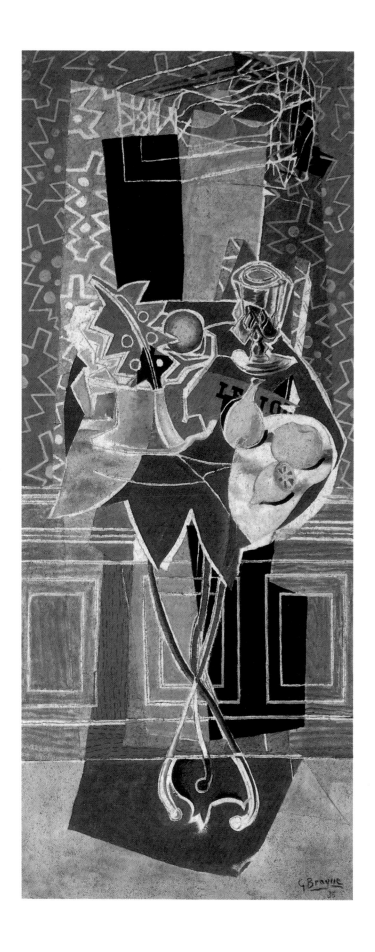

52

Still Life with Mandolin I (Nature morte à la guitare I). 1936

Oil on canvas, 38¼×51¼″ (97×130 cm)
Signed l.l.
Mangin 1961, p. 6
Collection Norton Gallery of Art, West Palm Beach, Florida

There exist two almost identical versions of this sumptuous still life.
The raised surface of the table with two legs seems to be too big for the
shallow space of the room in which it stands. There is the same type of
geometric ornamentation as in the preceding painting. Braque developed
the power of the colors, which include black, and contained the decorative
exuberance with the rhythmic harmony of the composition.

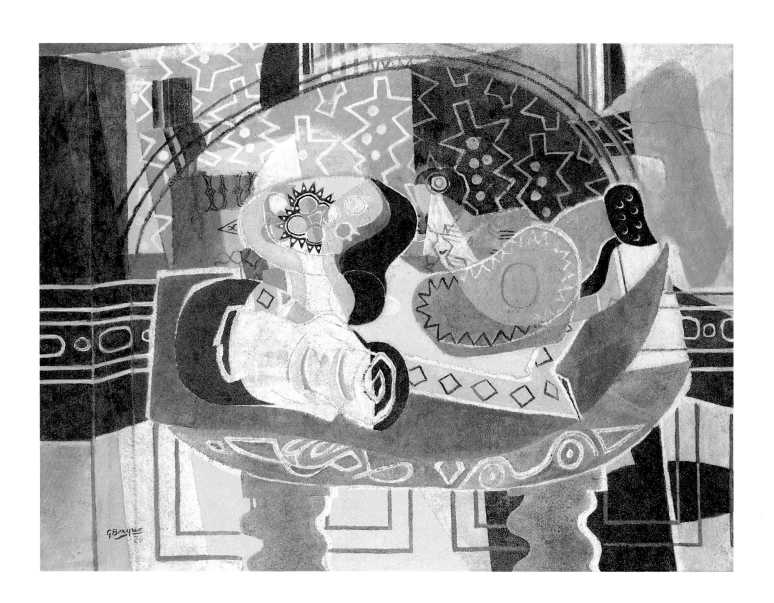

53
Bread, Oysters and Carafe (Pain, huîtres et carafe). 1937

Oil on canvas, 21¼×25⁹⁄₁₆″ (54×65 cm)
Signed and dated l. r.
Mangin 1961, p. 23
Collection Kunsthalle Hamburg

Oysters, delectably painted by Manet and Matisse, would seem to be
foreign to Braque's style, yet they appear from time to time in his works
after 1927. In 1937 he used them as motifs in three still lifes that are rela-
tively plain next to the more luxuriant ones of that same year. The dish of
oysters, the table, the long baguette that extends over its edge, and the
tall pitcher give a strong structure to the composition maintained in a
severe and refined color-scheme limited to green and ocher.

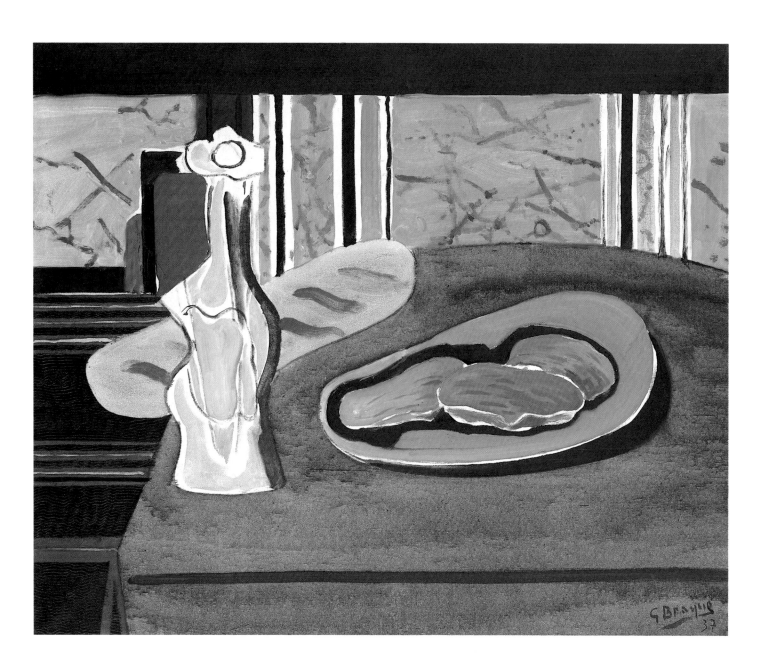

54
The Easel (Le Chevalet). 1938

Oil on canvas, 35¼×42⁵⁄₁₆″ (89.5×107.5 cm)
Signed and dated l. r.
Mangin 1961, p. 38
Courtesy Marlborough Fine Art (London) Ltd.

Between 1936 and 1939 Braque painted a dozen still lifes featuring a
palette and sometimes also an easel, the attributes of the painter. On the
table, near the palette shown with or without brushes, stands a strongly
tactile vase of flowers. The yellow and orange stand out in the middle of
the composition, between the dark and striped walls in the background.
The canvas on the easel, a painting within the painting, reveals the
mystery of creation and its metamorphoses.

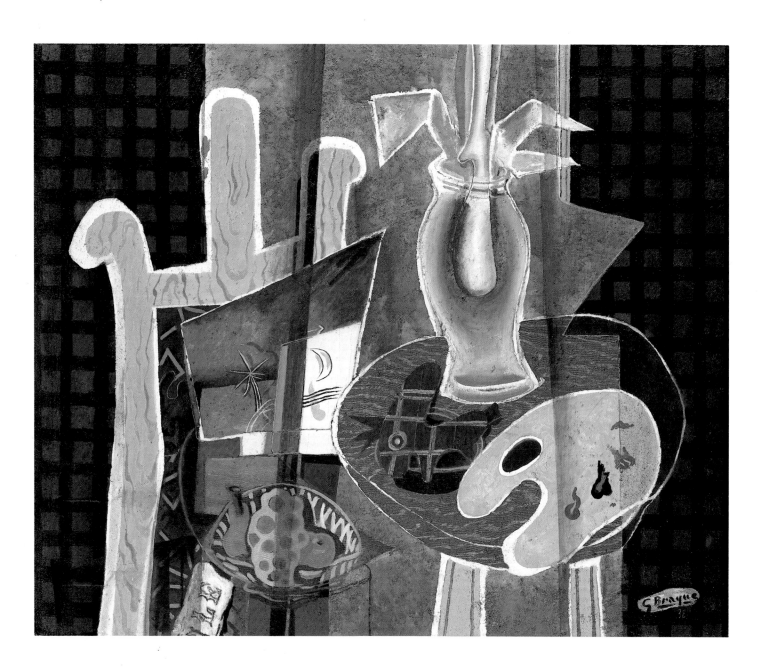

55

Studio with Black Vase (L'Atelier au vase noir). 1938

Oil and sand on canvas, 38¼×51″ (97.2×129.5 cm)
Signed l.l.
Mangin 1961, p. 40
Collection Mr. and Mrs. David Lloyd Kreeger, Washington, D.C.

The traditional theme of the studio, which took on a special importance in
Braque's work (see cat. nos. 56, 57, 61, 74, 75), was represented by many
contemporary artists, in particular Matisse and Picasso. This prelimi-
nary version with a rich decor and light colors, except for the black vase,
belongs to the genre of the painting within a painting. There are in fact
two paintings in this composition, one on an easel, the luminous wooden
texture of which the artist excelled in rendering, and another in a frame,
hanging on the wall at the top of the canvas. A palette without brushes,
but with dabs of paint, is on the table, next to a death's head, which
reappears in the following painting in a more somber atmosphere.

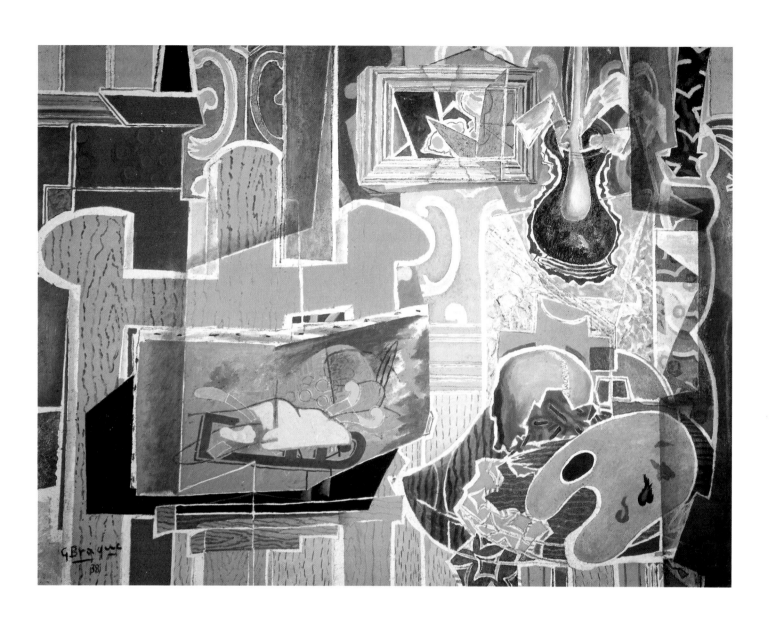

56

Studio with Skull (L'Atelier au crâne). 1938

Oil on canvas, 36³⁄₁₆×36³⁄₁₆″ (92×92 cm)
Signed and dated l. r.
Mangin 1961, p. 41
Private Collection

The interior space opens up to include the baseboard and wainscoting,
while the still life of painter's tools inaugurates the rich theme of the
studio without figures which we will see develop magnificently in
Braque's oeuvre. The easel holds a barely sketched-in pink canvas which
is extended by the overlapping panels in the background. The table
painted with imitation wood grain of the same color as the easel holds a
vase decorated with flowers, a palette and brushes, a palette knife and
tubes of colors, a guitar, a pipe and an ace of clubs. It also holds a skull,
which appears as well in two *vanitas* paintings of 1943 (see cat. no. 65).
The composition is inscribed in a square, a difficult and powerful format
which Braque tackled from time to time.

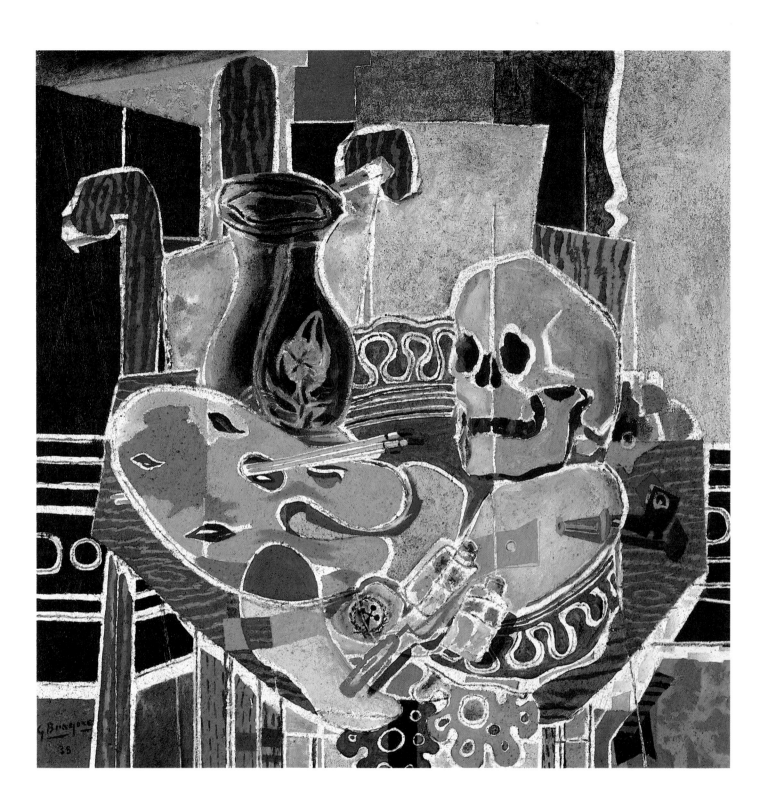

57
The Studio (L'Atelier). 1939

Oil on canvas, 44½×57½"(113×146 cm)
Signed and dated l.l.
Mangin 1961, p.59
Collection Lucille Ellis Simon, Los Angeles

This magnificent canvas marks the end of one series and the beginning of another. The room is shown frontally, with, for the first time, the rectangle of the window and a view of the sky. Braque abandoned the principle of a focus of attention in favor of a harmonious disposition of objects along the horizontal and the vertical axes. The composition is structured according to a succession of vertical planes of different textures, interrupted by fine oblique lines, such as those of the brushes. At top left the green plant in the black vase blends into the floral decoration of the wall. On the right is the painter's stool. Above is the easel, on which there is the schematic representation of a bird about to take flight, a prefiguration of the birds of the later period.

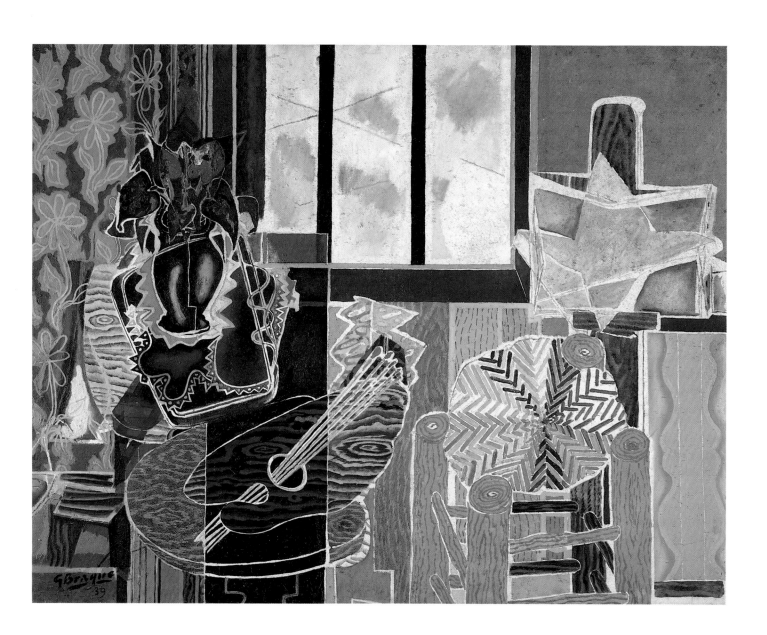

58

Two Mullets (Les Deux Rougets). 1940–41

Oil on paper, 18½ × 24⅜″ (47 × 62 cm)
Signed l. r.
Mangin 1961, p. 101
Private Collection, Paris

Fish, which appeared in two Cubist still lifes in 1909–11 (now in the col-
lections of The Tate Gallery, London, and the Philadelphia Museum of
Art), are frequent subjects between 1936 and 1942. They are usually red
mullets, at first painted naturalistically, with their scales, then more
stylized, and were later transformed into the famous *Brown Fish* (1941)
and *Black Fish* (1942), both in the Musée National d'Art Moderne,
Centre Georges Pompidou, Paris, one acquired in 1946 and the other given
by the painter in the following year. The present work, which Braque kept
in his studio, is painted on paper with the transparency and spontaneity
of a watercolor. The lemon lends a yellow note to the basic red and
green color-scheme. The letter M inscribed in blue on the black pitcher may
be an allusion to his wife Marcelle, the discreet and watchful guardian
of his home life.

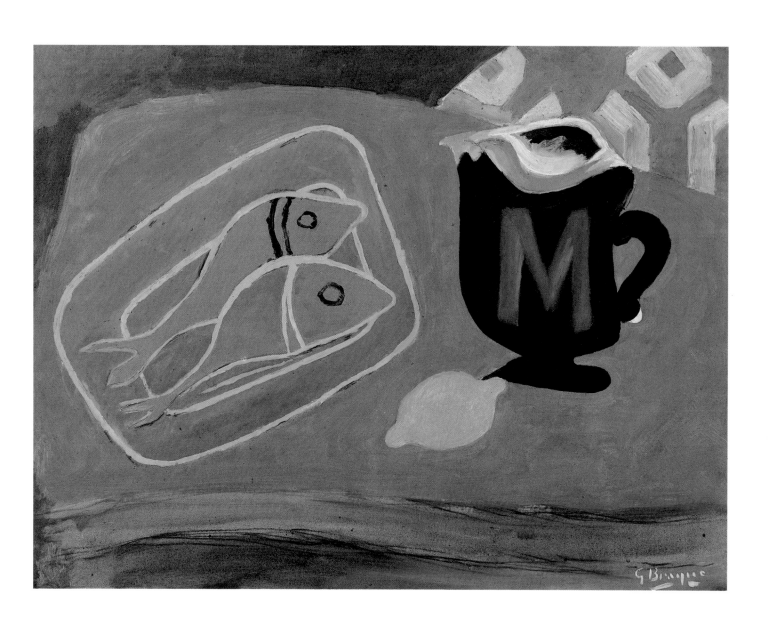

59

The Funnel (L'Entonnoir). 1941

Oil on canvas, 16¹⁵⁄₁₆ × 28⁵⁄₁₆″ (43 × 72 cm)
Signed l.l.
Mangin 1961, p. 92
Private Collection, Switzerland

The restrictions of the war and forced confinement indoors further ele-
vated the humble domestic reality to which Braque devoted himself. On
white or yellow tablecloths, in front of mural backgrounds that structure
the composition, next to a glass or a pitcher, he celebrated in their right
proportions the rare foodstuffs: a piece of bread, a slice of cheese or ham.
Several still lifes from 1941 and 1942 present as their main subjects
the basic kitchen utensils: funnel, knife, coffeepot, scales, saucepan,
coffee grinder.

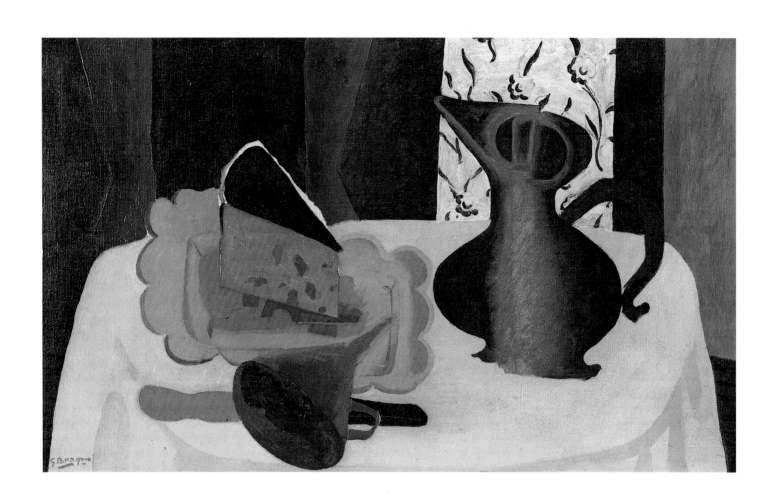

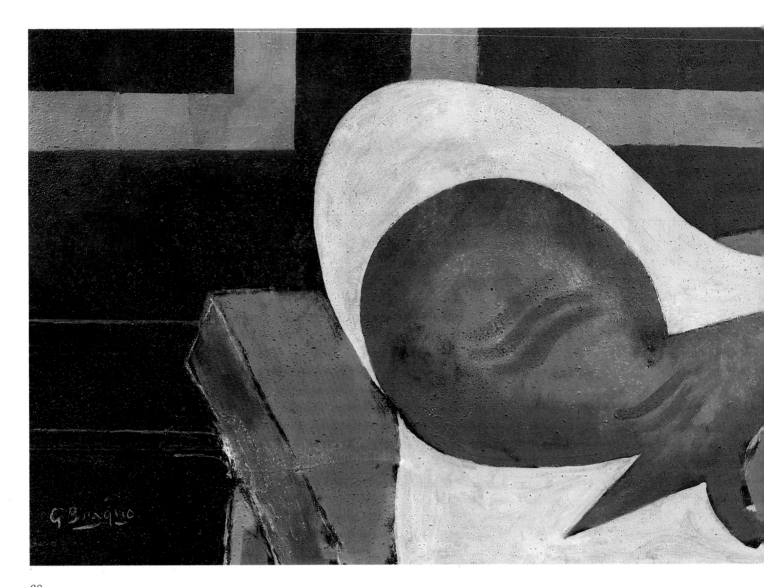

60

The Loaf of Bread (Le Pain). 1941

Oil and sand on canvas, 16⅛ × 47¼″ (41 × 120 cm)
Signed l. l.
Mangin 1961, p. 88
Pouillon and Monod-Fontaine 1982, no. 27
Collection Musée National d'Art Moderne, Centre Georges Pompidou, Paris,
Gift of Mrs. Georges Braque

The loaf of bread, which appeared as a motif in 1937, is present in several
still lifes from 1941 with the biblical dignity that it has in the paintings of
the Le Nain brothers and Chardin. The mural background with its
geometric bands gives a rhythmic structure to the horizontal composition,
the scansion of the obliques and curves created by the corners of the
table, the upturned edges of the tablecloth, the guitar-shaped piece of
bread, the cylindrical glass, the two round apples and the knife with a
triangular blade. The superb color harmony is made up of browns, whites
and yellows.

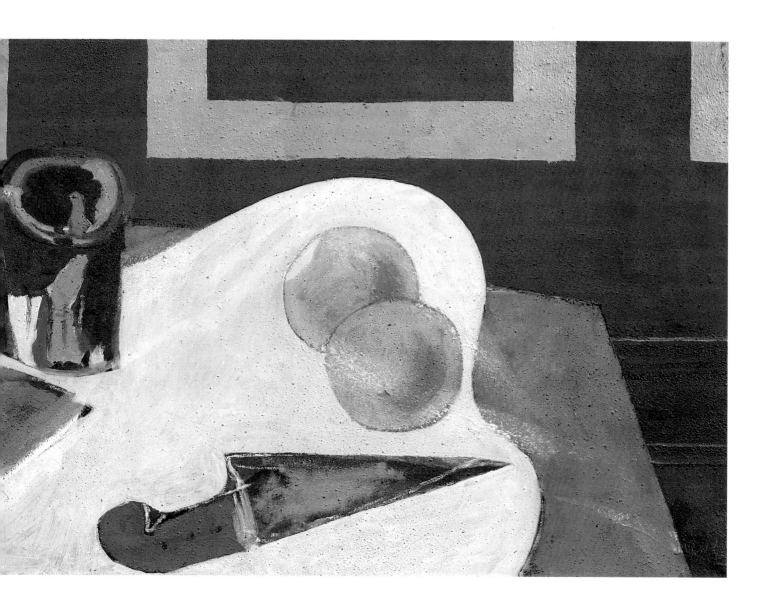

61

Interior with Palette (Grand Intérieur). 1942

Oil on canvas, 55⅝×77″ (141×195.6 cm)
Signed l.l.
Mangin 1960, p. 5
The Menil Collection, Houston

This interior is a floating harmony of browns, gray greens and rosy grays
on a solid black background relieved by white stripes. The green open-
backed chair casts a light shadow on the wall and one of its legs sets off a
table leg, whose rhythmic forms are echoed by those of the palette and of
the potted plant. The two transparent volutes superimposed on the com-
position, parallel to the picture plane, correspond to the two extremities
of the easel. In this way the spectator is led, like the painter, to look
through them at the tactile beauty of the objects and the rightness of the
spatial relationships.

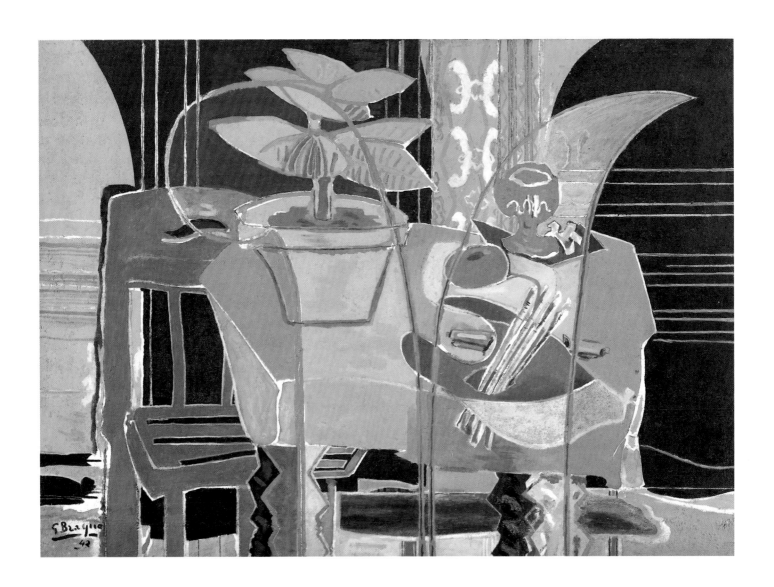

62
Young Woman with a Palette (Jeune Femme à la palette). 1942
Oil on canvas, 39⅜×31⅞″ (100×81 cm)
Private Collection, Paris

The theme of the young woman shown with the instruments of the painter
appeared in 1936, at the same time as the still life with a palette, and the
two were developed simultaneously. The figure is generally bipartite, one
side of the face in the light and the other a black profile, placed before an
easel. Here she is seated, palette in hand, before a table holding a bottle
and a glass. She stands out against a red background that is unusual for
this period of muted colors. Her face in profile with the odd hat recalls
Braque's earlier sculpted profiles, which he sometimes represented in his
paintings. Mrs. Braque kept this painting on a wall in her bedroom.

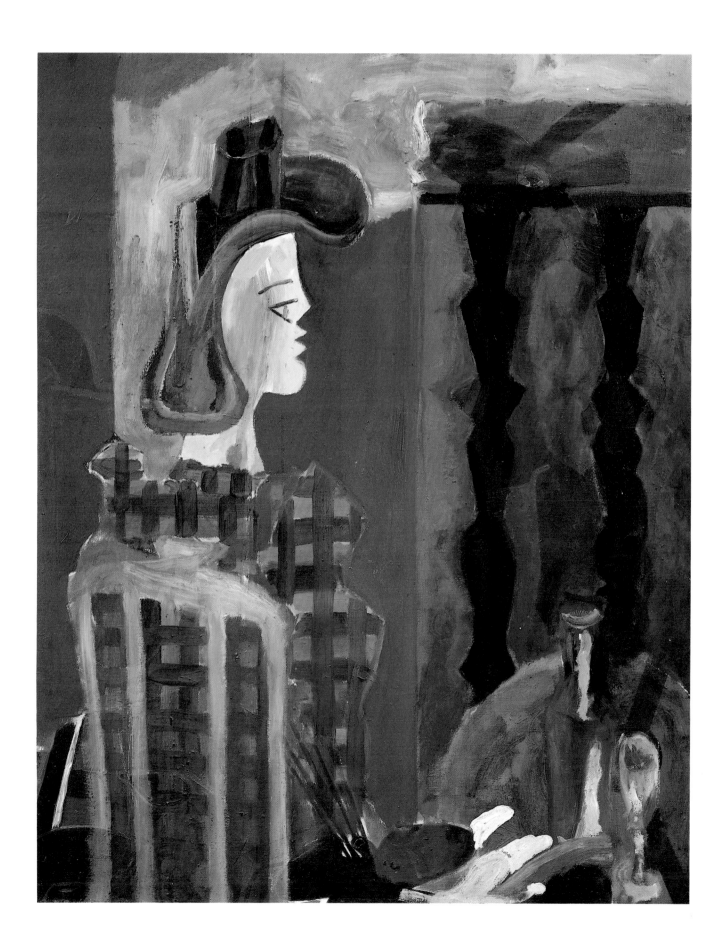

63

Man at an Easel (L'Homme au chevalet). 1942

Oil on paper mounted on canvas, 39⅝×31⅞″ (100×81 cm)
Collection Quentin Laurens, Paris

Almost all of the figures in Braque's interior scenes are females incarnating his tutelary activities, painting and music. However, in this and in the following work, both mysterious and little known, the protagonists are male. Here we see a man in a hat from the back, silhouetted against light surroundings. He is attentively observing the transposition of the real object into the represented motif. The cross-shaped easel divides the surface and the indistinct background into four rectangles that are echoed by the painting-within-the-painting, the empty frame and the window jambs. The paint was applied thickly with lively and spontaneous brushstrokes.

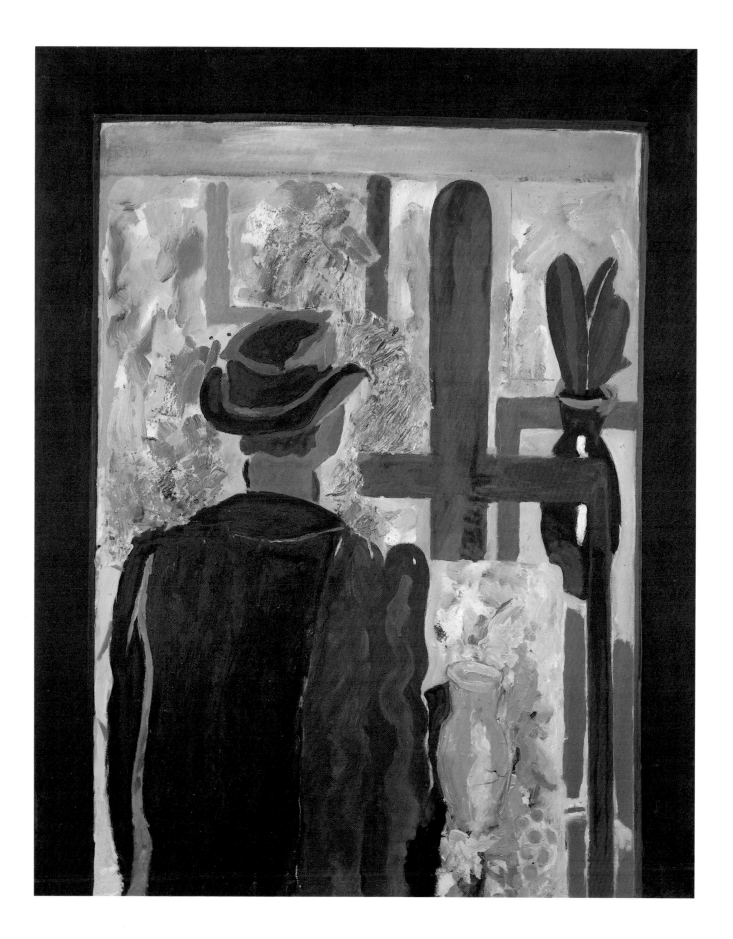

64

Man with a Guitar (L'Homme à la guitare). 1942–61

Oil on canvas, 51³⁄₁₆×38³⁄₁₆″ (130×97 cm)
Private Collection, Paris

This man with a guitar, begun in the same year as the figure of a man with an easel (cat. no. 63) but larger in format, was not finished until 1961. "I tend toward the unfinished," Braque used to say. The principle is the same – a dark figure against a light background – but the atmosphere is more complex and stranger still, with a cool color-scheme. The man, seated and bareheaded, is now on the right, and on the left side there is a woman, visible only by her hand and profile. The vase of flowers is replaced by a potted plant. The lamp is the same as in *Solitaire* of 1942, glowing yellow near the window.

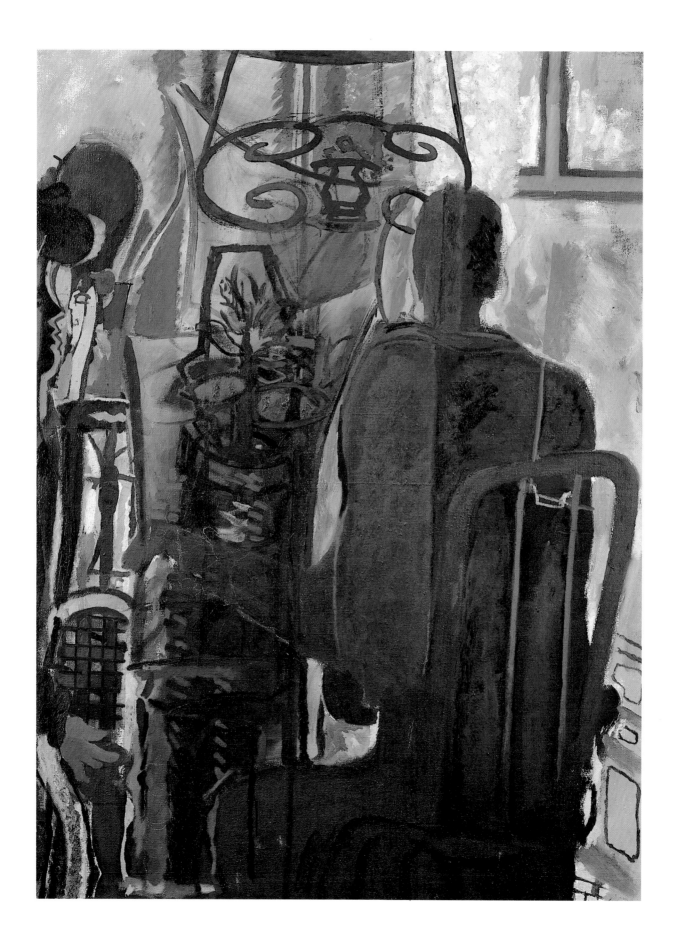

65
Pitcher and Skull (Pichet et crâne). 1943

Oil on canvas, 17×28¾″ (43×73 cm)
Signed and dated l. r.
Mangin 1960, p. 36
Collection Saarland Museum, Saarbrücken, West Germany

Like many painters, Braque had a skull in his studio. This motif, along
with a cross and a rosary, appeared in three traditional *vanitas* still lifes
in 1938 and 1939. The skull reappeared in 1943 – at the same time that
Picasso sculpted his famous skull – either alone or associated with a cross
and the familiar jug in a striking pictorial composition. The paint is thick
and the colors pallid. Braque disclaimed all symbolic interpretations of
his work, saying that it was subjected solely to pictorial and tactile con-
cerns; but he was nonetheless at the mercy of circumstance, which dic-
tated the choice of subjects and their significance. This still life is some-
times called *Hamlet*.

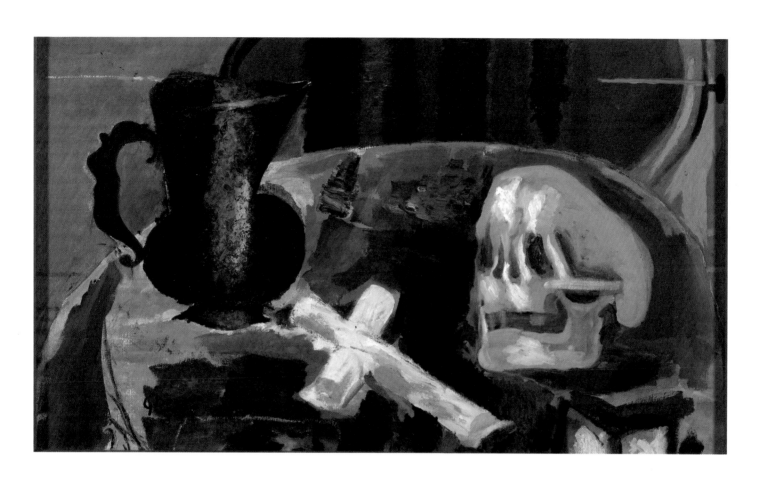

66

Still Life with a Ladder (Nature morte à l'échelle). 1943

Oil on canvas, 36³⁄₁₆×28³⁄₄″ (92×73 cm)
Private Collection, Paris

In 1943 Braque painted still lifes with an impasto technique on dense
grounds that were either light and striated or dark and absorbent. This
composition is quite unusual for its atmosphere and motifs. A barn ladder
placed lengthwise holds the ubiquitous large jug and a black bird pecking
upside-down. In the darkness behind the bars of the ladder glow the great
round eyes of a cow. "Mystery breaks up in the light of day; the mysterious
and the obscure are one," wrote Braque.

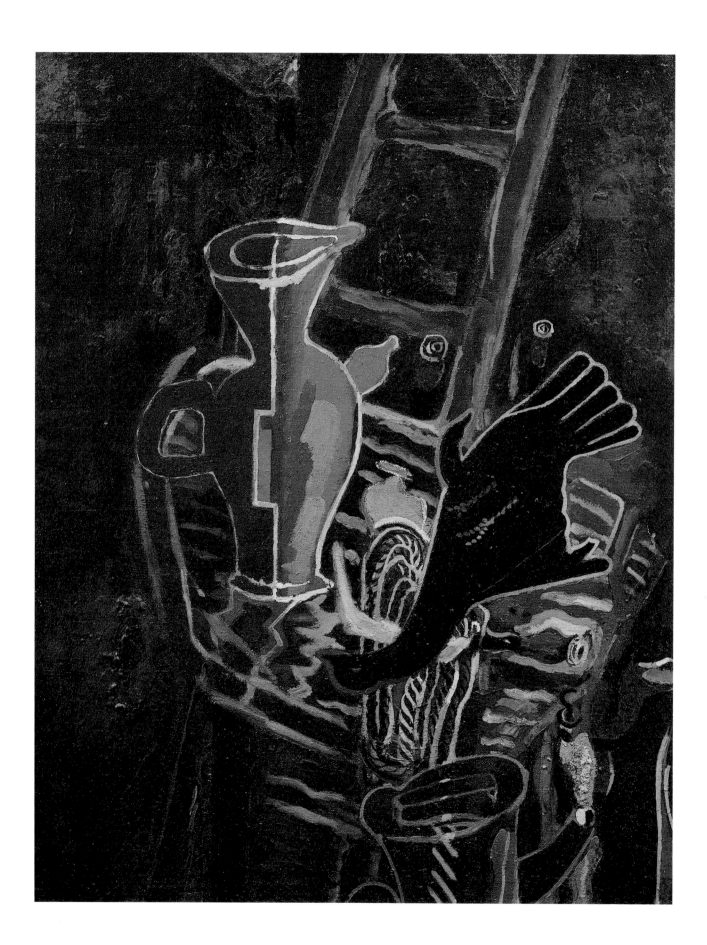

67
Kitchen Table with Grill (La Table de cuisine au gril). 1942–43

Oil on canvas, 51³⁄₁₆×28¹⁵⁄₁₆" (130×73.5 cm)
Signed l. r.
Mangin 1960, p. 71
Collection Gustav Zumsteg, Zürich

Braque stopped painting the *Gueridon* series and turned his attention to
ordinary wooden tables with everyday objects: bathroom tables turned
toward the window, kitchen tables in a closed space. A first version, from
1942, formerly owned by Jean Paulhan, without a grill and with the jug on
the left, is extremely concise. The second version, the present example,
displays the perfection of Chardin and of the finest interiors by Dutch
masters. It features two additions, the grill and – absent also from the
preliminary sketch – a broom half-hidden in the left-hand corner.
The vertical bands of the wall extend the upward movement of the table,
the grill and the broom. The legs of the table define the space be-
tween the baseboard and the floor. The apples and fish stand out
against a white ground.

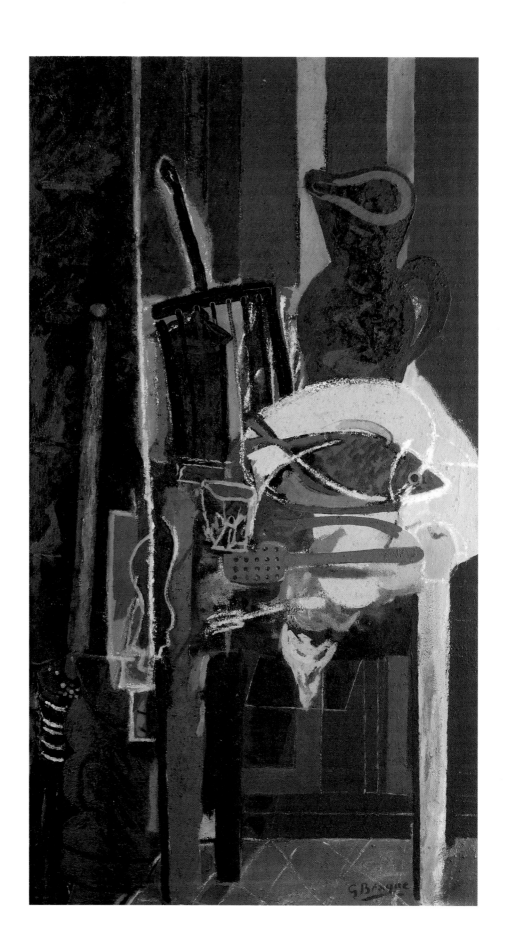

68
The Stove (Le Poêle). 1944

Oil on canvas, 57⅜×34¾″ (145.7×88.3 cm)
Signed l.l.
Mangin 1960, p. 6
Yale University Art Gallery, New Haven, Gift of Paul Rosenberg and Company in
Memory of Paul Rosenberg

In this picture Braque tried his hand at a theme that had been rep-
resented by Delacroix and Cézanne in particular: the stove in the studio.
During the war the food shortage was aggravated in the winter by the
shortage of heating fuel. The cylindrical stove with its precisely drawn
ornamental reliefs glows with heat and light in the room, while the tex-
tured volumes of the coal bucket and a waste paper basket are shown in
the foreground. The skull-shaped palette no longer has the brushes
depicted in the preparatory sketch. The vase of flowers has been replaced
by a potted plant on a brown table near the dark wall, on which hangs a
framed painting. Braque stressed the contrast between light and dark,
and between the living plant and the inanimate palette.

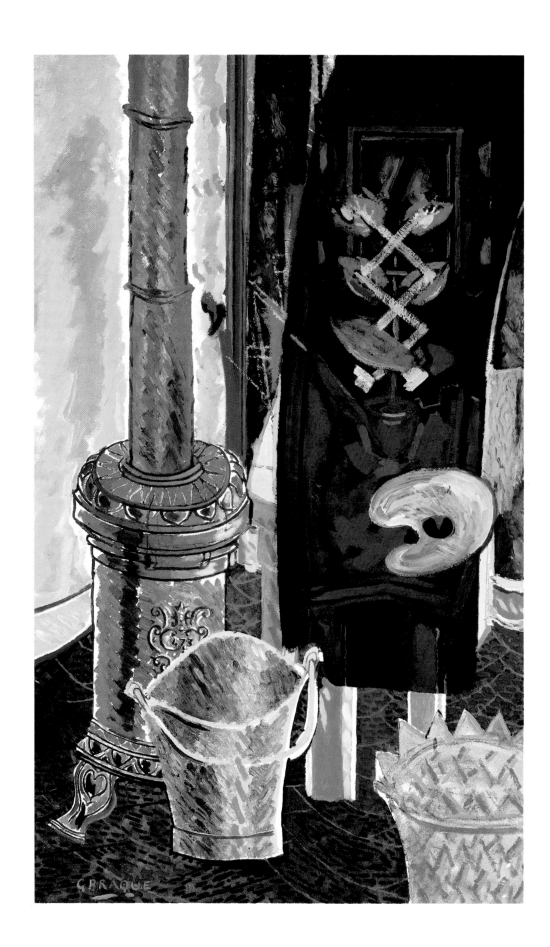

69

The Billiard Table (Le Billard). 1945

Oil on canvas, 35¼×45¹¹/₁₆″ (89.5×116 cm)
Private Collection, Paris

Between 1944 and 1949 – with one version finished in 1952 – Braque
painted seven daring compositions showing a billiard table seen from dif-
ferent angles and presented either obliquely, frontally or longitudinally.
In this medium-size version, the table, which is two-thirds folded and
tilted toward the spectator, is in about the same position as the first,
large-format version acquired by the Musée National d'Art Moderne,
Centre Georges Pompidou, Paris, which features balls in motion and
crossed cue sticks, and the transparent ends of an easel superimposed.
Between the geometric wainscoting and the billiard table, the objects are
set in linear patterns: stool with a vase of flowers, hanging light with two
lamps, mirror, scoring board at the window, armchair, hat on a hook. The
colors are predominantly cool, blues and greens, relieved by passages of
brown and ocher, the red accent of the ball.

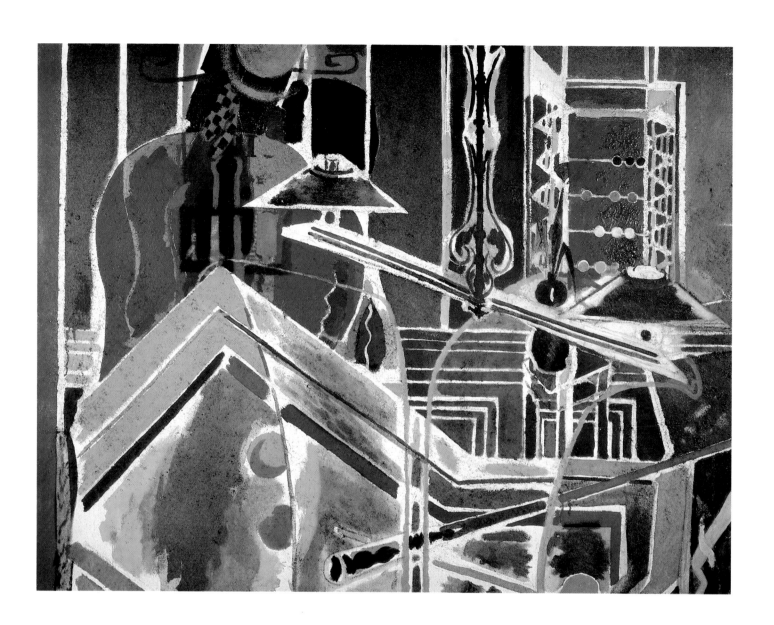

70

The Billiard Table (Le Billard). 1947–49

Oil on canvas, 57¹⁄₁₆ × 76¾″ (145 × 195 cm)
Signed l.l.
Mangin 1959, p. 12
Collection Museo de Arte Contemporáneo, Caracas

The present example is the largest and most adventurous version of this
theme. The billiard table is shown in its entirety, in a horizontal position,
pinched in the middle and with flared and raised ends. Three balls roll on
the green felt surface near the diagonally placed cue stick. The legs of the
table are visible and rest on a tile floor. Two long intersecting bands create
a dynamic tension in the composition and reinforce the extraordinarily
intricate pattern of lines. The lamp in the preparatory sketch has been
replaced by a hat rack with a hat. The background features curious
winged forms advancing toward the spectator, prefigurations of the bird
motifs to come.

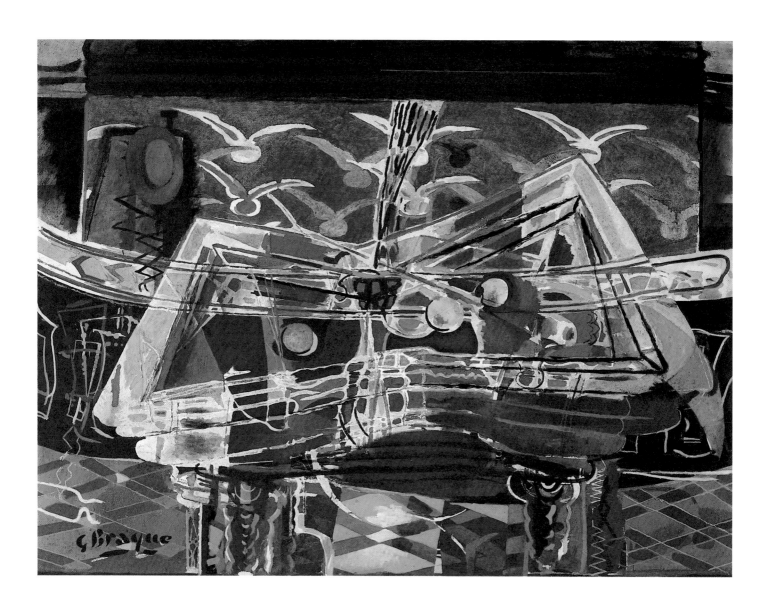

71
The Billiard Table (Le Billard). 1944–52

Oil on canvas, 71¼×38½″ (181×97.8 cm)
Signed l.l.
Mangin 1959, p. 37
The Jacques and Natasha Gelman Collection

Started in 1944, at the beginning of the series, this version was the last
one to be finished, in 1952, when Braque was also working on the *Studio*
paintings. The billiard table is shown both frontally and vertically, with
the far end raised and folded forward. The plastic qualities of the volume
and the movement of the balls have been rendered with supreme mastery.
The floor is composed of inlaid wood and not tiles as before. On the lumin-
ous wall in the back we can see a bracket light, a hat rack and a framed
painting.

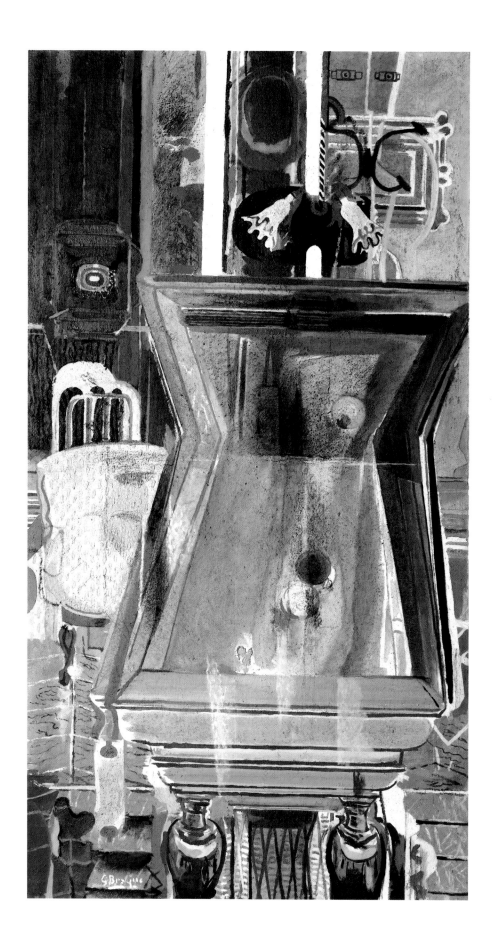

72

The Vase of Gaillardias (Le Vase de gaillardes). 1945

Oil on canvas, 26⅜×21⅝″ (67×55 cm)
Private Collection

After 1920 floral subjects periodically appeared in Braque's work, to the
delight of art collectors. He painted many at the end of the war, between
1944 and 1946, vases of flowers set on the corner of a table or a rustic piece
of furniture. In this little-known work, which the painter kept, the paint
was laid on in thick impasto. The yellow flowers that look like sunflowers
are in fact gaillardias, combined here with delicate white saxifrages,
which are so difficult to paint that they are called "the painter's despair"
and which Braque tackled a number of times.

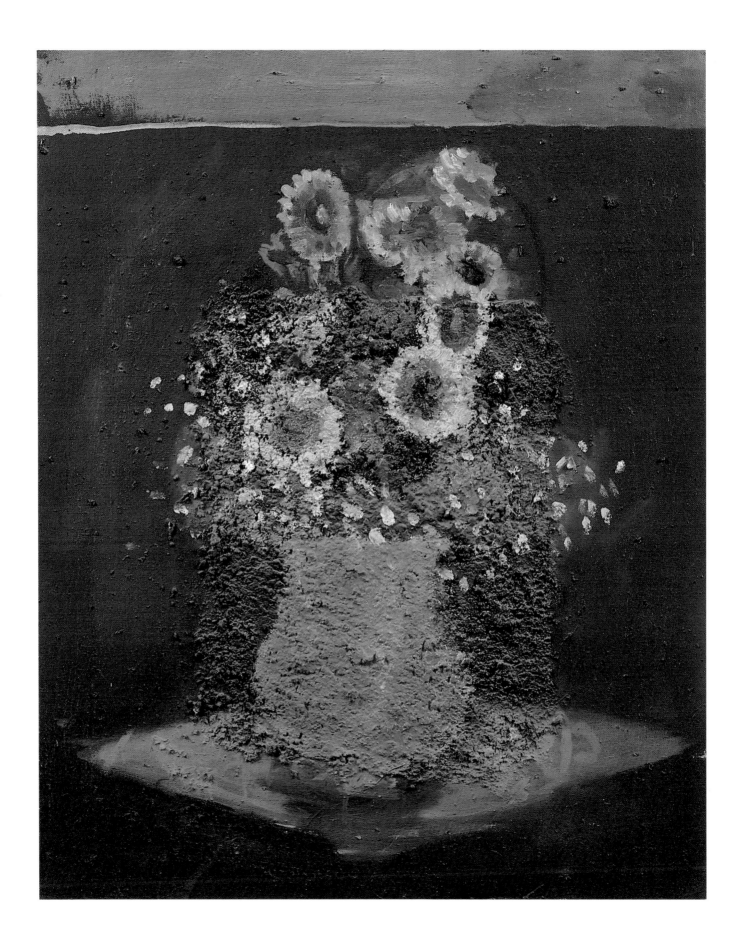

73

Still Life with Bottle, Vase and Lobster (Nature morte à la bouteille, vase et langouste). 1948

Oil on canvas, 71¼×55½″ (181×141 cm)
Collection Mr. and Mrs. Claude Laurens, Paris

Braque, who was fond of fish and other seafood, painted superb lobsters on several occasions. In this work the bright colors of the lobster animate a still life in which black and purple tones dominate against a gray background. The organic curve of the plant balances the tall and stark silhouettes of the vase and bottle. There is a later version in a darker tonality, without a plant, and with bird motifs in the background.

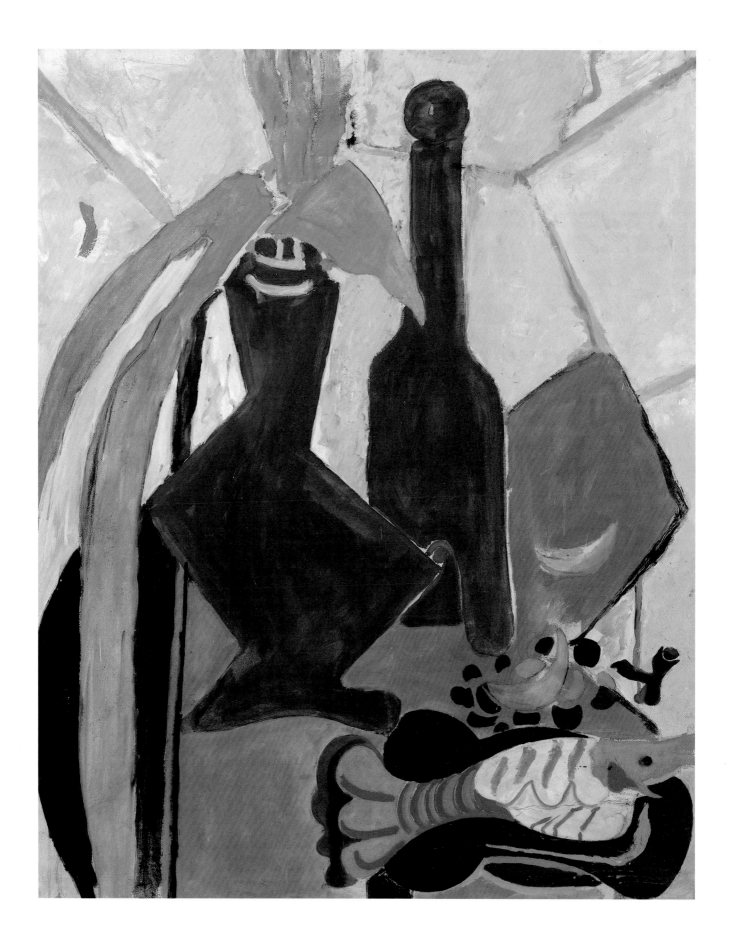

74
The Studio II (Atelier II). 1949

Oil on canvas, 51⅛×63¾″ (130×162 cm)
Signed l.l.
Mangin 1959, p. 8
Collection Kunstsammlung Nordrhein-Westfalen, Düsseldorf

The famous series of eight *Studio* works, which some have called sym-
phonic, was painted between 1949 and 1956, and is a celebration of paint-
ing in the place where it is realized. In a space that is fluid and permeable
to exchanges, real objects and invented forms interpenetrate metaphori-
cally. The versions numbered II to VI, dense and compact, are bathed in a
muted light; they are painted on a black background, in a scale of grays,
browns and tans relieved by occasional accents of bright color. The com-
position here is divided horizontally into two almost equal parts inter-
rupted by vertical stripes. The foreground is occupied by three tables, one
with a palette and a sculpted head, another with a jug and fruit dish, and
the third with an ornamental plate and a coffeepot. On the left, in the
back, we can see the easel, and on the right, a mysterious bird that pene-
trates into the interior space, modifying its laws and its nature. Its move-
ment is counterbalanced by a large arrow pointing in the opposite direc-
tion.

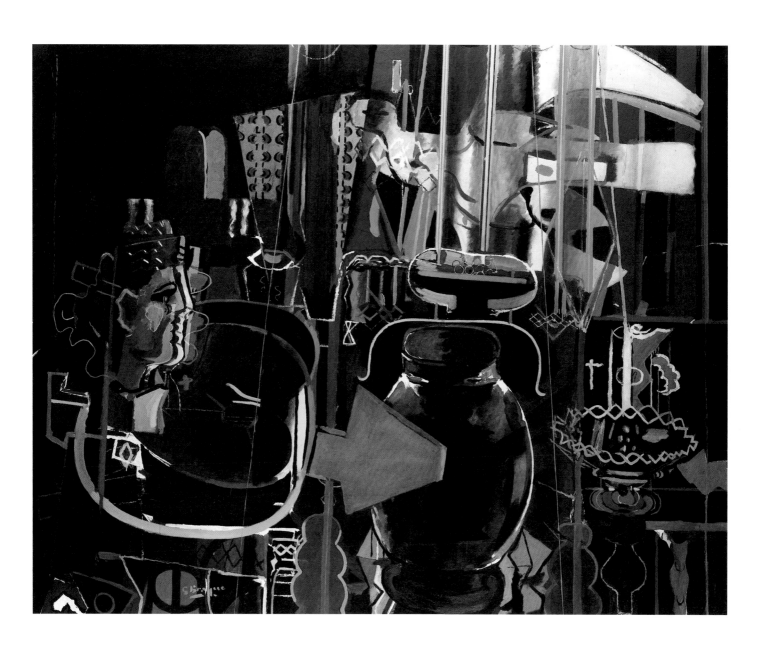

75

The Studio VIII (Atelier VIII). 1952–55

Oil on canvas, 51¹⁵⁄₁₆ × 77⁹⁄₁₆″ (132 × 197 cm)
Signed l.l.
Mangin 1959, p. 93
Private Collection

All of the *Studio* works have a deliberately subdued lighting except for
this one, which is bright and colorful. It is also the largest, the most daring
and, because of the number and variety of elements, the most complex.
Begun in 1952, it was reworked in 1955, after Braque had executed the
ceiling at the Louvre and designed the stained-glass windows for Var-
engeville, which noticeably influenced its treatment. The foreground is
taken up by tables filled with sparkling fruit – cherries, apples, grapes –
the light palette with long brushes, and the mauve bottle surrounded by a
pointillist aura of red and green. The center, above which flies a white
bird, is arranged into three red and yellow panels, and between them fall
the vertical folds of the blue and beige curtain. The intricacy of the planes
and the colored signs applies to all of the parts to structure the visionary
space and its intervals.

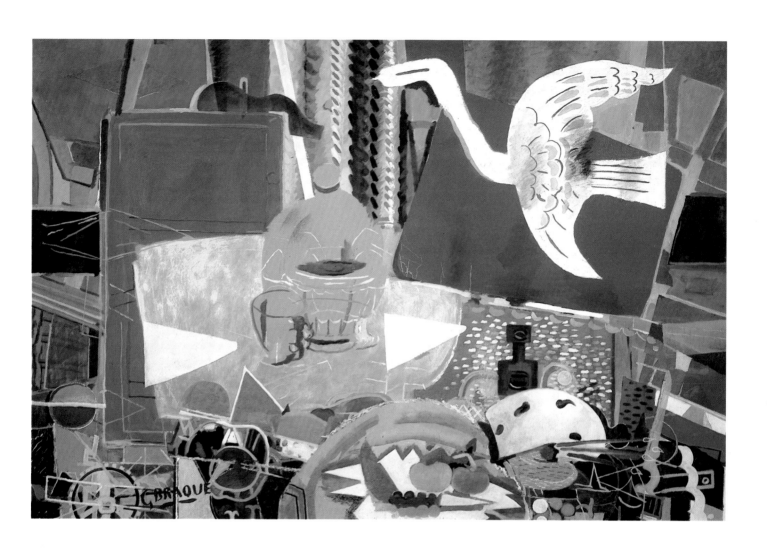

76

Two Windows (Les Deux Fenêtres). 1952

Oil on canvas, 38³⁄₁₆×51³⁄₁₆″ (97×130 cm)
Signed l. r.
Mangin 1959, p. 41
Courtesy Perls Galleries, New York

The window has played an important role in modern painting, especially
in the work of Matisse and Bonnard. Cubist space is a closed and dense
space. Gris opened his windows in 1915, Picasso in 1919, and Braque, long
concentrated on his domestic seclusion, only in 1939. In this canvas with
its fine grainy texture and its magic ocher and brown harmony, two win-
dows control the flow of light between the interior and exterior space.
Their rectangular jambs offset the curves of the table with its floating
tablecloth.

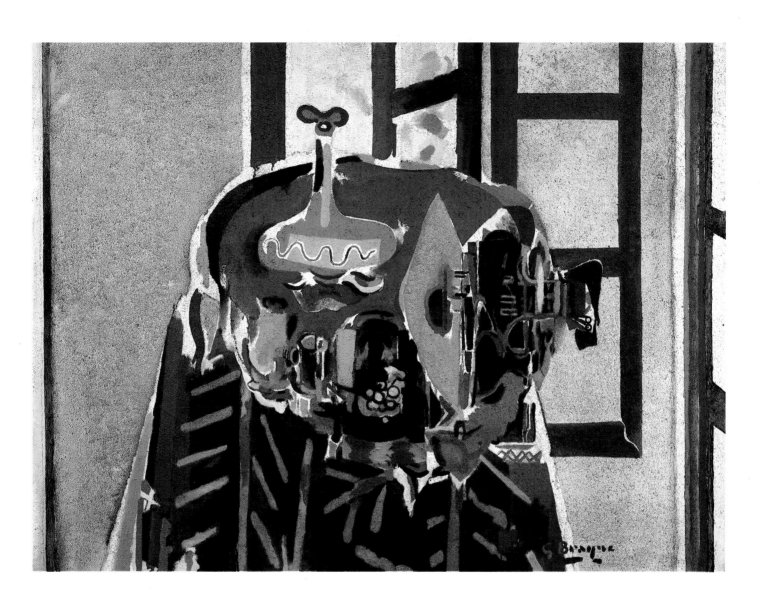

77
The Checkered Bird (L'Oiseau quadrillé). 1952-53

Oil on canvas, 52⅜×29¹⁵⁄₁₆″ (133×76 cm)
Private Collection, Paris

The great mysterious white bird that enters the *Studio* paintings, chang-
ing the nature of the space, pauses between the red grid among the flow-
ers and palms. It seems to want to rest before resuming its solemn flight
and reigning over the two projects that Braque was working on at the
time: a wall decoration for the villa of his dealer Aimé Maeght at Saint-
Paul-de-Vence, and the coffered ceiling of the room devoted to Etruscan
art at the Louvre, the Salle Henri II.

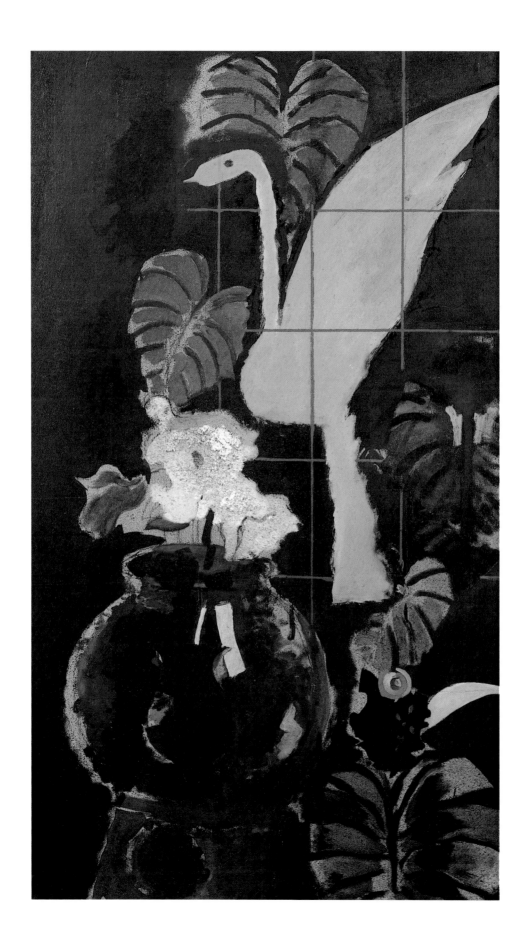

78
Oysters (Les Huîtres). 1954–57

Oil on canvas, 23⅝×28¾″ (60×73 cm)
Signed l.l.
Dedication *A Mariette Lachaud, G. Braque* on reverse
Mangin 1959, p. 122
Collection Mariette Lachaud, Paris

In his work Braque alternated between masterfully orchestrated compositions and, as he said, in order to "express direct emotion," simple still lifes of fruits, flowers or oysters. The oysters, rough, greenish and stonelike forms, are often shown closed, especially in 1937 (see cat. no. 53), for as Francis Ponge remarked about them, "it is a stubbornly closed world." In this luminous version, as succulent visually as its real-life counterparts, the oysters are open on a dish with a lemon. Green water shimmers between the mother-of-pearl shells, and the pitcher next to them has a purplish cast.

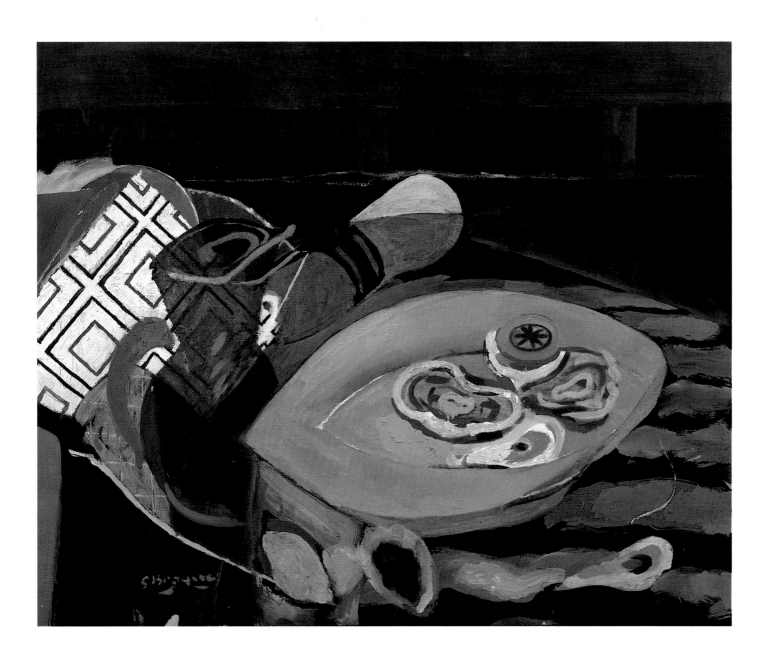

79
The Terrace (La Terrasse). 1949–61

Oil on canvas, 38³⁄₁₆×51³⁄₁₆ ″ (97×130 cm)
Collection Mr. and Mrs. Claude Laurens, Paris

This work was painted entirely at Varengeville over several consecutive
seasons. Photographs taken while it was in progress show its genesis and
the different stages through which it passed. Originally there was an
opening giving onto the outdoors, as in the version in the Hänggi Collec-
tion in Vaduz, Liechtenstein, finished in 1948. To avoid too much contrast
and dispersion, Braque decided to cover the background entirely with
panels of imitation wood grain in very warm and vibrant tones. The result
is a more intimate atmosphere. The radiance of the light and the sparkle
of the colors fall on the folding table with its pitcher standing proudly and
on the winding curves of the metal chairs.

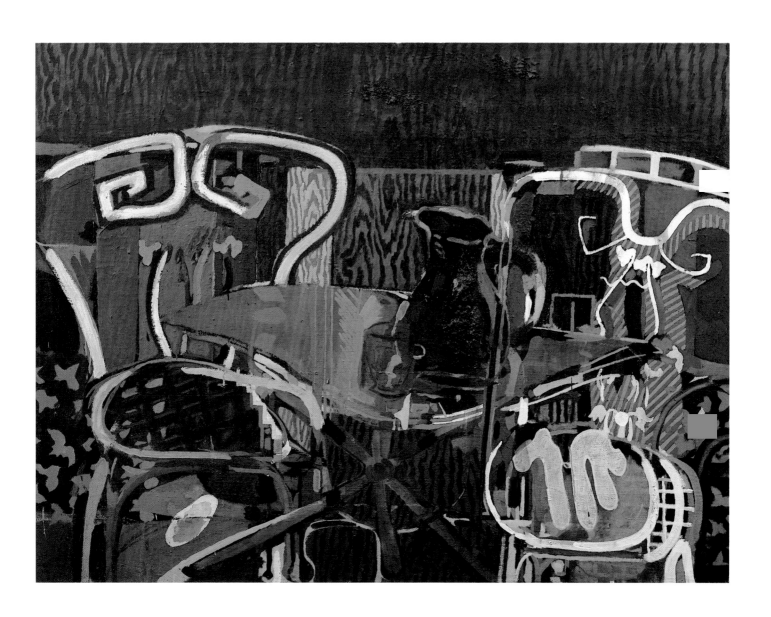

80
The Vase of Flowers (Le Vase de fleurs). 1956

Oil on canvas, 23⅝×17⁵⁄₁₆″ (60×44 cm)
Collection Mr. and Mrs. Claude Laurens, Paris

Braque liked green plants and the simple flowers of the fields, which he
arranged into bouquets according to the seasons. The marigolds, whose
yellow flowers glow against the black ground, are of the same species as
the gaillardias (see cat. no. 72). Flowers incarnate the natural beauty of
colors. A still life from the same period combines a bouquet of flowers and
a palette full of paints.

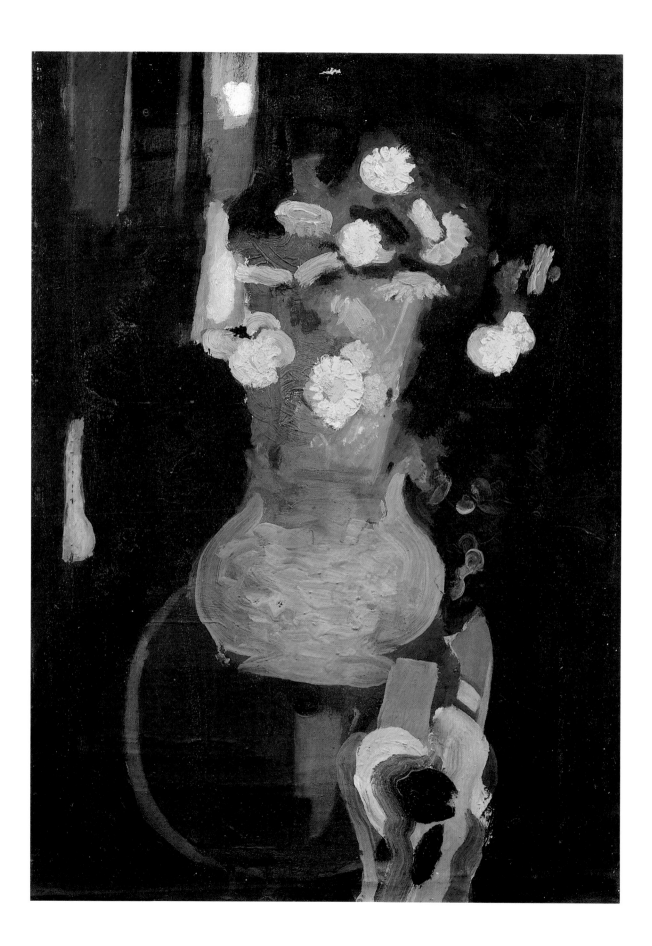

81

Bird in the Paulownia (L'Oiseau dans le paulovnia). 1956–62

Oil on canvas, 50¾×68⅛″ (129×173 cm)
Private Collection, Paris

The thickly painted bird, easily transformable, sinks into the paulownia
bush planted by Braque in his garden in Paris. It blends in with the broad
leaves and fragrant flowers, from which it borrows its colors. These leaves
and flowers, green, blue and mauve, are fashioned in thick impastos that
give them the sparkle of precious stones. There is another version dated
1957 in which several white birds converge toward the paulownia leaves
as if toward a nest.

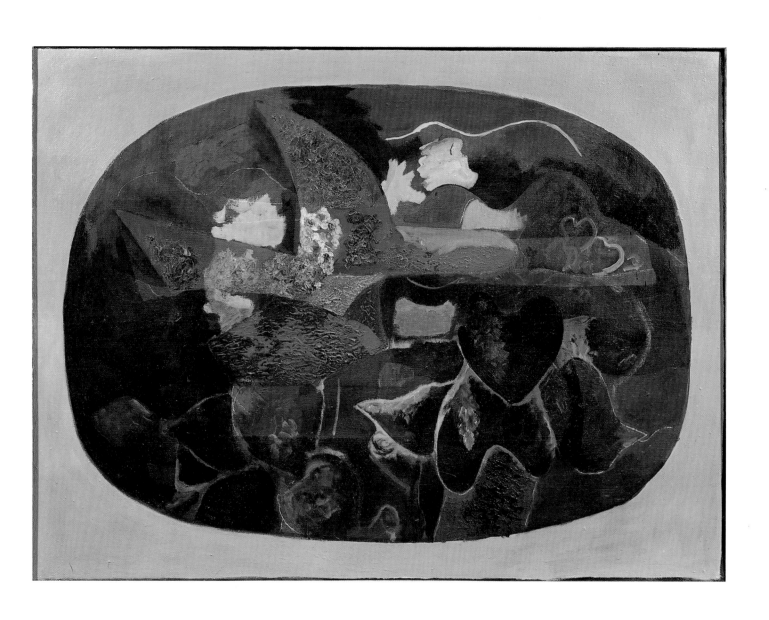

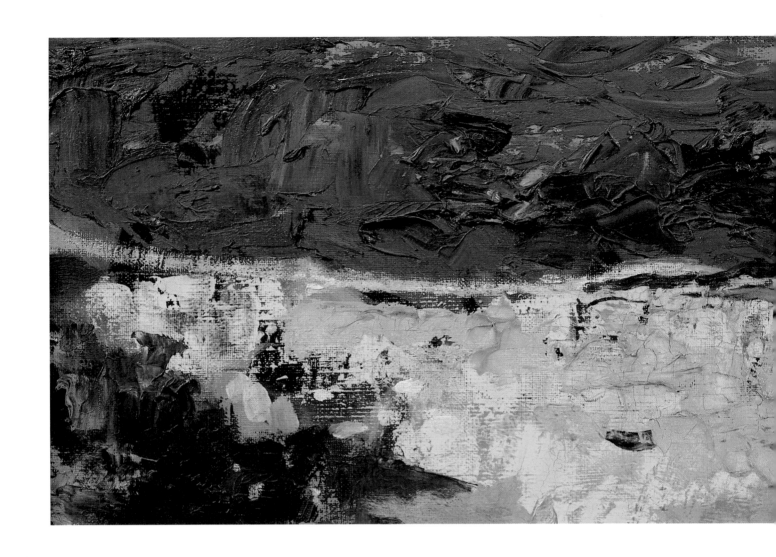

82

Landscape with Dark Sky (Paysage au ciel sombre). 1955

Oil on canvas, 8⅛ × 25⁹⁄₁₆″ (20.5 × 65 cm)
Private Collection, Paris

During his long stays in his Norman house at Varengeville, Braque
turned either to the sea or the surrounding fields. He painted his land-
scapes and seascapes with the raw density of the material, without a
graphic substructure. The dark sky and gold harvests are equally
balanced. In the foreground is a plow, both a tool and an emblem, and a
frequent motif in his last years. "I have plowed my furrow, and I have
advanced, slowly, in the same search," not by extension, but by deepening.

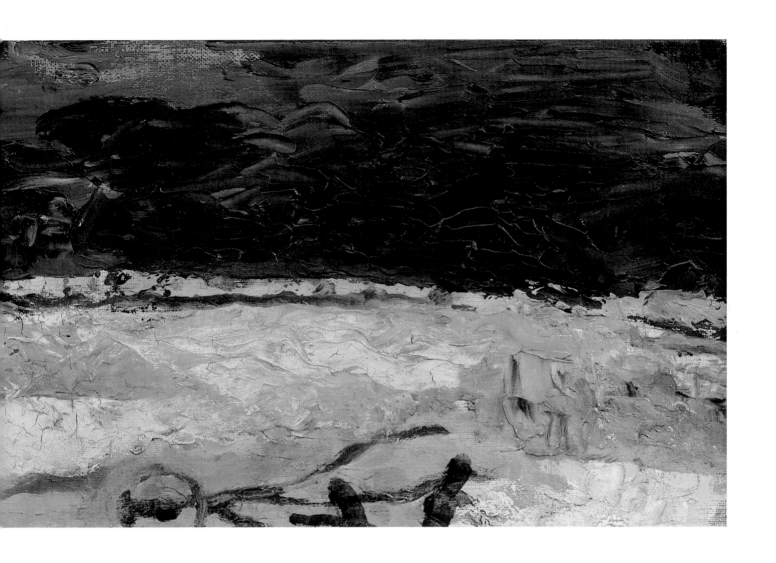

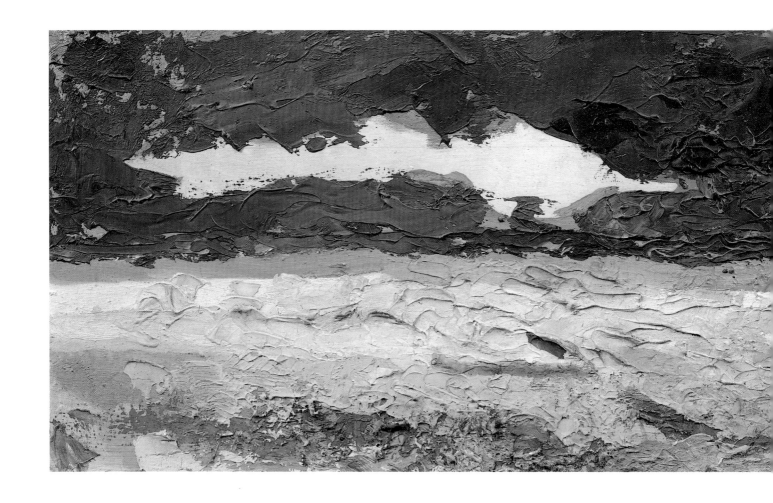

83

Landscape with Dark Sky (Paysage au ciel sombre). 1955

Oil on canvas, 7⅞ × 28⁹⁄₁₆″ (20 × 72.5 cm)
Private Collection, Paris

The elongated format that Braque used so well for his still lifes was even
better suited to unfold, at the twilight of his life, the infinite expanses of
sky and earth and their rhythm of light and dark. In the foreground
stands a plow or primitive plowshare, the vestige of a rural world that is
dying away. The stormy sky, the low flight of the birds and the powerful
brushwork recall van Gogh, but in a different climate. The feeling is not
one of anguish, but of a total communion with the elements, through the
tangible means of pure painting.

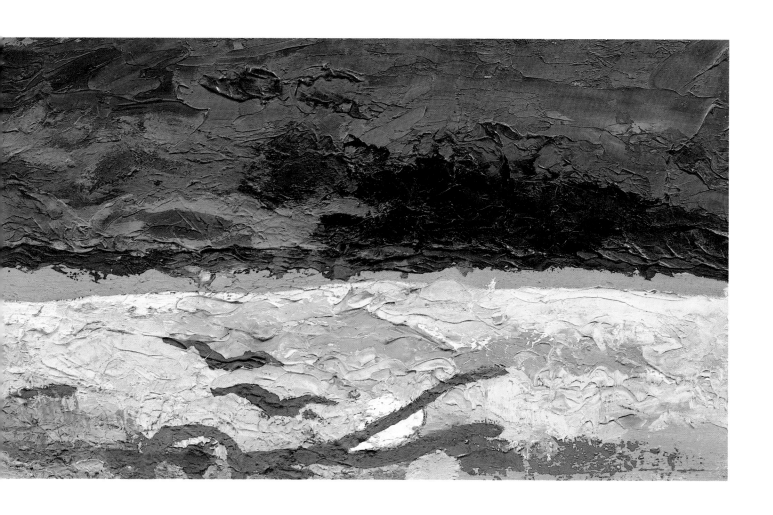

84

Seascape (Marine). 1956

Oil on canvas, 10¼×25⁹⁄₁₆″ (26×65 cm)
Collection Mr. and Mrs. Claude Laurens, Paris

In his landscapes Braque often represented plows, and in his seacapes,
boats pulled up on the shore, timeless reminders of man's activities and
presence in the face of the infinite elements. The French word "barque" is
also an anagram of Braque. The artist, at the peak of his mastery, attains
the freedom of pure painting by simply modulating the living material in
its most fitting nuances.

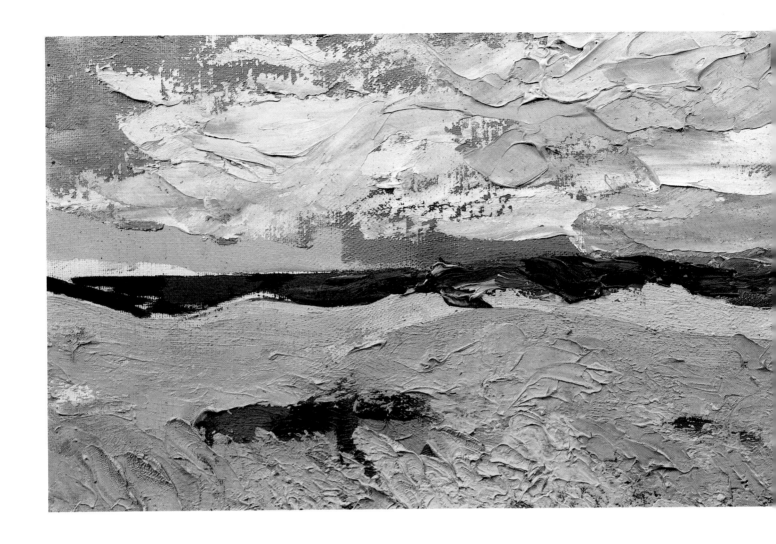

85

The Field of Colza (Le Champ de colza). 1956–57

Oil on canvas, 7⅞ × 25⁹⁄₁₆″ (20 × 65 cm)
Private Collection, Paris

The ever-changing skies of Normandy are often dark, but there are some-
times clearings and the sunshine bursts upon the yellow fields of colza.
When Braque died, Giacometti wrote this testimony: "In all this work,
what I look at with the most interest, curiosity and emotion are the small
landscapes, the still lifes and the modest bouquets of the last, the very last
years. I look at this imponderable, almost timid painting, this naked
painting, filled with an entirely different daring, a much greater daring
than that of former years; a painting which, for me, is at the very forefront
of today's art with all its conflicts."

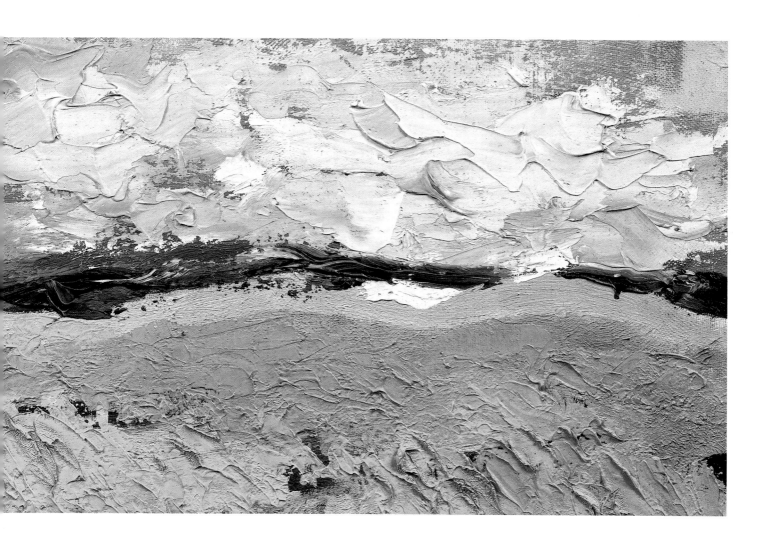

86
Seashore (Bord de mer). 1958

Oil on canvas, 12³/₁₆ × 25⁹/₁₆″ (31 × 65 cm)
Private Collection, Paris

"As a child, in Le Havre," Braque reminisced, "I would contemplate the vast sea for long hours. I was penetrated by infinity, and I dimly felt infinity penetrate all things." The earth, the sea, the sky and the frame itself are painted with the same organic material, the soil of the origins and of transmutations, the source and mainstay of spirituality. "Man was created from the loam of the earth. I try to draw my work out of the loam of the earth," the old painter acknowledged, faithful to a sublime *humility*.

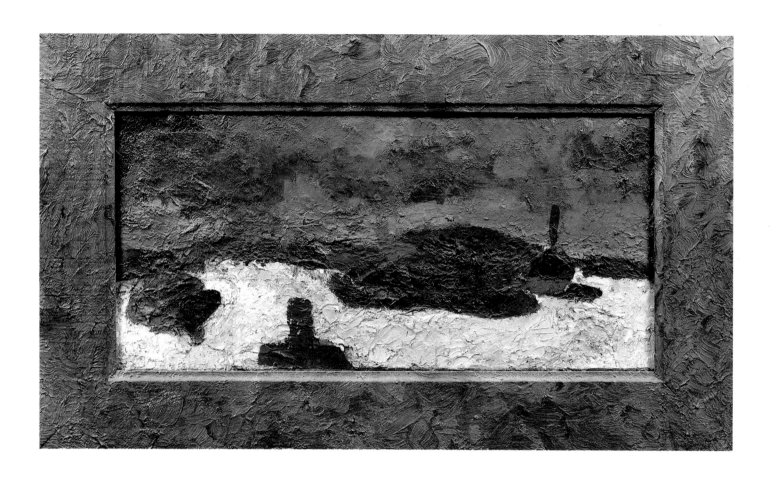

87
Black Bird and White Bird (L'Oiseau noir et l'oiseau blanc). 1960

Oil on canvas, 52¾×65¹⁵⁄₁₆″ (134×167.5 cm)
Private Collection, Paris

This large picture was a project for the cover of an illustrated book on the
then preponderant theme of birds. Exceptionally, Braque renounced a
dense treatment for very light and limpid colors. An airy blue gray fringe
separates the black bird from the white bird which simultaneously govern
the sky, one in its pink sphere, and the other in its yellow sphere.
The forms are drawn with the same bold simplification as Matisse's
gouache cutouts.

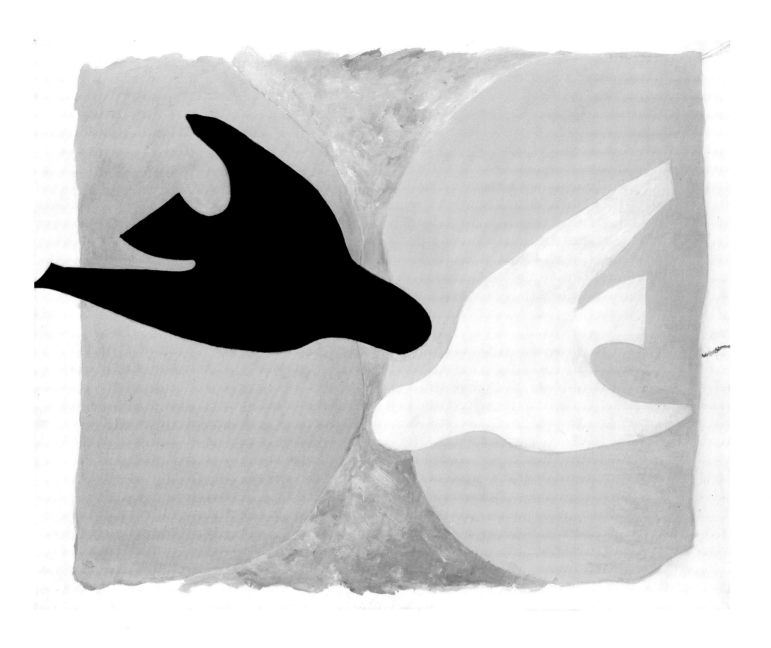

88
The Bicycle (La Bicyclette). 1961–62

Oil on canvas, 57¹⁵⁄₁₆×39″ (147.5×99 cm)
Courtesy Galerie Louise Leiris, Paris

Before becoming infatuated with the automobile, Braque often rode bicy-
cles in his youth, going from Paris to the sea. They haunted his painting
periodically after 1945, and he always represented them in the open coun-
tryside, leaning against a tree or set in front of his easel. In this last and
energetically brushed version, it seems to roll between heaven and earth,
in a halo of greenery and under a shower of white flowers.

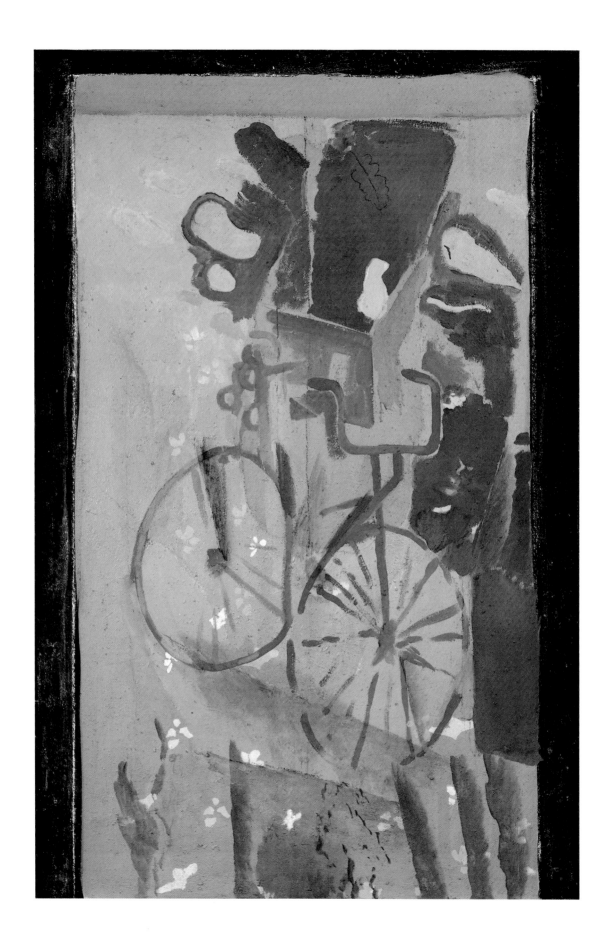

89

Birds (Les Oiseaux). 1954–62

Oil on paper mounted on canvas, 28¾×36¼″ (73×92 cm)
Collection Quentin Laurens, Paris

The birds in the *Studio* paintings were inventions, metaphors for his palette. Braque once explained the real origin of his last birds and their transformations: "A few weeks ago I was in Camargue. Above the marshes, I saw great flocks of birds. From this vision I retained aerial forms. The birds inspired me, I try to extract the best of this for my drawing and painting. However, I have to bury in my memory the natural function of birds ... to get as close as I can to my essential preoccupation: the construction of the pictorial fact." Here the slender black birds "knife through the sky," to use a poetic image that he liked to cite, and other birds with more supple forms regularize the pulse of the surrounding air.

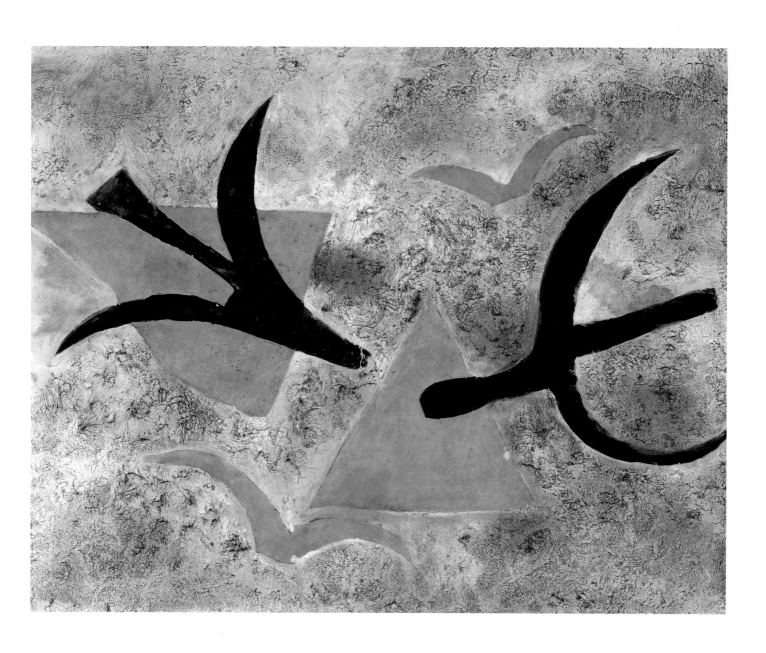

90

The Weeding Machine (La Sarcleuse). 1961–63

Oil on canvas, 40⅜×69½″ (102.5×176.5 cm)
Signed l.l.
Pouillon and Monod-Fontaine 1982, no. 39
Collection Musée National d'Art Moderne, Centre Georges Pompidou, Paris,
Gift of Mme. Georges Braque.

Braque departed, his harvest done, during the summer, on August 31,
1963. On his easel, with his signature among the sheaves of wheat, was
this last painting. The heat of the summer is full on the fields, with their
strong contrasts of light and shadow. A small white cloud in the stormy
sky, whose exact value he worked hard to render, is the source of light in
the composition. Birds fly above, while the ancient weeder with its metal-
lic silhouette and animal-like musculature stands out against the field of
wheat.

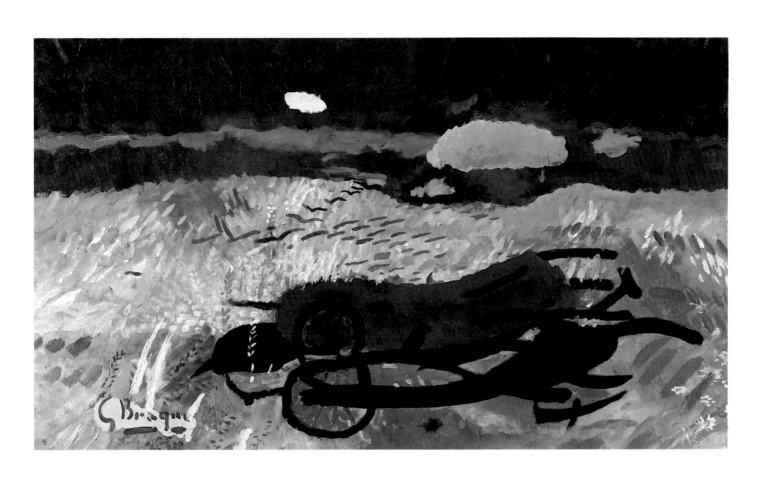

Drawings

Braque was not a draftsman of the same order as Matisse, Picasso or Léger, whose graphic work stood on the same footing as their painting, which it accompanied and prepared for, and was shown to the public. Like the old masters, and apart from a few rare exceptions – slowly elaborated works in pastel and red chalk which he considered paintings and from which he was able to part – he kept secret his important drawings and the precious *Cahiers* on which he worked regularly after the war. "My habit of keeping a sketchbook began in 1918. Before, I drew on scraps of paper that always got lost. Then I told myself I had to get a sketchbook. Since then, I have a sketchbook ever at hand and I draw all sorts of things, whatever comes to mind, and I noticed that this helps me a great deal. There are times when one feels like painting, and at other times one feels empty. There is great appetite for work, and so I use my sketchbook like a hungry person uses a cookbook. I open it and the slightest sketch can give me something to work on." These books of sketches and quick notations, occasionally accompanied by thoughts, like the diary of a writer, are what best reveal the secret of his method and the inner workings of his creativity. When a drawing seemed sufficiently complete, he would detach it and put it away along with other separate sheets. Works with oscillating yet very pure contours, in which every trace of the hand's mastery disappears to let the poetry of the figures and objects, and a radiant light, shine forth. A few examples from his different periods have been selected to show Braque's perfection as a draftsman, his scope and the variety of his genres and techniques.

91
Laundry Barges on the Seine (Les Bateaux-lavoirs sur la Seine). 1902

Sepia on paper, $5^{15}/_{16} \times 9^{3}/_{4}''$ (15×24.8 cm)
Monogram l. l.
Private Collection, Paris

In this typically Impressionist subject – riverbanks crossed by bridges
and plumes of smoke – Braque reveals his personal sensitivity, his
affinity for the color brown and broad horizontal expanses.

92
Composition. 1910

India ink on paper, 19¹¹⁄₁₆ × 12⅝″ (50 × 32 cm)
Private Collection, Paris

Braque's rare Cubist drawings and engravings demonstrate the rigorous
and shimmering structure on which the new style crystallized its forms.

93
Sorgues. 1912

Pencil on paper, 13⁹⁄₁₆×8⅛″ (34.4×21.6 cm)
Collection Mr. and Mrs. Claude Laurens, Paris

The inscriptions on the variously oriented and faceted planes of this magnificent and pure drawing indicate that it was done at Sorgues in 1912, during the votive feasts of this little town near Avignon. The figure of a musician emerges through a fine prismatic network of straight and curved lines.

94
Bottle of Rum (Bouteille de rhum). 1914

Pencil on paper, 9½×6¹¹⁄₁₆″ (23.5×17 cm)
Private Collection, Paris

The pointillist technique was popular in 1914, the year that was cut short
by the war. The bottle of rum is also the main subject of a painting and of
a collage (cat. no. 28) from that same year.

95
Still Life on a Table (Nature morte sur la table). 1917–18

India ink and pencil on green cardboard, 6⁵⁄₁₆×7⁷⁄₈″ (16×20 cm)
Private Collection, Paris

The bottle of rum reappears on a table with flowing instead of angular
lines, next to a guitar with feminine curves. The background is composed
of fine and broad horizontal stripes.

96

Still Life (Study for Cover of "Nord-Sud") (Nature morte [Etude pour la couverture de la revue "Nord-Sud"]). 1917–18

India ink and gouache on paper, 11⁷⁄₁₆ × 18⅛″ (29 × 46 cm)
Private Collection, Paris

The review *Nord-Sud,* which took its name from the metro line connecting Montmartre and Montparnasse, was founded in March 1917 by the poet Pierre Reverdy, a defender of Cubism and one of Braque's closest friends. In December 1917 it published Braque's *Pensées et réflexions sur la peinture,* two drawings from which were reproduced in plates in the March 1918 issue. This superb ink drawing is enlivened by two bands of blue and brown gouache.

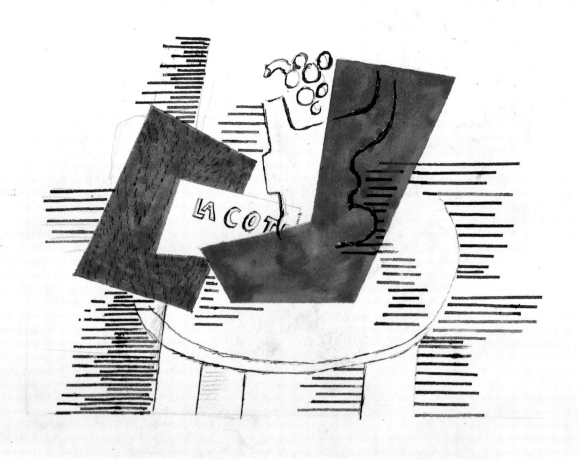

97

Still Life with Ace of Hearts (Nature morte à l'as de coeur). 1919

Red chalk on paper, 11×19¹¹⁄₁₆″ (28×50 cm)
Collection Mr. and Mrs. Claude Laurens, Paris

Red chalk is the ideal medium for rendering the luminous skin tones of
nudes and portraits. It was also used in the eighteenth century for land-
scapes, and Braque adopted it for still lifes with a subdued sensuality.

98

Still Life with a Bunch of Grapes (Nature morte à la grappe de raisin). 1919

Red chalk on paper, 17⅛×24″ (43.5 ×61 cm)
Collection Mr. and Mrs. Claude Laurens, Paris

Same medium, same date and same style as the preceding drawing, and
with a related subject. The red chalk is more heavily applied, with white
highlights, and the objects, more numerous, are nestled inside the man-
dorla shape inscribed within the rectangle.

99
Basket of Fruit (Corbeille de fruits). 1919

Red chalk on paper, 12³⁄₁₆ × 18½″ (31 × 47 cm)
Private Collection

The same technique, style and date as the two preceding works, with the addition of the word *"journal"* written in capital letters.

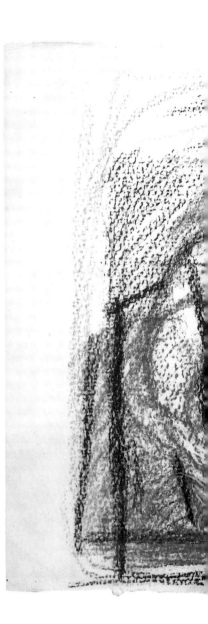

100

Still Life (Nature morte). 1921

Colored pencils on paper, 9¹³⁄₁₆ × 18⅛″ (25 × 46 cm)
Private Collection, Paris

Colored pencils, a modern invention, have about the same properties as
pastels, but are easier and quicker to use. Braque isolated the light-
colored glass and pitcher in the center and distributed his colors in the
planes on either side.

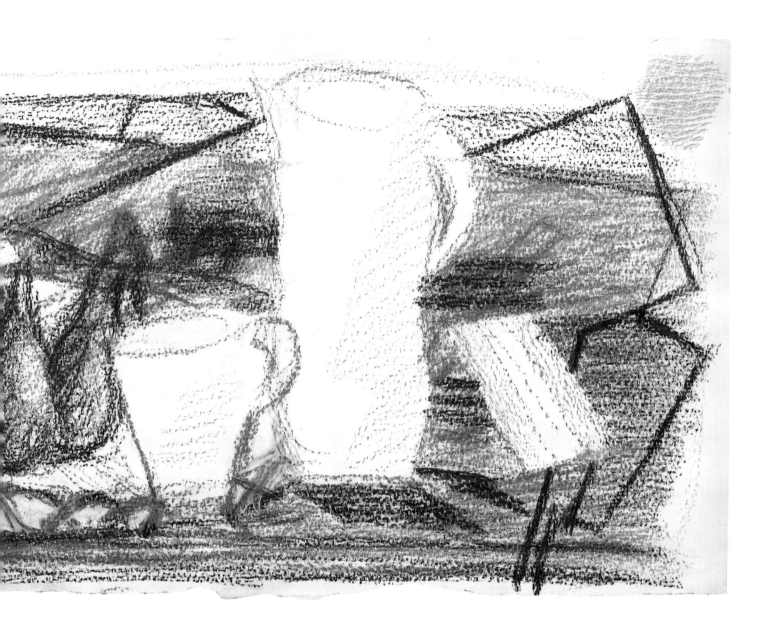

101
Study for a Canephora (Etude de Canéphore). 1922

Pencil on paper, $8\frac{5}{8} \times 6\frac{11}{16}''$ (22×17 cm)
Private Collection, Paris

This preparatory study for the *Canephora* (cat. no. 37) with arms raised
above and behind her head, bears notes for the colors and frame. As yet, it
is only a nude, without drapery or stylization, with well-defined contours
and a strong realism.

Gris

Blanc.

E d'ombre
clair

Jaune œuf
ou
Vert de mer
sur fond blanc.

maron

Zon
pierre plus
clair

Ton pierre

Ton pierre

Blanc

Terre d'Om,
Clair.

Ton pierre

102

Study for a Canephora (Etude de Canéphore). 1922

Pencil on paper, 8⅝×6¹¹⁄₁₆″ (22×17 cm)
Private Collection, Paris

This preparatory study for the *Canephora* (cat. no. 38) with arms raised in front of her head also has notes for the colors and frame. The antique-style drapery clothes and enhances the more broadly proportioned nude. The simpler line is undulating and sensitive.

103
Head of a Woman (Tête de femme). 1922

Red chalk and pastel on paper, 18⅛×14⁹⁄₁₆″ (46×37 cm)
Collection Mr. and Mrs. Claude Laurens, Paris

Braque combined pastel with red chalk to bring it closer to the sepia tone
that he liked for its nobility and sublime discretion. The period following
the war saw a renewed interest in antique and classical sources.

104
Head of a Woman (Tête de femme). 1923

Charcoal on paper, 14⁹⁄₁₆ × 10¼″ (37 × 26 cm)
Private Collection, Paris

During his neoclassical phase, Braque drew some faces of young girls with
a grave and true charm, an unusual subject in his work. "If you try to copy
them," wrote Rebecca West, "you realize the effort of complex attention
that was necessary to render such a perfect simplicity."

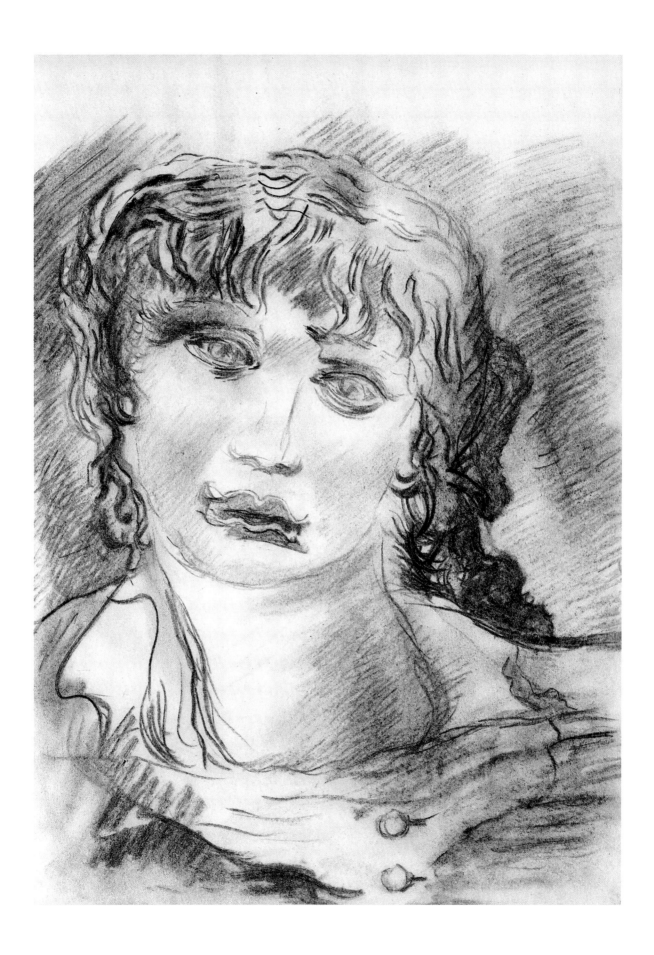

105
Standing Woman with Basket (Femme debout à la corbeille). 1923

Red chalk on paper, 14⅝ × 10¼″ (37 × 26 cm)
Collection Mr. and Mrs. Claude Laurens, Paris

This figure belongs to the hieratic series of *Canephora* paintings (see. cat.
nos. 37, 38). The young woman walks with bare feet and bared breasts, the
rest of her body covered with drapery. She raises her right arm to her hair
while the other arm holds a bowl of fruit against her side.

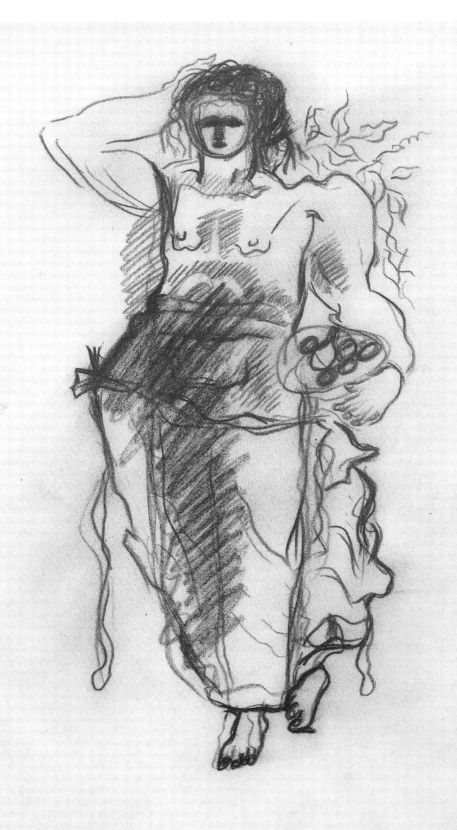

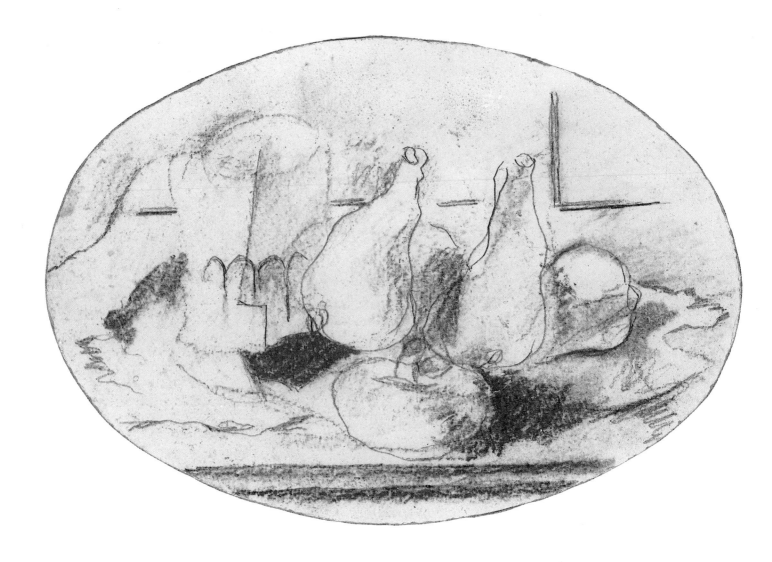

106
Oval Still Life (Nature morte ovale). 1924

Pencil and gouache on paper, 15⁹⁄₁₆ × 9¹⁄₁₆″ (39.5 × 23 cm)
Collection Mr. and Mrs. Claude Laurens, Paris

The oval in a rectangle gave Braque the opportunity to realize his most
harmonious variations.

107
Seated Nude (Nu assis). 1925

Pencil on paper, 37¹³⁄₁₆ × 28⁵⁄₁₆″ (96 × 72 cm)
Signed and dated l. l.
Collection Mr. and Mrs. Eric Estorick

Among the few drawings that Braque signed and showed in public during
his lifetime were several imposing nudes done in pencil or pastel, related
to the *Canephora* works.

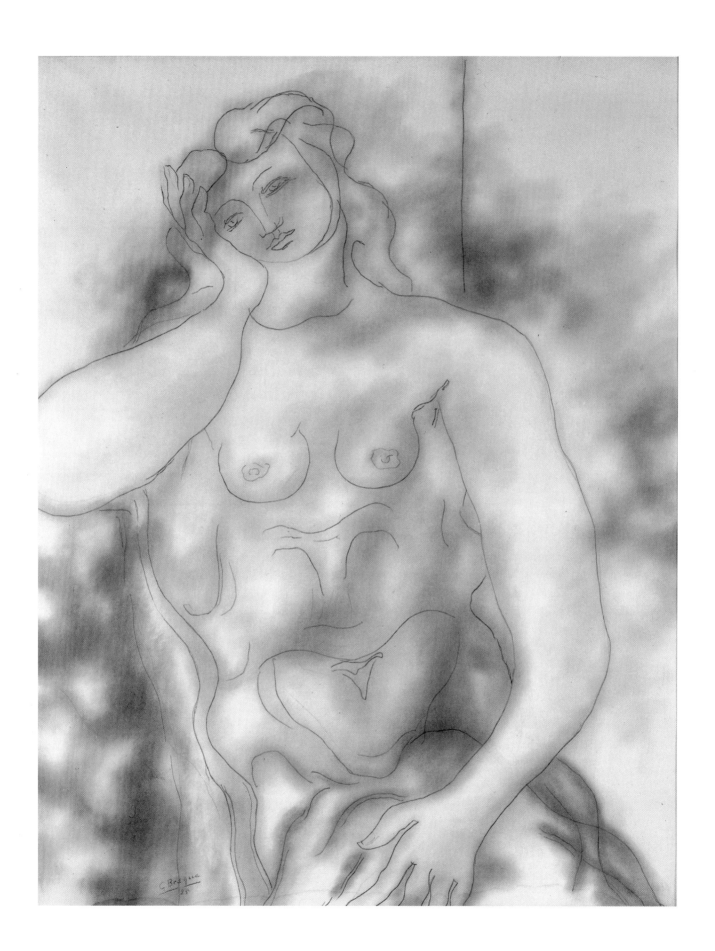

108
Still Life (Nature morte). 1926

Pencil on paper, 13⁹⁄₁₆ × 23⁷⁄₁₆″ (34.5 × 59.5 cm)
Private Collection, Paris

A fruit dish, ornamental glass and fruit shown in the delicate purity of
their linear structure.

109
Fruit Dish and Guitar (Compotier et guitare). 1930

Pastel on paper, 28¾×36¼″ (73×92 cm)
Collection Mr. and Mrs. Claude Laurens, Paris

A curvilinear composition characteristic of this period, in light tones of
brown, green and pink pastel.

110

Mythological Scene (Scène mythologique). 1931

Pastel on paper, 18⅞×19⅛″ (48×48.5 cm)
Private Collection, Paris

This drawing of almost square format is contemporary with the illustrations for Hesiod and the incised plaster panels with mythological subjects.

111
Still Life with Apples and Glasses (Nature morte aux pommes et verres). 1932

Pastel on paper, 8¼×8⅝″ (21×22 cm)
Private Collection

The dry and matte texture of pastels lends itself well to the linear stylization and simplification of forms.

112
Still Life (Nature morte). 1940

Pastel on paper and cardboard, 10⅝×14⁹⁄₁₆″ (27×37 cm)
Signed l. c.
Private Collection, Paris

During the war Braque concentrated with great force and simplicity on
the tutelary virtues of objects. The drawing is surrounded by a second
frame of brown cardboard which bears the signature in a cartouche.

G.BRAQUE

114
Double Profile (Double Profil). 1947

India ink, gouache and colored ink on paper, 12⅝ × 10⅝″ (32 × 27 cm)
Private Collection, Paris

Mixed media blending uniform and colored grounds with linear patterns
to create a double profile.

115
Bouquet and Sign (Bouquet et signe). 1949

Pencil and India ink on paper, 12⅝ × 9¹³⁄₁₆″ (32 × 25 cm)
Courtesy Galerie Louise Leiris, Paris

Braque rejected abstraction, which he considered decorative, but imbued
with a sense of Oriental culture, he sometimes hazarded a few graphic
signs as seals or emblems.

113
Arums (Les Arums). 1940–41

Pencil on paper, 14⁹⁄₁₆ × 9¹⁄₁₆″ (37 × 23 cm)
Private Collection, Paris

Braque often painted and drew white cornet-shaped arum flowers.

116
Two Apples (Deux Pommes). 1953

Charcoal on cardboard, 9⁷⁄₁₆×13″ (24×33 cm)
Monogram l. r.
Courtesy Galerie Louise Leiris, Paris

In Cézanne's work the apple has a pictorial and symbolic function that
has been learnedly discussed. Several paintings by Braque, like this
drawing, depict two apples, with their absolute fullness and round forms
like orbs or breasts.

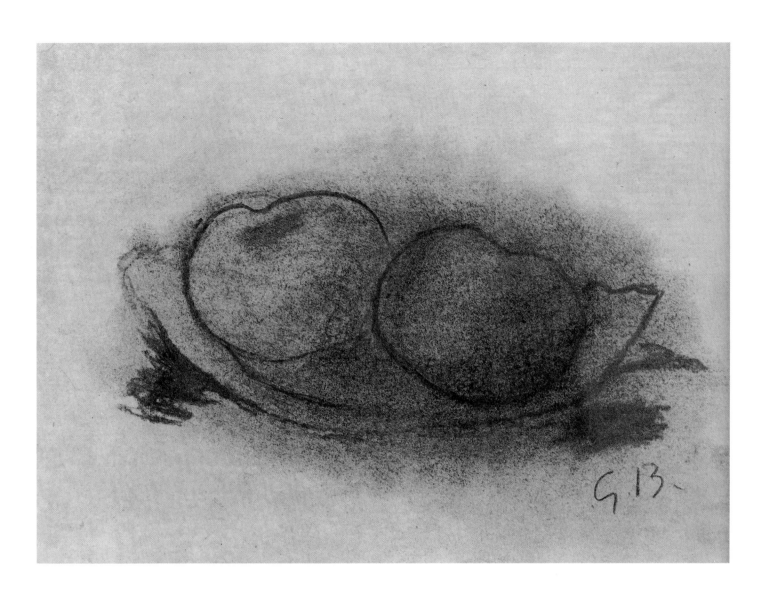

117
Head of a Man (Une Tête d'homme). 1956–57

India ink and pencil on paper, 12⅝×9⅞″ (32×25 cm)
Private Collection

The profile of a bearded man with a straight nose was drawn in India ink and the hat and costume in pencil.

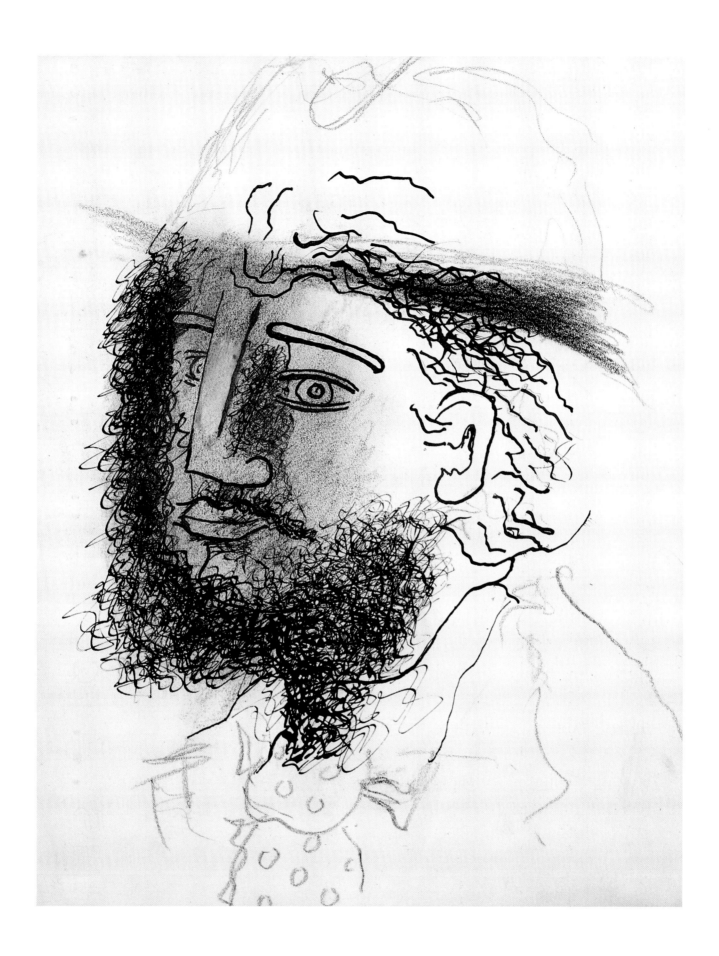

118
Bird (L'Oiseau). 1958

Gouache on paper, 19⅝×25⅝″ (50×65 cm)
Collection Mr. and Mrs. Claude Laurens, Paris

A gray bird with accents of brown and blue flies in the open sky, the
essence and principle of movement.

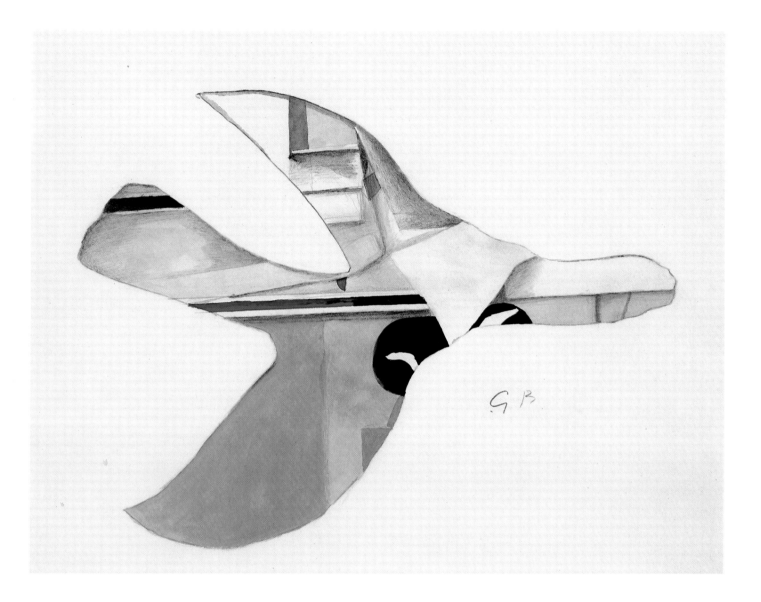

119
Bouquet (Le Bouquet). 1959

Gouache and India ink on paper, 12⅝×9¹³⁄₁₆″ (32×25 cm)
Private Collection, Paris

Braque wrote: "The vase gives form to the void, and music to silence." The vase is all white in verdant surroundings, while the flowers burst with yellows and reds.

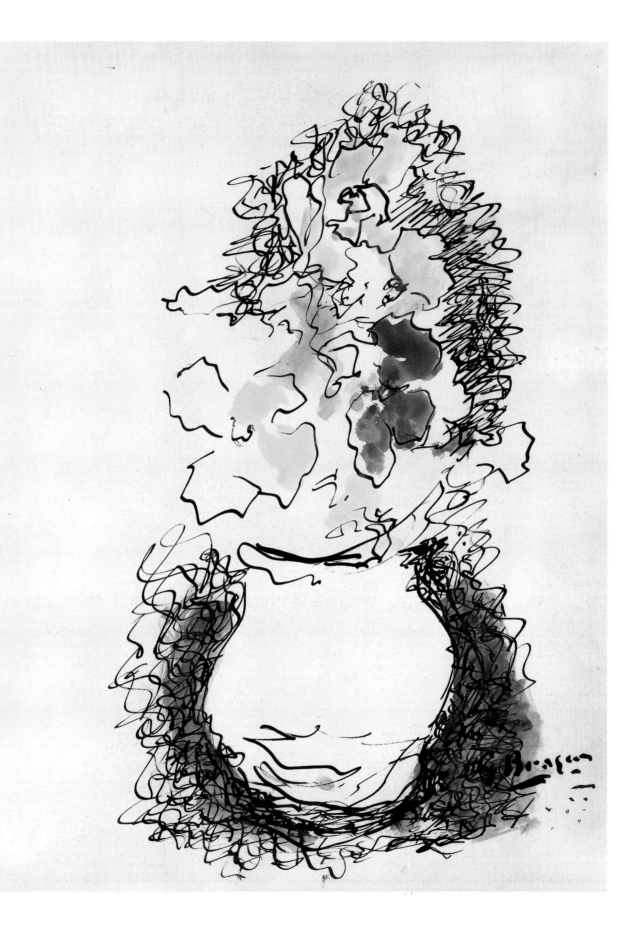

120
Bird on a Newspaper Background (Oiseau sur fond de journal). 1961

Gouache on newspaper mounted on cardboard, 28¾×37⅜″ (73×95 cm)
Collection Mr. and Mrs. Claude Laurens, Paris

This large gouache was used as the model for a lithograph. A blue circle
surrounds the black bird against an irregular pattern of newspaper.

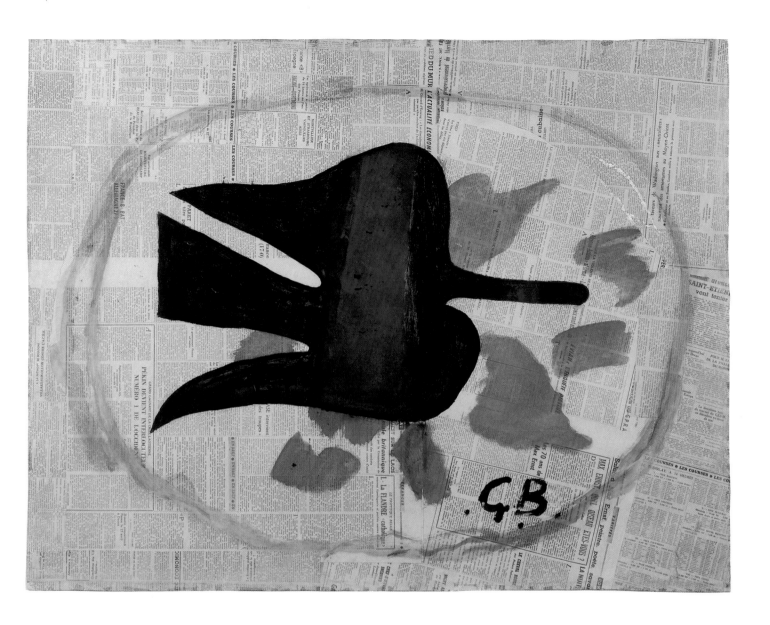

Sculpture

The sculpture of painters, after the examples of Daumier and Degas, has become an important feature of modern art. The activity of Matisse in this field, and of Picasso especially, was considerable. As for Braque, despite his close friendship with the excellent sculptor Henri Laurens, for a long time he resisted the call of volume, so contrary to his gifts as a painter. The paper constructions that he made at Sorgues in 1912, during a phase of intense experimentation, were lost. Apart from a lone female statuette with a lozenge-shaped body from 1920, and the incised plaster panels of 1931, which are closer to glyptics than to statuary, he did not really take it up before the summer of 1939, after finding on the beach at Varengeville the materials suited to his style and means. He continued during the war and the Occupation in a special studio that he set up in Paris, as a diversion from his painting, and then because of the shortage of colors, as well as by a tactile obsession and curiosity to see the other side of the picture, so to speak. Faithful to the overlapping planes of Cubism, and with rare exceptions, he did not work on sculpture in the round or on modeling. His sculptures are like *profiles* or very low reliefs. He worked on a number of basic themes: Faces, Horses, Fish, Birds, Plants, Vases, Plows, in other words, Nature, the symbols of the elements, and the realm of everyday objects and tools. Real entities or invented signs that measure space, rhythmically structuring man's Works and Days, imposing a familiar Theogony. They are successful decorations in the best sense of the word, small of format and archaic in feeling, combining both Greek and Chinese influences. They are also, like everything that emanates from Braque, spiritual emblems charged with radiant poetry.

121
Marriage (Hymen). 1939

Bronze, 29½×19¹¹⁄₁₆×11¹³⁄₁₆″ (75×50×30 cm)
Signed and numbered: 4/6
Collection Mr. and Mrs. Claude Laurens, Paris

This sculpture was made at Varengeville in the fall of 1939. Braque
carved a piece of soft limestone from the nearby cliffs into two facing pro-
files to create a monument to Marriage. The double base and crown were
made from flat eroded stones found on the beach.

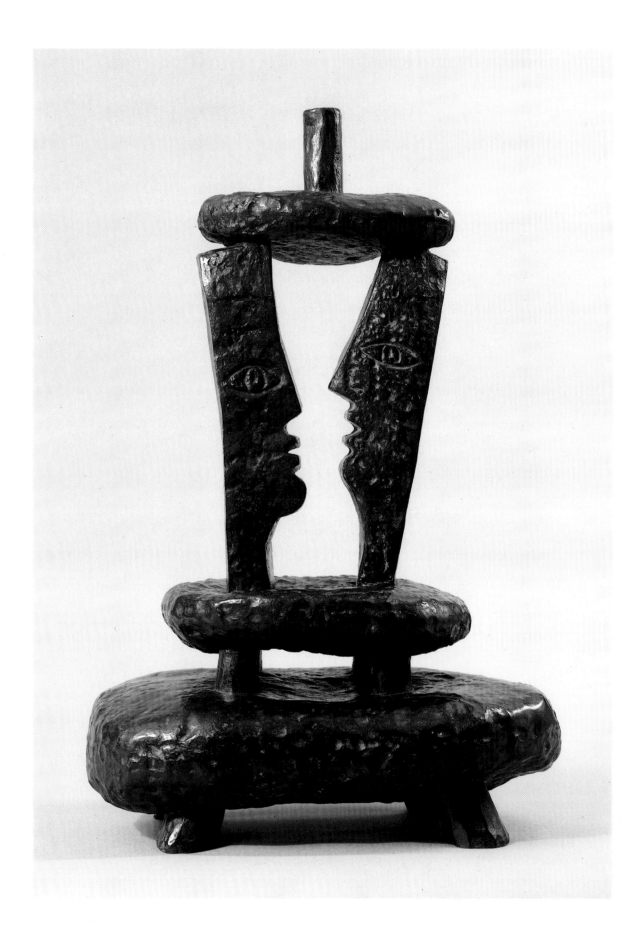

122
Hesperis. 1939

Original plaster, 16⅛×23⅛×4⅝″ (41×23×11 cm)
Collection Mr. and Mrs. Claude Laurens, Paris

Braque illustrated an edition of Hesiod's *Theogony*. Hesperis is the per-
sonification of Night and the mother of the Hesperides, the three nymphs
of Evening who lived in the garden where the Golden Apples were
watched over by a dragon. This profile of antique inspiration appears in
many of his paintings.

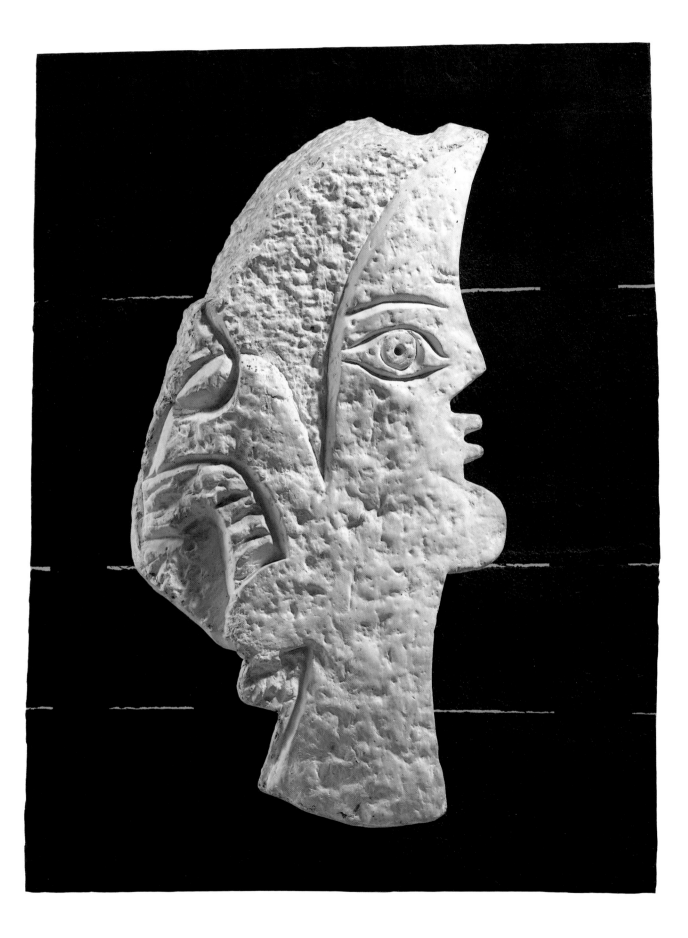

123
Large Head of a Horse (Grande Tête de cheval). 1942–43
Zinc, 16⁹⁄₁₆ × 35¹³⁄₁₆ × 7⁹⁄₁₆″ (42 × 91 × 18.5 cm)
Collection Mr. and Mrs. Claude Laurens, Paris

After having sculpted a number of freestanding bridled or harnessed
Small Horses, Braque made this large *Head of a Horse* which he cast in an
edition of three bronze and three zinc examples. It revives and condenses
in a modern register and with the texture peculiar to the artist the forms
of archaic Greece. The preliminary sketches and a study painted on paper
go back to 1940.

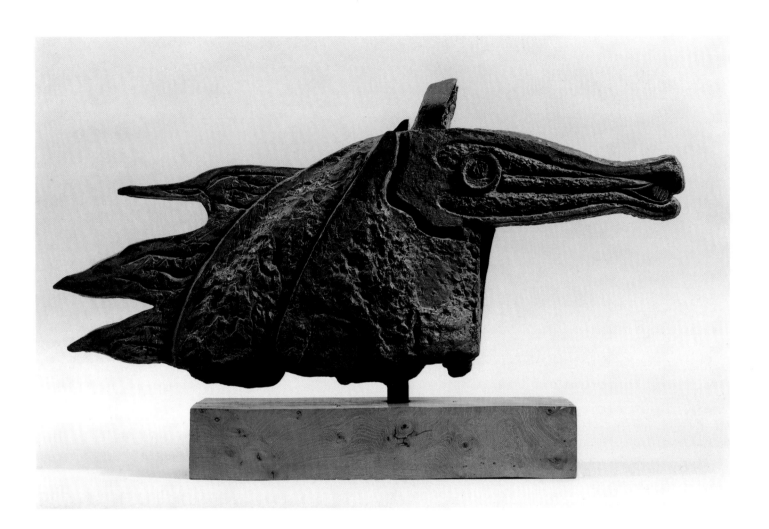

Documentation

Chronology

1882 May 13: Birth of Georges Braque, son of Charles Braque, a painting contractor, and of Augustine Johanet, living at 40, rue de l'Hôtel-de-Ville, in Argenteuil-sur-Seine.

1890 The Braque family moves to Le Havre, 33, rue Jules-Lausne.

1893 Georges Braque enters the lycée and attends Courchet's evening class at the local Ecole des Beaux-Arts. Takes flute lessons from Raoul Dufy's brother, Gaston.

1899 Georges leaves the lycée and apprentices with the painter-decorator Roney.

1900 Moves to Paris in the autumn to complete his apprenticeship with Laberthe, a friend and former employee of his father's. Lives on rue des Trois-Frères in Montmartre. Evening drawing classes at Cours Municipal at the Batignolles taught by Quignolot.

1901–02 Military service in Le Havre.

1902 October: Moves to rue Lepic in Montmartre.
Frequents the Louvre (Greek and Egyptian antiquities), the Musée du Luxembourg (Impressionists) and the galleries of Durand-Ruel and Vollard. Attends the Académie Humbert where he meets Marie Laurencin and Francis Picabia.

1903 Studies briefly at the Ecole Nationale des Beaux-Arts in the atelier of Léon Bonnat, then returns to the Académie Humbert.

1904 After vacationing in Brittany and Normandy, returns to Paris and rents a studio on rue d'Orsel where he begins to paint for himself.

1905 Summers at Honfleur and Le Havre with the sculptor Manolo and the critic Maurice Raynal. Is impressed by the Matisses and Derains in the Fauve room at the Salon d'Automne (in which his friends from Le Havre, Dufy and Othon Friesz, also showed).

1906 March: Exhibits seven pictures at the Salon des Indépendants. August 14–September 11: In Antwerp with Friesz. September – October: Returns to Paris. November – January: Winters at L'Estaque. First Fauve paintings.

1907 February: Back in Paris. March: Exhibits six pictures (all sold, five of them to Wilhelm Uhde) at the Indépendants. Meets Henri Matisse, André Derain, Maurice de Vlaminck. Spends the beginning of the summer at La Ciotat and the end at L'Estaque. Meets the young art-dealer Daniel-Henry

Kahnweiler and Guillaume Apollinaire, who takes him to the Bateau-Lavoir, where he sees *Les Demoiselles d'Avignon* in Pablo Picasso's studio.
He is profoundly impressed by the Cézanne retrospectives at the Salon d'Automne and Bernheim-Jeune, Paris.

1908 Spends the spring and summer at L'Estaque.
The jury of the Salon d'Automne rejects all of the canvases submitted by Braque except one, which he withdraws.
November 9–28: First one-man exhibition, at Galerie Kahnweiler, Paris. Apollinaire writes the catalogue preface. In the review in *Gil Blas* (November 14), Louis Vauxcelles speaks of the reduction to "cubes."

Braque in his studio, ca. 1910–11

Braque in Varengeville

1909 Exhibits two paintings at the Salon des Indépendants. Summers at La Roche-Guyon, then at Carrières-Saint-Denis with Derain. Becomes close friends with Picasso. Analytical Cubism.

1910 Has studio on rue Caulaincourt. Returns to L'Estaque in the summer.

1911 Meets Picasso at Céret. Uses numerals and letters in his paintings.
October: Back in Paris. Becomes friends with the sculptor Henri Laurens.

1912 Kahnweiler publishes his *Fox* and *Job* etchings. Exhibits at the Cologne *Sonderbund* and with the *Blaue Reiter*.
Marries Marcelle Lapré.
Summers at Sorgues, near Picasso in Avignon.
September: Makes the first papier collé. Paints with sand and sawdust. Synthetic Cubism.

1913 Represented at the Armory Show in New York.
In the early summer stays briefly at Céret, where he joins Picasso, Juan Gris and Max Jacob, then goes on to Sorgues.

1914 Summers at Sorgues, near Picasso and Derain, until his mobilization.

1915 May 11: Seriously wounded at Carency, undergoes trepanation.

1916 April: Returns to Sorgues to convalesce. Demobilized.

1917 January 15: Banquet organized by his friends in Paris to celebrate his recovery.
Starts to paint again. Affinities with Gris and Laurens.
December: Publishes "Pensées et réflexions sur la peinture" in the review *Nord-Sud* edited by his friend Pierre Reverdy. Léonce Rosenberg becomes his dealer.

1918 Paints still lifes on a table; the *Gueridon* series.

1919 March: Exhibits at Galerie de l'Effort Moderne, Paris, Léonce Rosenberg's gallery on rue de la Beaume.

1920 Exhibits four works at the Salon des Indépendants and three at the Salon d'Automne.
Wood engravings for Erik Satie's *Le Piège de Méduse*. Executes his first sculpture, a *Standing Woman*.
Kahnweiler reestablishes himself in Paris and opens the Galerie Simon.

1922 Exhibits his *Canephora* paintings and *Mantelpiece* still lifes in a room devoted to his work at the Salon d'Automne.
Moves from Montmartre to Montparnasse (avenue Reille).

1924 January 19: Premiere in Monte-Carlo of the ballet *Les Fâcheux*, with music by Georges Auric and sets by Braque.
May: Exhibits at Galerie Paul Rosenberg, Paris, his new dealer.
Designs the set for the ballet *Salade* produced by Etienne de Beaumont.
Moves into house built to his specifications by Auguste Perret near the Parc Montsouris, at 6, rue du Douanier, today rue Georges Braque.

1925 Designs the sets for Serge Diaghilev's ballet *Zéphyre et Flore*.
Trip to Italy (Rome).

1928 New *Gueridon* series. Changes style.

1929 Vacations at Dieppe, paints small seascapes.

1931 Summers at Varengeville in his newly renovated cottage. Incised plaster panels; mythological figures.

1932 Etchings for Hesiod's *Theogony*.

1933 First important retrospective, at the Kunsthalle Basel.

1936 Exhibition at the Palais des Beaux-Arts, Brussels. Interiors with figures and large still lifes.

1937 Awarded First Prize at the Carnegie International, Pittsburgh.
April: Exhibits compositions with painters and musicians at Galerie Paul Rosenberg, Paris.

1939–40 Winters at Varengeville, works on sculpture. Retrospective at The Arts Club of Chicago, which travels to the Phillips Memorial Gallery, Washington, D.C., and the San Francisco Museum of Art.

1940 After the German Occupation begins, goes to the Limousin, then to the Pyrenees. Returns to Paris in the fall and stays for the duration of the war.

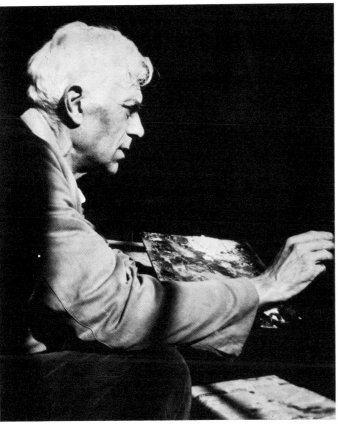

1943 Exhibits in a room devoted to him at the Salon d'Automne (twenty-six paintings, nine sculptures).

1945 Exhibitions at the Stedelijk Museum, Amsterdam, and the Palais des Beaux-Arts, Brussels.
Stops working for several months after an operation.

1946 Braque-Rouault exhibition at The Tate Gallery, London.

1947 First exhibition at Galerie Maeght, Paris, his new dealer.

1948 Awarded First Prize for *The Billiard Table,* 1944, at the Venice Biennale, which devotes a room to his work.
Maeght publishes his notes and reflections *Cahiers de Georges Braque: 1917–1947.*

1949 Completes the first paintings of the *Studio* series. Important retrospective at The Museum of Modern Art, New York, and The Cleveland Museum of Art.

1952 One-man exhibition at National Museum, Tokyo.

1952–53 Commissioned by Georges Salles, Director of French Museums, to decorate the ceiling of the Salle Henri II in the Louvre.

1953 Exhibition at Kunsthalle Bern, which travels to Kunsthaus Zürich.

1954 Designs stained-glass windows for the church of Varengeville and decorations for the Mas Bernard at Saint-Paul-de-Vence.

1956 Exhibition at Royal Scottish Academy, Edinburgh, which travels to The Tate Gallery, London.

1958 Two rooms devoted to Braque at the Venice Biennale. One-man show at the Palazzo Barberini, Rome.

1960 Retrospective at the Kunsthalle Basel.

1961 Exhibition *L'Atelier de Braque* at the Musée du Louvre, Paris.

1963 Retrospective at the Haus der Kunst, Munich.
August 31: Braque dies in Paris.
September 3: State funeral at the Louvre, André Malraux gives memorial speech. Burial at Varengeville.

Georges Braque in his studio,
1947 (above) and ca. 1950

Exhibitions

Selected One-Man Exhibitions

Galerie Kahnweiler, Paris, *Georges Braque,* Nov. 9–28, 1908. Catalogue with text by Guillaume Apollinaire

Galerie de l'Effort Moderne (Léonce Rosenberg), Paris, *Georges Braque,* Mar. 5–31, 1919

Grand Palais, Paris, *Salon d'Automne* (Salle d'honneur), Nov. 1–Dec. 20, 1922

Galerie Paul Rosenberg, Paris, *Georges Braque,* May 2–21, 1924

Galerie Paul Rosenberg, Paris, *Exposition d'œuvres de Braque,* Mar. 8–27, 1926

Galerie Paul Rosenberg, Paris, *Georges Braque,* May 1929; May 1930

Kunsthalle Basel, *Georges Braque,* Apr. 9–May 14, 1933. Catalogue with text by Carl Einstein

Alex Reid & Lefevre Ltd., London, *Georges Braque,* July 1934. Catalogue

Valentine Gallery, New York, *Exhibition of recent paintings by Georges Braque,* Nov. 26–Dec. 15, 1934. Catalogue

Galerie Paul Rosenberg, Paris, *Exposition d'œuvres récentes de Georges Braque,* Jan. 8–31, 1936. Catalogue

Alex Reid & Lefevre Ltd., London, *Paintings by Georges Braque,* July 1936

Palais des Beaux-Arts, Brussels, *Georges Braque,* Nov.–Dec. 1936. Catalogue

Galerie Paul Rosenberg, Paris, *Exposition d'œuvres récentes de Georges Braque,* Apr. 3–30, 1937. Catalogue

Galerie Pierre, Paris, *Georges Braque: Paysages de l'époque fauve (1906),* Feb. 4–21, 1938

Rosenberg & Helft Ltd., London, *Recent Works of Braque,* July 1938. Catalogue

Buchholz Gallery, New York, *Some Selected Paintings by G. Braque,* Oct. 14–29, 1938. Catalogue

Galerie Paul Rosenberg, Paris, *Exposition Braque,* Nov. 16–Dec. 10, 1938. Catalogue

Galerie Paul Rosenberg, Paris, *Exposition Braque (œuvres récentes),* Apr. 4–29, 1939. Catalogue

Rosenberg & Helft Ltd., London, *Georges Braque: Recent Works,* June 6–July 8, 1939. Catalogue

The Arts Club of Chicago, *Georges Braque Retrospective Exhibition,* Nov. 7–27, 1939. Catalogue with texts by Henry McBride, Duncan Phillips and James Johnson Sweeney. Traveled as *Retrospective Exhibition of Paintings by Georges Braque* to Phillips Memorial Gallery, Washington, D.C., Dec. 6, 1939–Jan. 6, 1940; San Francisco Museum of Art, Feb. 6–Mar. 3

Valentine Gallery, New York, *An Exhibition of Paintings by Georges Braque,* Jan. 13–Feb. 8, 1941. Catalogue

Paul Rosenberg & Co., New York, *An Exhibition of Paintings by Braque,* Apr. 7–25, 1942. Catalogue

The Baltimore Museum of Art, *Georges Braque,* Nov. 22–Dec. 27, 1942

Galerie de France, Paris, *Douze Peintures de Georges Braque (1908–1910),* May 21–June 19, 1943

Palais des Beaux-Arts de la Ville de Paris, *Salon d'Automne* (Salle d'honneur), Sept. 25–Oct. 31, 1943

Stedelijk Museum, Amsterdam, *Georges Braque,* Oct. 20–Nov. 12, 1945. Catalogue

Palais des Beaux-Arts, Brussels, *Georges Braque,* Nov. 24–Dec. 13, 1945. Catalogue

Paul Rosenberg & Co., New York, *Paintings by Braque,* Apr. 29–May 18, 1946. Catalogue

Galerie Maeght, Paris, *Georges Braque,* May 30–June 30, 1947. Catalogue with texts by René Char and Jacques Kober and excerpts from statements by the artist

Galerie Seligmann-Helft, New York, *Georges Braque,* Nov. 1947

Paul Rosenberg & Co., New York, *Paintings by Braque,* Jan. 5–24, 1948. Catalogue

Venice, *XXIV Biennale Internazionale d'Arte* (special room), May 29–Sept. 30, 1948. Catalogue with text by Raymond Cogniat

Galerie Maeght, Paris, *Œuvres graphiques,* June 1948

Freiburg-in-Breisgau, Paulussaal, *Georges Braque,* Oct. 1948. Catalogue with text by Elfried Schulze

Galerie Maeght, Paris, *Georges Braque,* Jan. 1949

The Cleveland Museum of Art, *Georges Braque,* Jan. 25–Mar. 13, 1949. Catalogue with texts by Jean Cassou, Henry R. Hope and William S. Lieberman. Traveled to The Museum of Modern Art, New York (organizer), Mar. 29–June 12

Galerie Maeght, Paris, *G. Braque,* Jan.–Feb. 1950; June–July 1952

National Museum, Tokyo, *Georges Braque,* Sept.–Oct. 1952

Paul Rosenberg & Co., New York, *Braque 1924–1952,* Oct. 6–25, 1952

Kunsthalle Bern, *Georges Braque,* Apr. 24–May 31, 1953. Catalogue with text by A. Rüdlinger. Traveled to Kunsthaus Zürich, June 7–July 19,

Musée des Beaux Arts, Liège, *Braque: L'Œuvre graphique,* Nov. 14–Dec. 6, 1953. Catalogue with text by Michel Seuphor

Institute of Contemporary Art, London, *Braque: Paintings and Drawings from Collections in England,* May 14–July 3, 1954

Paul Rosenberg & Co., New York, *Paintings by Braque,* Oct. 3–Nov. 29, 1955

Galerie Maeght, Paris, *Œuvres récentes de Georges Braque,* Apr.–May 1956

Royal Scottish Academy, Edinburgh, *Georges Braque: An Exhibition of Paintings* (organized by the Arts Council of Great Britain in association with the Edinburgh Festival Society), Aug. 18–Sept. 15, 1956. Catalogue with text by Douglas Cooper. Traveled to The Tate Gallery, London, Sept. 28–Nov. 11

Contemporary Arts Center, Cincinnati, *The Sculpture of Georges Braque,* Dec. 1956–Jan. 1957

Venice, *XXIX Biennale Internazionale d'Arte* (2 special rooms), June 15–Oct. 19, 1958. Catalogue

Palazzo Barberini, Rome, *Ente premi Roma, Mostra antológica di Georges Braque,* Nov. 1958–early Jan. 1959

Galerie Maeght, Paris, *Georges Braque,* June 1959

Kunsthalle Basel, *Georges Braque,* Apr. 9–May 29, 1960. Catalogue with texts by Carl Einstein, Arnold Rüdlinger and Pierre Volboudt

Pasadena Art Museum, *Georges Braque,* Apr. 20–June 5, 1960

Bibliothèque Nationale, Paris, *Georges Braque: Œuvre graphique,* June 24–Oct. 16, 1960. Catalogue with texts by Jean Adhémar and Julien Cain

Musée du Louvre, Paris, *L'Atelier de Braque,* Nov. 1961. Catalogue with text by Jean Cassou

Galerie Adrien Maeght, Paris, *Georges Braque: Dessins,* June 21–July 26, 1962

Contemporary Arts Center, Cincinnati, *Homage to Georges Braque,* Sept. 22–Oct. 22, 1962. Catalogue with text by A. T. Schoener. Traveled to The Arts Club of Chicago, Nov. 6–Dec. 6, 1962; Walker Art Center, Minneapolis, Dec. 20, 1962–Jan. 6, 1963

Galerie Maeght, Paris, *Georges Braque: Papiers collés 1912–1914,* May 1963

Haus der Kunst, Munich, *Georges Braque,* Oct. 18–Dec. 15, 1963. Catalogue with text by Douglas Cooper

New York, *Georges Braque 1882–1963: An American Tribute,* Apr. 7–May 2, 1964: Saidenberg Gallery, *Fauvism and Cubism;* Perls Galleries, *The Twenties;* Paul Rosenberg & Co., *The Thirties;* M. Knoedler and Co., *The Late Years and Sculpture.* Catalogue edited by John Richardson

Salle des Expositions du Grenier à Sel, Honfleur, *Hommage à Georges Braque,* July 26–Aug. 31, 1964

Kunstnernes Hus, Oslo, *Georges Braque 1882–1963,* Nov. 14, 1964–

Jan. 3, 1965. Traveled to Kunstforening, Bergen, Jan. 15–Feb. 7

Musée du Louvre, Paris, *Présentation de la Donation Braque,* May 26–Sept. 30, 1965. Catalogue with texts by Jean Cassou and Jean Leymarie

Nouveau Musée du Havre, *Georges Braque,* Apr. 15–May 31, 1967

Galerie Maeght, Paris, *Georges Braque: Derniers messages,* June 1967

Galerie Beyeler, Basel, *Georges Braque,* July–Sept. 1968

The Art Institute of Chicago, *Braque: The Great Years,* Oct. 7–Dec. 3, 1972. Catalogue with text by Douglas Cooper

Orangerie des Tuileries, Paris, *Georges Braque,* Oct. 16, 1973–Jan. 14, 1974. Catalogue with text by Jean Leymarie

Accademia di Francia, Villa Medici, Rome, *Braque,* Nov. 15, 1974–Jan. 20, 1975

Centre Culturel et Artistique, Montrouge, *XXIIIe Salon de Montrouge: Art Contemporain et Georges Braque,* Apr. 26–May 28, 1978

Fondation Anne et Albert Prouvost à Septentrion, Marcq-en-Baroeul, France, *G. Braque,* Oct. 7, 1978–Jan. 21, 1979

Fondation Maeght, Saint-Paul-de-Vence, *Georges Braque,* July 5–Sept. 30, 1980. Catalogue

Staatsgalerie Stuttgart, *Georges Braque: Ausstellung zum 100. Geburtstag,* Nov. 22, 1981–Jan. 31, 1982

Musée des Beaux-Arts, Bordeaux, *Georges Braque en Europe,* May 14–Sept. 1, 1982. Traveled to Musée d'Art Moderne, Strasbourg, Sept. 11–Nov. 28

Galerie Louise Leiris, Paris, *Braque et la mythologie,* June 16–July 17, 1982

Musée National d'Art Moderne, Centre Georges Pompidou, Paris, *Georges Braque: Les Papiers Collés,* June 17–Sept. 27, 1982. Catalogue with texts by Dominique Bozo, E. A. Carmean, Jr., Douglas Cooper, Pierre Daix, Edward F. Fry, Alvin Martin and Isabelle Monod-Fontaine. Traveled to National Gallery, Washington, D. C., Oct. 31, 1982–Jan. 16, 1983. Revised English edition of catalogue

Musée National d'Art Moderne, Centre Georges Pompidou, Paris, *Braque dans les collections publiques françaises,* June 17–Sept. 27, 1982. Catalogue of exhibition in Nadine Pouillon and Isabelle Monod-Fontaine, *Braque: Collections du Musée National d'Art Moderne,* Paris, 1982

The Phillips Collection, Washington, D. C., *Georges Braque: The Late Paintings (1940–1963),* Oct. 9–Dec. 12, 1982. Catalogue with texts by Robert C. Cafritz, Hershel B. Chipp and Laughlin Phillips. Traveled to California Palace of the Legion of Honor, San Francisco, Jan. 1–Mar. 15, 1983; Walker Art Center, Minneapolis, Apr. 14–June 14; The Museum of Fine Arts, Houston, July 7–Sept. 14

Galerie Adrien Maeght, Paris, *Georges Braque: Sculptures,* 1985

Musée National Fernand Léger, Biot, *Bonjour Georges Braque,* Mar. 1985

Fundacion para el apoyo de la Cultura, Barcelona, *Georges Braque 1882–1963,* 1986

Selected Group Exhibitions

Städtische Ausstellungshalle am Aachenertor, Cologne, *Internationale Kunstausstellung des Sonderbundes,* May 25–Sept. 30, 1912

69th Regiment Armory, New York, *International Exhibition of Modern Art* (Armory Show), Feb. 17–Mar. 15, 1913. Traveled to Chicago and Boston

Moscow, *Bubnovyi valet* (Jack of Diamonds), Mar. 3–Apr. 6, 1913

Brooklyn Museum, *An International Exhibition of Modern Art Assembled by The Société Anonyme,* Nov. 19, 1926–Jan. 9, 1927. Catalogue

Galerie Alfred Flechtheim, Berlin, *Matisse, Braque, Picasso,* Sept. 21–mid-Oct. 1930. Catalogue

Galerie "Beaux-Arts" and "Gazette des Beaux-Arts," Paris, *Les Créateurs du cubisme,* Mar.–Apr. 1935. Catalogue with texts by Raymond Cogniat and Maurice Raynal

The Museum of Modern Art, New York, *Cubism and Abstract Art,* Mar. 2–Apr. 19, 1936. Catalogue with text by Alfred H. Barr, Jr.

Musée du Petit Palais, Paris, *Maîtres de l'art indépendant 1895–1937,* June–Oct. 1937. Catalogue

Carnegie Museum of Art, Pittsburgh, *The 1937 International Exhibition of Paintings,* Oct. 14–Dec. 5, 1937. Catalogue

Kunsthalle Bern, *Picasso, Braque, Gris, Léger, Borès, Beaudin, Vinés,* May 6–June 4, 1939

Marie Harriman Gallery, New York, *Les Fauves,* Oct. 20–Nov. 22, 1941

Buchholz Gallery, New York, *Early Work by Contemporary Artists,* Nov. 16–Dec. 4, 1943

Galerie de France, Paris, *Le Cubisme 1911–1918,* May 25–June 30, 1945. Catalogue with texts by Bernard Dorival and André Lhote

The Tate Gallery, London, *Braque and Rouault,* Apr. 1946. Catalogue

Kunsthaus Zürich, *Georges Braque, Wassily Kandinsky, Pablo Picasso,* Sept. 21–Oct. 20, 1946. Catalogue

Palais des Papes, Avignon, *Exposition de peintures et sculptures contemporaines,* June 27–Sept. 30, 1947. Catalogue with statement by the artist

Kunsthalle Basel, *Braque – Gris – Picasso,* Feb. 26–Mar. 24, 1948. Catalogue. Traveled to Kunsthalle Bern, Apr. 2–29

The Museum of Modern Art, New York, *Collage,* Sept. 21–Dec. 5, 1948

Kunsthalle Bern, *Les Fauves,* Apr. 29–May 29, 1950

Venice, *XXV Biennale Internazionale d'Arte: Mostra dei Fauves,* June 8–Oct. 15, 1950. Catalogue

Sidney Janis Gallery, New York, *Les Fauves,* Nov. 13–Dec. 23, 1950

Musée National d'Art Moderne, Paris, *Le Fauvisme,* June–Sept. 1951

Musée National d'Art Moderne, Paris, *L'Œuvre du XXe siècle,* May–June 1952. Traveled to The Tate Gallery, London, July 15–Aug. 17

Musée National d'Art Moderne, Paris, *Le Cubisme 1907–1914,* Jan. 30–Apr. 9, 1953

Palais des Beaux-Arts, Brussels, *50 Ans d'art moderne,* Apr. 17–July 21, 1958

Musée National d'Art Moderne, Paris, *Les Sources du XXe siècle (les arts en Europe de 1884 à 1914),* Nov. 4, 1960–Jan. 23, 1961

The Museum of Modern Art, New York, *The Art of Assemblage,* Oct. 2–Nov. 12, 1961. Catalogue with text by William S. Seitz. Traveled to The Dallas Museum of Contemporary Arts, Jan. 9–Feb. 11, 1962; San Francisco Museum of Art, Mar. 5–Apr. 13

The Museum of Fine Arts, Houston, *The Heroic Years: Paris 1908–1914,* Oct. 21–Dec. 8, 1965

Kunstverein Hamburg, *Matisse und seine Freunde,* May 25–July 10, 1966

Kunstgewerbemuseum Zürich, *Collagen,* June 8–Aug. 18, 1968

Louisiana Museum, Humlebæk, Denmark, *Georges Braque, Henri Laurens,* Mar. 22–May 4, 1969

Los Angeles County Museum of Art, *The Cubist Epoch,* Dec. 15, 1970–Feb. 21, 1971. Catalogue with text by Douglas Cooper. Traveled to The Metropolitan Museum of Art, New York, Apr. 9–June 8

The New York Cultural Center, in association with Fairleigh Dickinson University, *Laurens et Braque: Les donations Laurens et Braque à l'Etat français,* Jan. 15–Mar. 21, 1971. Catalogue

Galerie des Beaux-Arts, Bordeaux, *Les Cubistes,* May 4–Sept. 1, 1973. Catalogue with texts by Jean Cassou, Jacques Lassaigne and G. Martin-Mery. Traveled to Musée d'Art Moderne de la Ville de Paris, Sept. 26–Nov. 10

Grand Palais, Paris, *Jean Paulhan à travers ses peintres,* Feb. 1–Apr. 15, 1974

The Museum of Modern Art, New York, *The "Wild Beasts": Fauvism and Its Affinities,* Sept. 11–Oct. 31, 1976. Catalogue with text by John Elderfield

The Museum of Modern Art, New York, *European Master Paintings from Swiss Collections,* Dec. 17, 1976–Mar. 1, 1977. Catalogue

Kunsthalle Bielefeld, *Zeichnungen und Collagen des Kubismus: Picasso, Braque, Gris,* Mar. 11–Apr. 29, 1979

The Tate Gallery, London, *The Essential Cubism: Braque, Picasso and their friends, 1907–1920,* Apr. 27–July 9, 1983. Catalogue with texts by Douglas Cooper and Gary Tinterow

Musée National d'Art Moderne, Centre Georges Pompidou, Paris, *Donation Louise et Michel Leiris,* Nov. 22, 1984–Jan. 2, 1985

Bibliography

General

G. Apollinaire, *Les Peintres cubistes. Méditations esthétiques,* Paris, 1913
G. C. Argan, *L'arte moderna 1770–1970,* Florence, 1970
A. Barr, *Cubism and Abstract Art,* New York, 1936
P. Cabanne, *L'Epopée du cubisme,* Paris, 1963
J. Cassou, *Panorama des arts plastiques contemporains,* Paris, 1960
D. Cooper, *The Cubist Epoch,* London, 1970
P. Daix, *Journal du cubisme,* Geneva, 1982
B. Dorival, *Peintres du XXe siècle,* Paris, 1957
G. Duthuit, *Les Fauves,* Geneva, 1949
C. Einstein, *Die Kunst des 20. Jahrhunderts,* Berlin, 1926
J. Elderfield, *The Wild Beasts: Fauvism and Its Affinities,* New York, 1976
P. Francastel, *Peinture et société,* Paris and Lyon, 1951
E. Fry, *Cubism,* London, 1966
M. Giry, *Le Fauvisme, ses origines, son évolution,* Neuchâtel, 1981
J. Golding, *Cubism, History and Analysis, 1907–1914,* New York, 1959
M. Guiney, *Cubisme et littérature,* Geneva, 1972
G. Habasque, *Le Cubisme,* Geneva, 1959
W. Haftmann, *Malerei im 20. Jahrhundert,* Munich, 1954
G. H. Hamilton, *Painting and Sculpture in Europe 1880–1940,* London, 1967
R. Huyghe, *Histoire de l'art contemporain,* Paris, 1935
G. Jarreau, *L'Art cubiste,* Paris, 1929
W. Judkins, *Fluctuant Representations in Synthetic Cubism: Picasso, Braque, Gris,* New York and London, 1976
D.-H. Kahnweiler, *Der Weg zum Kubismus,* Munich, 1920
J. Laude, F. Will-Levaillant and R. Jullian, *Le Cubisme,* Saint-Etienne, 1973
J. Leymarie, *Le Fauvisme,* Geneva, 1959
A. Lhote, *Peinture d'abord,* Paris, 1942
M. Raynal, *Anthologie de la peinture en France de 1906 à nos jours,* Paris, 1927
R. Rosenblum, *Cubism and Twentieth-Century Art,* New York, 1959
A. Salmon, *L'Art vivant,* Paris, 1920
C. Zervos, *Histoire de l'art contemporain,* Paris, 1938

On the Artist
Books

U. Apollonio and A. Martin, *Georges Braque,* Paris, 1966
R. Bissière, *Georges Braque,* Paris, 1920
M. Brion, *Georges Braque,* Paris, 1963
C. Brunet, *Braque et l'espace,* 1971
M. Carra and M. Valsecchi, *L'opera completa di Braque, 1908–1929, dalla composizione cubista al recupero dell'oggetto,* Milan, 1971
M. Carra and P. Descargues, *Tout l'œuvre peint de Braque: 1908–1929,* Paris, 1973
J. Cassou, *Braque,* Paris, 1956
R. Cogniat, *Braque,* Paris, 1970
R. Cogniat, *Braque,* Paris, 1976
D. Cooper, *Braque: Paintings 1909–1947,* London, 1948
D. Cooper, *Braque: The Great Years,* Chicago, 1972
J. Damase, *Georges Braque,* Deventer, London and Paris, 1963
P. Descargues, A. Malraux and F. Ponge, *Georges Braque,* Paris, 1971
C. Einstein, *Georges Braque,* Paris, 1934
F. Elgar, *Braque: 1906–1920,* Paris, 1958
E. Engelberts and W. Hofmann, *L'Œuvre graphique de Georges Braque,* Lausanne, 1960
S. Fauchereau, *Braque,* Paris, 1987
I. Fortunescu and D. Grigorescu, *Braque,* Bucharest, 1977
S. Fumet, *Georges Braque,* Paris, 1941
S. Fumet, *Braque,* Paris, 1945
S. Fumet, *Sculptures de Georges Braque,* Paris, 1951
S. Fumet, *Braque,* Paris, 1965
A. E. Gallatin, *Georges Braque: Essay and Bibliography,* New York, 1943
M. Gieure, *Georges Braque: Dessins,* Paris, 1955
M. Gieure, *Georges Braque,* Paris, 1956

J. Grenier, *Braque, Peintures 1909–1947,* Paris, 1948
R. Hauert and A. Verdet, *Georges Braque,* Geneva, 1956
P. Heron, *Braque,* London, 1958
H. R. Hope, *Georges Braque,* New York, 1949
G. Isarlov, *Catalogue des œuvres de Georges Braque: 1906–1929,* Paris, 1932
F. Laufer, *Georges Braque,* Bern, 1954
A. Lejard, *Braque,* Paris, 1949
J. Leymarie, *Braque,* Geneva, 1961
N. Mangin, *Catalogue de l'œuvre peint de Georges Braque,* 7 vols.:
 Peintures 1948–1957, Paris, 1959
 Peintures 1942–1947, Paris, 1960
 Peintures 1936–1941, Paris, 1961
 Peintures 1928–1935, Paris, 1962
 Peintures 1921–1927, Paris, 1968
 Peintures 1916–1923, Paris, 1973
 [N. Worms de Romilly], *Le Cubisme 1907–1914,* Paris, 1982
F. Mourlot and F. Ponge, *Braque lithographie,* Monte Carlo, 1963
E. Mullins, *Braque,* London, 1968
J. Paulhan, *Braque, le patron,* Paris, 1945
F. Ponge, *Braque le réconciliateur,* Geneva, 1946
F. Ponge, *Braque: Dessins,* Paris, 1950
N. Pouillon, *Braque,* Paris, 1970
N. Pouillon and I. Monod-Fontaine, *Œuvres de Georges Braque,* Paris, 1982
M. Raynal, *Georges Braque,* Rome, 1921
P. Reverdy, *Une Aventure méthodique,* Paris, 1949
J. Richardson, *Georges Braque,* London, 1959
J. Russell, *Georges Braque,* London, 1959
J. Selz, *Braque: 1920–1963,* Paris, 1973
D. Vallier, *Georges Braque,* Basel, 1968
D. Vallier, *L'Œuvre gravé de Braque,* Paris, 1982
A. Verdet, *Espaces,* Paris, 1957
A. Verdet, *Braque le solitaire,* Paris, 1959
L. Vinca-Masini, *Georges Braque,* Florence, 1969
C. Zervos, *Georges Braque: Nouvelles Sculptures et plaques gravées,* Paris, 1960

Articles

J. Alvard, "Braque's Studio," *Art News,* no. 66, 1967
G. Apollinaire, "Georges Braque," *Le Mercure de France,* January 16, 1909
G. Apollinaire, "Georges Braque," *La Revue indépendante,* August 1911
M. Arland, "Braque," *L'Age nouveau,* no. 42, 1949
Art International (Zürich), vol. VI, November 1962. Special edition on Braque
"Témoignages," *Arts,* September 4, 1963. Special edition on Braque with texts by Borsi, P. Cabanne, Carzou, M. Chagall, Ciry, S. Delaunay, A. Dunoyer de Segonzac, J. Lurçat, A. Maeght, A. Magnelli, Verdet, Waroquier and O. Zadkine
J. Babelon, "Braque et la nature morte," *Beaux-Arts,* September 30, 1943
J. Bazaine, B. Dorival and S. Fumet, "Braque: Un Enrichissement de l'espace," *La Cité,* no. 19, 1964
G. Bazin, "Braque 1939," *Prométhée,* June 1939
G. Bazin, "Braque," *Labyrinthe,* January 15, 1945
G. Bazin, "Sur l'espace en peinture: La Vision de Braque," *Journal de psychologie,* no. 45, 1953
J. Bertholle and Manessier, "Témoignages," *L'Art sacré,* September–October 1963
Bissière and J. Cain, "Témoignages," *Les Lettres françaises,* September 5, 1963
J. Bonjean, "L'Epoque fauve de Braque," *Beaux-Arts,* February 1938
A. Bosquet, "La Musique de Braque," *La Nouvelle Revue française,* no. 253, 1974
R. Boullier, "Braque et l'espace," *La Nouvelle Revue française,* no. 253, 1974
J. Bouret, "Braque ou l'andante noir et gris," *Arts,* February 17, 1950
E. Bove, "Georges Braque," *Formes,* no. 3, 1930
G. Braque, "Still Life with Glass," *Saint Louis Art Museum Bulletin,* vol. 12, no. 2, 1977

L. G. Buchheim, "Im Atelier am Parc Montsouris," *Die Kunst,* 1962
G. Buffet-Picabia, "Matières plastiques," *XXe Siècle,* no. 2, 1938
Cahiers d'art, no. 1–2, 1933. Special edition on Braque with texts by G. Apollinaire, R. Bissière, A. Breton, J. Cassou, B. Cendrars, H. E. Ede, A. Lhote, A. Salmon, A. Soffici and C. Zervos
J. Cain, "Braque," *Gazette des beaux-arts,* July 13, 1966
F. Calvo Serraller, "En Madrid, antologica de Georges Braque," *Guadalimar,* no. 45, 1979
J. Cassou, "Georges Braque," *Cahiers d'art,* no. 1, 1928
J. Cassou, "Œvres récentes de Braque," *L'Amour de l'art,* no. 11, 1930
J. Cassou, "Le Secret de Braque," *L'Amour de l'art,* no. 8, 1946
J. Cassou, "L'Atelier de Braque," *La Revue du Louvre et des Musées de France,* no. 6, 1961
B. Cendrars, "Braque," *La Rose rouge,* June 1919
K. Champa, "The Georges Braque Exhibition in Munich," *Art International* (Lugano), vol. VII, no. 9, 1963
R. Char, "Peintures de Georges Braque," *Cahiers d'art,* no. 26, 1951
R. Char, "Songer à ses dettes," *La Nouvelle Revue française,* October 1, 1963
A. Chastel, "Braque et Picasso 1912: La Solitude et l'échange," *Mélanges Kahnweiler* (Stuttgart), 1954
R. Cogniat, "Braque et les Ballets Russes," *L'Amour de l'art,* 1931
D. Cooper, "Georges Braque, l'ordre et le métier," *La France libre,* no. 67, May 1946
D. Cooper, "Georges Braque," *Town and Country,* March 1949
D. Cooper, "Georges Braque," *L'Oeil,* no. 107, 1963
B. Dahan, "Georges Braque ou un judicieux usage de la raison," *Tendance,* June 1965
L. Degand, "A propos des ateliers," *Art aujourd'hui,* no. 7–8, 1950
Derrière le miroir, 1947, 1952, 1954, 1956, 1959, 1962, 1963, 1964, 1967. Special editions on Braque
P. Descargues, "Braque à l'Orangerie," *L'Oeil,* October 1977
P. Dufour, "Actualité du cubisme," *Critique,* August–September 1969
C. Einstein, "Tableaux recentes de Georges Braque," *Documents,* November 1929
F. Elgar, "Une Conquête du cubisme: Le Papier collé. Derniers collages de Braque," *XXe Siècle,* no. VI, 1956
E. Foye, "Braque's Real Art in the 'Still Life with Violin and Pitcher,'" *Artforum,* vol. 16, no. 2, 1977
P. Francastel, "Braque e il cubismo," *La Biennale di Venezia,* no. 30, anno XIII, 1958
A. Frankfurter, "Georges Braque," *Art News,* February 1949
A. Fried, "Braque," *Forum* (Bratislava), no. 6, 1937
G. Gatellier, "Le Présent perpétuel de Braque," *Galerie des arts,* June 1967
W. George, "Georges Braque," *L'Esprit nouveau,* no. 6, 1921
W. George, "Georges Braque," *L'Amour de l'art,* October 1922
P. Gilmour, "Georges Braque," *Arts Review,* vol. 24, no. 22, 1972
L. Gowing, "Two Contemporaries, Braque and Ben Nicholson," *New Statesman,* April 1957
C. Greenberg, "Pasted Papers Revolution," *Art News,* September 1958
J. Grenier, "Introduction à la peinture de Braque," *Variété,* no. 3, 1946
W. Grohmann, "Georges Braque," *Cicerone* (Leipzig), 1929
W. Grohmann, A. Tudal and R. West, *Verve,* vol. VIII, no. 31–32, 1955
P. Heron, "Braque at the Zenith," *Arts* (London), February 1957
H. Hertz, "Braque et le réveil des apparences," *L'Amour de l'art,* April 1926
T. J. Hines, "L'Ouvrage de tous les temps admiré: 'Lettera amorosa,' René Char et Georges Braque," *Bulletin du bibliophile,* no. 1, 1973
E. Hoffmann, "Braque in Paris," *The Burlington Magazine,* vol. 850, 1974
F. Horter, "Abstract Painting, A Visit to Braque," *Pennsylvania Museum Bulletin,* March 1934
A. Jakowski, "Georges Braque," *Arts de France,* no. VIII, 1946
G. Jedlicka, "Georges Braque," *Universitas* (Stuttgart), no. IX, 1954
E. Kallai, "Georges Braque," *Magyar Müzevet* (Budapest), October 10, 1938
A. Kohler, "En hommage à Braque," *Coopération,* September 28, 1963
L. Laloy, "Georges Braque," *Comœdia* (Paris), January 23, 1924
P. Larson, "Five Cubist Prints," *Print Collector's Newsletter,* vol. 7, no. 4, 1976
D. Le Buhan, "Braque, textes illustrés," *Opus International,* no. 47, 1973
J. Leymarie, "Georges Braque, l'oiseau et son nid," *Quadrum* (Brussels), no. V, 1958
A. Lhote, "Exposition Braque à la Galerie Léonce Rosenberg," *La Nouvelle Revue française,* June 1, 1919
A. Lhote, "Le Symbolisme plastique de Georges Braque," *La Nouvelle Revue française,* no. 48, 1937
A. Liberman, "Braque," *Vogue,* December 1954
G. Limbour, "Georges Braque, découvertes et traditions," *L'Oeil,* no. 33, 1957
I. Loos, "Braque neben Picasso," *Das Kunstwerk,* vol. XIII, no. 9, 1960
S. Marcus, "The Typographic Element in Cubism 1911–1915," *Art International* (Zürich), vol. XVII, May 1973

R. McMullen, "Something More Difficult Than Painting: The Work of Georges Braque," *Réalités,* no. 281, 1974
Mizue (Tokyo), October 1952. Special edition on Braque with texts by A. Imaizumi and F. Ponge
H. Moe, "Georges Braque," *Kunsten Dag* (Oslo), vol. 1, 1964
J. Paulhan, "Le Patron des cubistes," *Nouveau Femina,* February 1956
J. Paulhan, "Peindre en Dieu," *La Nouvelle Revue française,* October 1, 1963
G. Picon, "Allocution prononcée à l'église de Varengeville le 4 septembre 1963," *Le Mercure de France,* October 1963
M. Pleynet, "Georges Braque et les écrans truqués," *Art Press,* no. 8, 1973
A. Podesta, "Braque," *Emporium* (Bergamo), July–August 1948
Le Point (Souillac), no. XLVI, October 1953. Special edition on Braque with texts by S. Fumet, G. Limbour and G. Ribemont-Dessaignes
F. Ponge, "Braque le réconciliateur," *Labyrinthe,* December 23, 1946
M. Ragon, "Georges Braque," *Jardin des arts,* no. 148, 1967
J. F. Revel, "Le Cubisme mis en regard de l'art abstrait, *Connaissance des arts,* no. 108, 1961
J. Revol, "Braque et Villon: Message vivant du cubisme," *La Nouvelle Revue française,* August–September 1961
G. Ribemont-Dessaignes, "L'Abstraction c'est de la peinture mondaine," *Arts,* December 1953
J. Richardson, "The Ateliers of Braque," *The Burlington Magazine,* no. 627, 1955
J. Richardson, "Le Nouvel Atelier de Braque," *L'Oeil,* no. 6, 1955
J. Richardson, "Braque," *Réalités* (American edition), 1958
J. Richardson, "Braque: Pre-Cube to Post-Zen," *Art News,* vol. 63, no. 2, 1964
G. Rosenthal, "The Art of Braque," *Baltimore Museum of Art News,* April 1948
W. Rubin, "Cézanne and the Beginning of Cubism," in *Cézanne: The Late Works,* exh. cat., The Museum of Modern Art, New York, 1977
G. Salles, "Histoire d'un plafond,"*Preuves,* June 1963
Sélection (Antwerp), vol. III, no. 4, 1924. Special edition on Braque
J. Selz, "L'Oiseau et la grève," *Lettres nouvelles,* July 1959
A. Soffici, "Picasso e Braque," *La Voce,* August 24, 1911
Les Soirées de Paris, April 15, 1914. Special edition on Braque
R. de Solier, "L'Oiseau de Braque," *Cahiers d'art,* no. 31–32, 1956–57
L. Steinberg, "The Polemical Art," *Art in America,* no. 2, 1979
E. Tériade, "Les Dessins de Georges Braque," *Cahiers d'art,* no. 2, 1927
E. Tériade, "L'Epanouissement de l'œuvre de Braque," *Cahiers d'art,* no. 10, 1928
E. Tériade, "Documentaire sur la jeune peinture, II: L'Avènement classique du cubisme," *Cahiers d'art,* no. 10, 1929
E. Tériade, "Emancipation de la peinture," *Minotaure,* no. 3–4, 1933
A. Terrasse, "La Règle est l'émotion," *La Nouvelle Revue française,* no. 253, 1974
G. Tinterow, "Paris, Beaubourg–Braque Centenary Exhibition," *The Burlington Magazine,* vol. 955, October 1982
D. Vallier, "Braque, la peinture et nous," *Cahiers d'art,* no. I, 1954
D. Vallier, "Braque dans sa force," *La Nouvelle Revue française,* no. 253, 1974
L. Vauxcelles, "Georges Braque," *Gil Blas,* March 10 and November 14, 1908, and March 25, 1909
L. Vauxcelles, "Georges Braque," *Télégramme,* January 5, 1909
A. Verdet, "Braque le solitaire," *XXe Siècle,* no. XI, 1958
A. Verdet, "Avec Georges Braque," *XXe Siècle,* no. XVIII, 1962
A. Verdet, "Le Sentiment du sacré dans l'œuvre de Braque," *XXe Siècle,* no. XX, 1962
G. Veronesi, "L'Atelier de Georges Braque," *Emporium* (Bergamo), January 1962
Verve, vol. VIII, no. 31–32, 1955. Special edition on Braque
A. Warnod, "Braque s'est remis au travail," *Arts,* no. 55, 1946
A. Warnod, "Tous les ismes conduisent au conformisme, nous déclare Braque," *Arts,* no. 146, 1947
A. Watt, "Paris Letter: With Braque," *Art in America,* no. 3, 1961
A. Watt, "Visage d'artiste," *Studio,* no. 162, 1961
M. Zahar, "Orientation de Georges Braque," *Panorama des arts,* 1947
C. Zervos, "Georges Braque et la peinture française," *Cahiers d'art,* no. 2, 1927
C. Zervos, "Georges Braque," *Kunst und Künstler,* July 1929
C. Zervos, "Georges Braque et le développement du cubisme," *Cahiers d'art,* no. 10, 1929, and nos. 1–2, 1932
C. Zervos, "Observations sur les peintures récentes de Georges Braque," *Cahie d'art,* no. 1, 1930
C. Zervos, "Le Classicisme de Braque," *Cahiers d'art,* no. 6, 1931
C. Zervos, "Réponse à une enquête," *Cahiers d'art,* nos. 1–4, 1935, and nos. 1- 1939
C. Zervos, "Braque et la Grèce primitive," *Cahiers d'art,* nos. 1–2, 1940
C. Zervos, "Œuvres de Braque," *Cahiers d'art,* no. 22, 1947
C. Zervos, "Georges Braque," *Cahiers d'art,* no. 25, 1950

By the Artist

G. Braque, "Pensées et réflexions sur la peinture," *Nord-Sud,* December 1917

G. Braque, "Réponse à une enquête," *Les Lettres françaises,* March 1946

G. Braque, "Sa Vie raconté par lui-même," *Amis de l'art,* nos. 4 – 8, 1949

G. Braque, *Cahiers de Georges Braque: 1917–1949,* Maeght, Paris, 1949

G. Braque, *Le Jour et la nuit, 1917–1952,* Gallimard, Paris, 1952

G. Braque, *Cahiers de Georges Braque: 1949–1955,* Maeght, Paris,1956

G. Braque, "Gedanken zur Kunst," *Das Kunstwerk,* vol. XIII, no. 9, 1960

G. Charbonnier, *Le Monologue du peintre,* vol. I, *Georges Braque,* Paris, 1959

G. Diehl, "L'Univers pictural et son destin: Une Conversation avec Georges Braque," *Les Problèmes de la peinture,* Paris, 1945

G. Jedlicka, "Begegnung mit Georges Braque," *Begegnung,* 1933

J. Lassaigne, "Un Entretien avec Georges Braque," *XXe Siècle,* vol. XXXV, no. 41, 1973

Pierre Reverdy, "Entretien avec Pierre Reverdy," *Derrière le miroir,* nos. 144 – 145, 1964

J. Richardson, "Braque Speaks: The Power of Mystery," *The Observer,* December 1, 1957

E. Tériade, "Confidences d'artistes: Georges Braque," *L'Intransigeant,* April 3, 1928

E. Tériade, "Propos de Georges Braque," *Verve,* vol. VII, nos. 27–28, 1952

Photographic Credits

12/09, 16/11